Skira paperbacks

Lea Vergine

Art on the Cutting Edge
*A Guide to
Contemporary Movements*

The texts Happening *and* Fluxus
are by Rosella Ghezzi, who also put
together the critical anthologies and the
bibliographies accompanying each chapter.
Rhoda Billingsley compiled the general
bibliography.

The author would like to thank Carla
Pellegrini Rocca, Enzo Cannaviello, Gino
Di Maggio, Giuliana Rovero, Lucrezia
De Domizio, Valeria Belvedere, and Giorgio
Zanchetti for all the bio-bibliographic data
they supplied.
Giorgio Tartaro was of great help in editing
the annexes.

Cover
(from top to bottom, left to right)
Giulia Niccolai, Poem and Object*, 1973;*
Konrad Klapheck, Der Superman*, 1962;*
Claes Oldenburg, Soft Typewriter*, 1963;*
Abigail Lane, Murdered Typewriter*, 1994*

Art Director
Marcello Francone

Editing
Doriana Comerlati

Layout
Eliana Gelati

Translation
Rhoda Billingsley

Printed and bound in Italy. First edition
ISBN 88-8118-739-6 (paperback)
ISBN 88-8118-740-X (hardcover)

Distributed in North America and Latin
America by Abbeville Publishing Group,
22 Cortlandt Street, New York, NY 10007,
USA.
Distributed elsewhere in the world by
Thames and Hudson Ltd., 181a High
Holborn, London WC1V 7QX, United
Kingdom.

First published in Italy in 1996 by
Skira Editore S.p.A.
Palazzo Casati Stampa
via Torino 61
20123 Milano
Italy

Contents

*Each chapter is accompanied by
a bibliography of original sources
and selected further reading, while
the general bibliography at the end
of the book refers to the development
of art in the last forty years.*

Art Informel
Gesture, colour, sign

At the end of the Fifties, the general topic of discussion was Art Informel, although the initiative had already developed some ten years earlier. Neither a school, nor a theory, Art Informel was more of a convergence of manners and styles that differed from one other yet were, at the same time, united by the idea of a total adventure.

Alberto Burri, Sack SPI, 1956

Art Informel investigates the expressive and emotional possibilities of the material. It reveals its structure and exalts its morphological ambiguities, whether these be in the woven fabric of jute, in layers of overlapping colour or in scrapings, lumps, or fragments. The Informel works are charged with a tension that potentiates the cognitive will in its attempt to reach the limit of its own finiteness, or so it was said.

The most outstanding spokesmen of such an aesthetic were the French Fautrier and Dubuffet, the Italian Burri, the Japanese Shiraga and the Spaniard Tàpies. The delicate, built up layers of coloured impasto of Jean Fautrier were rash inventions at the time, and they spoke of a world in disintegration. Ascetic degradation, *píetas*, material and memory.

Jean Dubuffet, multiform and heteroclite, was the interpreter of a truly linguistic adventure. With infantile fe-

7

rocity he noted down, dispersed, and amassed erratic homunculi and whimsical games of the colour lexicon. These "personages", born out of the affections of the soul, and the "landscapes" of fleeting fascinating vegetation proliferate in his painstakingly investigated material.

The terse, peremptory and dazzling Alberto Burri burned *sacks*, *iron* and *wood*. The dark, living substance of the sutures and patches, the mass of centrifuged reds and blacks, and the splitting of the surfaces turned the wreckage he chose into privileged places.

With Antoni Tàpies, Art Informel reached the extreme limit, touching on the silence of the concluded tragedy. His "walls", dug out of furrows in relief, refer to the conflict between us and the things we see in a period of existing uncertainties. The same is true for another Spaniard, Manolo Millares.

Kazuo Shiraga reached an emotional range without

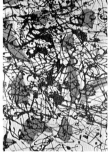

Jackson Pollock, Seven, 1950

Jean Fautrier, La Marie Salope, 1955

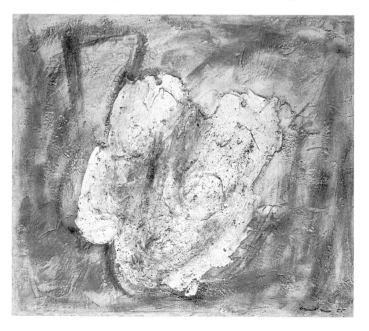

8

equal in his surfaces where the material levitates and the colour deflagrates, spreading in all directions, the result of the instinctual automatism in which the painter trusted.

Art Informel also made use of a sign, violent, febrile, and *baroque*, to translate those unconscious perceptions that had accumulated below the threshold of the conscious, and which were later elaborated in the creative process. This characterises the work of the Germans, Wols and Hans Hartung, the Italian Emilio Vedova, and the Frenchmen Henri Michaux and Georges Mathieu, although they all came from different backgrounds. In Japan, the Gutai group, founded in 1950 by the painter Yiro Yoshihara, not only adhered fully to these same theories, but became the forerunners of other new forms that will be discussed later.

Louise Nevelson, Dawn's Wedding Chapel I, 1959

In the United States, principally in New York, the equivalent of what Michel Tapié termed Art Informel in France in 1951 had been defined as Action Painting in 1949 by the critic Harold Rosenberg.

The actual gesture of painting took on the principal role in Action Painting, and, more than as an automatic act, it was interpreted as an extension of the painter's experience on the canvas.

Willem de Kooning returned to the dramatic violence of the Expressionists; Franz Kline painted large black shapes on white grounds; Robert Motherwell, Clyfford Still and Sam Francis were certainly among the most significant artists. But it was Jackson Pollock who most represented the American myth of the Fifties and Sixties and broke the New York School's traditional dependence on European painting.

Fausto Melotti, Rags, 1963

In 1947, Pollock began to use the technique of dripping which he continued until his death in 1956 at the age

of forty-four. "The canvas is placed flat on the floor; and the artist executes the painting by moving an industrial paint can with some holes punched in the bottom, dripping the colour on the canvas", explained the critic Dora Vallier in 1964. "Pollock's wish was fulfilled: he was finally, according to his own words, literally in the painting."

Parallel situations

During the Fifties, the world of art was roughly divided between Realism – figurative painting and sculpture – and Abstraction – painting and sculpture – in which forms and colours were placed with no regard for expressing any recognisable truth. Realism reproduced the human figure or objects and landscapes in a slightly deformed but still legible form. Among the Realists were Renato Guttuso, Titina Maselli, and Giuseppe Guerreschi in Italy; Francis

10

Bacon and Graham Sutherland in England; and Ben Shahn and Jack Levine in the United States.

In Italy, Lucio Fontana, the precursor and leading figure of diverse tendencies, among which *Informale* (as it was called in that country), made cuts and holes on the surfaces of his canvases, inventing the idea of *Concetto Spaziale* (Spatial Concept). Close to him were Salvatore Scarpitta, Fausto Melotti, Ettore Colla, Luigi Veronesi, Costantino Nivola and the young Gastone Novelli. Among the many who adhered to Fontana's Spatialism were Gianni Dova and Roberto Crippa, while Enrico Baj, Sergio Dangelo and Mario Colucci reinterpreted Dadaism and Surrealism. Italian sculptors made a name for themselves internationally: Leoncillo Leonardi, Francesco Somaini, Arnaldo and Giò Pomodoro, Andrea and Pietro Cascella, Alik Cavaliere, and Quinto Ghermandi. At the same time, Franceso Lo Savio and Piero Manzoni were experimenting with signs and monochromatic surfaces that were later considered the forerunners of many of the tendencies of the Seventies. In Rome, the formation of the Gruppo Forma (1947) with Carla Accardi, Pietro Consagra, Piero Dorazio, Achille Perilli and Giulio Turcato was followed by that of the Origine (1951) with Mario Ballocco, Alberto Burri, Giuseppe Capogrossi and Ettore Colla.

In Naples, the Gruppo '58 (Lucio Del Pezzo, Guido Biasi, Mario Persico, Bruno Di Bello and Sergio Fergola) which formed around Luigi Castellano (Luca) had close ties with the avant-garde poets Emilio Villa and Edoardo Sanguineti.

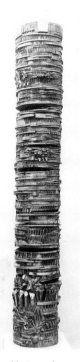

Arnaldo Pomodoro,
The Traveller's Column,
1964

Art Informel

Giulio Carlo Argan

[…] The many manifestations of Art Informel share one common feature: the emergence and the aggression of the material. The "emphasis" of the material means that the notions of space and time have been lost. The material is present like a thick wall, rough and hostile, one that can hurt, make bleed, kill. There is neither space nor time, indeed space and time are no longer there. We did have them, we did have a possibility of movement and choice; now we are no longer free, no longer do we have a choice, there is no other space or time left to live. We have exhausted the possibilities that make men free, we are now in a condition of need, and the hour of need is marked by the actual emergence of the material, irrefutable, unvoiced, and suffocating like the dank soil of the tomb. We have reached this point, and we cannot go back.

[…] Nothing could be falser than to liken the cold vehemence of Art Informel to Surrealist automatism: there is nothing unconscious in an act that identifies existence and awareness and which, if anything, represents not the emergence of the unconscious but rather the anguished struggle of a consciousness that is unable to realise itself, or place itself in a dimension of time and space. But there is no point in criticising the negativity of the modern technique by using an absurd yet incontestable technicality that neither forms an object nor sets a value, but always and invariably reproduces the material. Moreover, it does not organise it but upsets it instead; it does not model it, but takes it apart instead; it does not reduce it into preordained spatial structures, but liberates and excites instead its uncontrollable dangerous vitality.

[…] The material of a Wols, a Fautrier or a Burri is not the unformed heap of embers that anguish-ridden life is reduced to, since the artist, faced by the material, has cast off his own spiritual pride and has accepted an identification. From its inert past, the material has become memory; it has been remade into the present and the human; it has become open to the infinite possibilities of the *eide* (form); it has expanded into a new dimension of space and time. The present determines the past and future

together, binding them into a relation-
ship that is no longer logical, but is
much richer in moral interests: for
morality is not only a question of imag-
ining a plan of action, but also being
consciously present, existing, and ready
to create in the quick of the historical
situation.
("Materia, tecnica e storia nell'Infor-
male", 1959, in *Salvezza e caduta nel-
l'arte moderna*, Il Saggiatore, Milan
1964).

Maurizio Calvesi

[...] For us, but not only for us, Art In-
formel signifies only what it has really
been, that is, a series of researches and
instigations whose common denomina-
tor has been one of a commitment,
which is still current, to go beyond the
old idealistic, spiritualistic and rational-
ising conceptions of Form. Not only the
abstract image as an eidetic entity that
transcends the phenomenon, but also
the naturalistic image as effigy and sym-
bol that refers to yet is distinct from
phenomena, in order to consider the ad-
ditional possibilities, *other ones*, of a
form that proposes its own self as a phe-
nomenon.
There is also an unquestionable need
again to restore to the work the full, lit-
eral significance of "informel", which is
not a derivation or a synonym of un-
formed, but which, on the contrary,
means "non formal".
Art Informel, understood in this broad-
er sense which, in our opinion, is histor-
ically more concrete and accurate, in-
vested and conditioned a moment of art
in its entirety. It was a compulsory pas-
sage, something that, sooner or later,

ended up by having a more or less direct
influence on all the artistic manifesta-
tions after the Second World War. More
than a movement and a tendency, it was
in fact an instance, a point in which the
latest researches converged, a critical
and creative attitude that characterised
an era of crisis and development. Art In-
formel was obviously not restricted to
individual countries although the char-
acteristics it assumed in single nations
were generally different. The typically
American phenomenon of Action Paint-
ing, for example, was quite distinct from
the French *matérisme* of Fautrier and
Dubuffet. [...]
("L'informale in Italia fino al 1957",
1963, in *Le due avanguardie*, Lerici, Mi-
lan 1966).

Fabrizio D'Amico

[...] It was some time between 1953 and
1954 that a crucial step was taken in
Rome towards a modernity that was no
longer acquired through stylistic fea-
tures, laborious updatings, and precon-
ceived comparisons. It was finally mas-
tered by a vocation that had become in-
ternalised: the only horizon left to the
artistic operation was the internal one.
The work of art abdicated the dubious
role it had inherited from a post-war cli-
mate caught up in the unimportant de-
lights of ideological enunciations. It now
refers to a reality other than itself; it mat-
ters little whether it is objective or men-
tal. It has stopped defining itself in ad-
vance with respect to its real consistence,
and is now concerned only with its *own*
reality. It questions its own meaning, its
becoming concrete, and the fact that it is
independent from servile obligations.

That obscure spectre of "content" – whether it originated from political militancy or civic duty or, on the contrary, from the programmatic adhesion to its counterpart of pure formal speculation – has been eclipsed. It has dragged the insoluble diatribes that had fomented it out of history. In its place, an anxiety – precarious, dubious, timorous – to establish itself *wholly* in the work and with the work becomes central. This will no longer be a receptive mirror of an image that is, in any case, external, but a coagulum of results that are no longer entirely estimated which issue from a dialectic between the intentions of form and the potentiality of the material, between consciousness and adventure, between the project and destiny.

[…] Michel Tapié – the fundamental mentor, together with Emilio Villa, behind the artistic theories that flourished in Rome during those years – recognised that that culture was basic to the already then mature and, for many, fundamental experience of Capogrossi.

[…] Villa and shortly thereafter Tapié were also among the first critics to follow the work of Burri, and the way he "signed" his material which was, however, so unlike that of Capogrossi: his ulcerations, cuts, and holes were not anxious probes for further knowledge but "events" which could recount the bare and, at the same time, grandiose appearance of that material.

[…] Brought together in Paris by Tapié in *Individualités d'aujourd'hui* (at the Galerie Rive Droite in 1955) and again in *Structures en devenir* (Stadler in 1956), those painters (Capogrossi, Burri, and Carla Accardi were from Rome, but quite significantly not Sanfilippo, who would shortly be noticed by the French critic) were the young protagonists of the European *Art Autre* where they were lined up on the common front of the modern, in positions then defined as "cold" which were in marked contrast with the bright, all over expressionism of Action Painting. For them, the sign was not the intense existential emotionality of the gesture, but rather a neutral cramp of the hand, an entirely abstract phoneme, one that was finally separated from its Surrealist origins which had used it as an automatic instrument of truth. […]

("Gli sviluppi a Roma", in *Arte in Italia 1945–1960*, edited by L. Caramel, Vita e Pensiero, Milan 1994).

Jean Dubuffet
Starting from the unformed

The departure point is a surface that has to be animated – a canvas or a sheet of paper – and the first spot of colour or ink that is thrown on it: the effect that is produced, the adventure that results from it. It is this spot, as it is slowly enriched and oriented, that must guide the work.

One does not construct a painting like a house, starting from architectural plans, but by turning one's back on the result – by groping! backwards! It is not by staring at gold, alchemist, that you will find a way to make it; go back to your retorts, boil some urine, observe the lead avidly, what you need is there. And you, painter, spots of colour, spots and tracings, observe your palettes and your rags, the key you are looking for is inside! […]

*How the colour is applied is more
important than the choice of that colour*
When you really consider it, there are
no colours, only coloured materials.
Even ultramarine dust takes on an infin-
ity of different aspects when oil, egg,
milk or gum are mixed with it. Or if it is
applied to plaster, wood, pasteboard or
canvas (and, naturally, there are canvas-
es of different qualities and prepara-
tions). Smooth or rough. More or less
opaque. What is underneath always
transpires a little and comes into play,
even if it is difficult to see it with the
naked eye. The same colours used indis-
criminately would seem insipid and,
when used well, full of sense [...]. It is
not so important to use black, blue or
red to paint a face or a tree, it is much
more important to make *a certain use* of
the chosen colour. So much so that my
painting could be painted just with
black (and not black and white, only
black) – but varied and applied in a
thousand appropriate ways – without
losing much, while reproduced in the
entire range of colours but lacking in
this diversity, it would no longer mean
anything. Colours have less importance
than what is commonly imagined. The
way of applying them has much more.
[...]

The material is a language
That is not to say that this preoccupa-
tion with technical means drags art into
a sensual or artisan terrain that is extra-
neous to it. This is not true. Of course, it
is easy to find examples of painting in
which such technical means were em-
ployed without inspiration or ones lack-
ing in spirit. That is when we say that
they have been badly and insufficiently
used. Art must originate from the mate-
rial. Each material has its own language,
it is a language. There is no need to add
another language to it or to place it at
the disposal of a language. [...]

Dance with chance
Starting a painting is an adventure that
leads you, you know not where. The
artist would not be very interested if he
were to know from the very beginning
that he had to execute a painting that
was already completed in his spirit. It is
not like that: the artist has chance as a
partner; it is not a dance that one can do
alone, two are needed; chance is part of
the game. It pulls here and there, and
the artist guides as he can; he does it
gently, careful to take advantage of for-
tuity as it appears, making it serve his
needs, without ever impeding the latter
from yielding the slightest bit. But one
really should not speak of chance. In
this and in all the other circumstances.
There is no chance. Man calls chance
everything that comes from that big
black hole of unknown causes. The
artist is really not grappling with chance
in general, it is more a matter of a par-
ticular chance, inherent in the nature
of the material employed. The term
"chance" is inexact; it would be better
to speak of the velleity and aspirations of
the recalcitrant material. [...]
("Notes pour les fins-lettrés", 1945, in
Prospectus, Gallimard, Paris 1946).

Umberto Eco
To speak of an aesthetic of Art Informel
as typical of contemporary painting im-
plies a generalisation: "informel", from a
critical category, becomes characteristic
of a general tendency of the culture of a

period, so as to include figures like Wols or Bryen, the real Tachistes, the masters of Action Painting, Art Brut, Art Autre, etcetera. The category of Art Informel is thus qualified under the broader definition of an aesthetic of the open work.

The open work is proposed as a "field" of possibile interpretations like a configuration of stimuli that are basically indeterminate, so that the user is led to make a series of "readings" that are always variable. The structure, lastly, is like a "constellation" of elements that are open to a variety of reciprocal relationships. In such a sense the "informel" in painting can be associated with the open musical structures of post-Webernian music, and with the very latest poetry which has already accepted the definition of "informel" according to its representatives.

Art Informel may be viewed as the last link in a chain of experiments that intend to introduce a certain "movement" within the work. [...]

("L'informale come opera aperta", in *Opera aperta*, Bompiani, Milan 1962).

Jean Fautrier

[...] Two solutions are possible when faced with reality. Opposite and apparently contradictory, they join up again in any case, reaching the same end from opposite directions. One follows reality and adheres to it no matter what; the other rejects it, avoiding it at all costs.

One could indeed abandon oneself, though not without a second thought, to the stimulus of what has been seen and perceived. The real offers the initial stimulus, the beginning of everything that is about to follow. The only thing to do is let oneself go. What counts is the need to paint, that is, to experience and express an emotion.

But one can also refuse to accept that which has no reality, or any ties to an abhorrent reality, and, on experiencing all the possible combinations, find oneself very close to the point at which the first arrived by the most natural ways. The unreality of an absolute "informel" nevertheless contributes nothing. It is a gratuitous game. No art whatsoever can provide emotion if a part of reality is not mixed in with it. No matter how subtle or impalpable such an allusion may be, it is the key to the work. It renders it legible; it illuminates its meaning, and discloses its profound, fundamental reality to the sensitivity that is real intelligence. One does nothing but reinvent what already is, and restore in emotional gradations the reality inherent in material, form and colour; the results of the ephemeral are resolved in that which changes no longer.

("La réalité dans l'œuvre", in *A chacun sa réalité*, inquiry in *XX^e Siècle*, Paris 1957, no. 9).

Lucio Fontana

Art is eternal but it cannot be immortal. It is eternal inasmuch as its gesture, like any other completed gesture, cannot help but continue to remain in the spirit of man as a perpetuated race. In this way, paganism, Christianity, and everything else that has been spiritual, are completed, eternal gestures that remain and will always remain in the spirit of man. But its being eternal does not mean it is immortal at all. On the contrary, it is never immortal. It may live for

a year or for millennia, but the time of its material destruction will always come. It will remain eternal as a gesture, but it will die as material. We have now reached the conclusion that until today artists, consciously or unconsciously, have always confused the terms of eternity and immortality. As a consequence, in searching for the most suitable material for each art so that it will last longer, they have become the victims, consciously or unconsciously, of the material. They have let a pure eternal gesture decline into a lasting one in the impossible hope of immortality. We think about freeing art from the material, freeing the sense of the eternal from a preoccupation with the immortal. It does not interest us whether a gesture, once it is finished, lives a second or a millennium, because we are really convinced that it is eternal once it has been completed. Today, in a transcending reality, the human spirit tends to transcend the particular in order to arrive at the united and at the universal by freeing the spirit from all material. We refuse to think that science and art are two distinct facts, that is, that the gestures concluded by one of the two activities do not also belong to the other one. The artists anticipate scientific gestures, and the scientific gestures always provoke artistic gestures. Neither the radio nor the television can originate from the spirit of man without science provoking art. It is impossible for man not to pass from the canvas, bronze, plaster, or plastiline to a pure, universal and suspended, aerial image, just as it was impossible for him not to pass from graphite to the canvas, bronze, plaster or plastiline, without ever denying the eternal validity of the images created with graphite, bronze, canvas, plaster or plastiline. It will be impossible to adapt images that once satisfied past needs to these new requirements. As a result, we are convinced that nothing of the past will be destroyed, neither the means nor the ends. We are convinced that artists will continue to paint and sculpt using the materials of the past, but we are also equally convinced that these materials, as a result, handled and observed with other hands and eyes, will be pervaded by a more refined sensitivity.

Beniamino Joppolo, Lucio Fontana, Giorgio Kaisserlian, Milena Milani
(*Primo manifesto dello spazialismo*, Milan, May 1947).

Clement Greenberg

[…] In spite of their apparent convergence, basic differences do exist between the French and American versions of so-called Abstract Expressionism. In Paris, the abstract painting is uniformed and finished so that it is acceptable for the current taste (to which I object, not because it is current, seeing that in the long run the best taste is in accordance with it, but because it is generally at least a generation behind the best contemporary art). However "daring" their images may be, the Paris painters of the last generation are still interested in the "quality of the painting" in the conventional sense, "enriching" their surfaces with a buttery colour and layers of oil or varnish. And the design is expressly meant to attract attention by way of a certain complicity. Or the unity of the painting is guaranteed by a trace of the ancient illusion of depth ob-

tained by means of veils or by the dilution and gradation of the tonalities of colour. The result is almost always softer, sweeter and more conventionally grandiose and sumptuous than that which the "idea" or inner logic of the new type of painting seems to concur with. If Abstract Expressionism bears within it its own particular vision, this vision has been tamed in Paris, but not disciplined as the French may think.

The American version of Abstract Expressionism is generally characterised, both when successful and unsuccessful, by a fresher, more open, more immediate surface. Whether it is a matter of enamel colour that reflects the light or a diluted colour that has penetrated a canvas that has not been primed or prepared, the surface manages somehow to *breathe*. No finish isolates it, nor is the pictorial space created "pictorially" by means of intense or veiled colour; it is a question rather of frank, full-bodied contrasts and optical illusions that are difficult to specify. Nor is our painting "manufactured", wrapped and beribboned in order to be called easel painting; the shape of the painting itself is not considered so much an a priori receptacle as an open field whose unity must be permitted to *emerge* rather than be imposed or forced.

Naturally, all this renders the American product more difficult to accept. Common taste is offended by what appears as an unjust imprecision and, as always, erroneously exchanges the new spontaneity and immediacy for disorder or, in the best of cases, for solipsistic decoration.

Am I perhaps saying that the new abstract American painting is on the whole superior to French painting? Certainly. In painting every new and productive stimulus starting from Manet, and maybe every tendency of the same kind even before Manet, has repudiated the received notions of unity and finishing, and put into action within art what until then seemed too difficult to work, too rough and random to be conducted back into the ambience of the aesthetic end. This broadening of the possibilities of the means (and tradition) is a necessary element of exaltation that must be obtained from art, and it is what I miss the most from the latest French painting which simply does not stimulate my sensitivity enough. The best paintings of Gorky, Gottlieb, Hoffmann, Kline, de Kooning, Motherwell, Newman, Pollock, Rothko (and these are not our only painters) offer a fullness of presence that is rarely equalled by those of Fautrier, or even by Dubuffet between 1945 and 1948, or by Hartung or Tal Coat (four Parisian painters under fifty whose work I was able to see and which I prefer). And when I say "fullness of presence" I do not mean a new extravagant tension, but something that I find to be equivalent to the great art of the past.[...]

(Translated from Italian, "Contributo a un simposio", in *Arte e Cultura*, Allemandi, Turin 1991).

Jackson Pollock

[...] I don't work starting from drawings and sketches. I paint directly. Usually I paint on the floor. I like to work on a big canvas. I feel better, more at ease with a big space. With the canvas on the

floor I feel nearer, more part of the painting, since this way I can walk around it, work from the four sides, and literally be in the painting. This is akin to the Indian sand painting of the West. Sometimes I use a brush, but I often prefer to use a stick. Other times I pour the colour directly from the can. I like to drip fluid paint. I also use sand, glass shards, pebbles, strings, nails or other foreign matter. The method of painting is the natural growth out of a need. I want to express my feelings rather than illustrate them. Technique is just a means of arriving at a statement. When I am painting I have a general notion as to what I am about. I can control the flow of paint: there is no accident, just as there is no beginning and no end. Sometimes I lose the picture. But I'm not afraid of changes, of destroying the image, because a picture has a life of its own. […]

(*Pollock's narration to the film made by Hans Namuth and Paul Falkenberg*, 1950-51).

Jackson Pollock

[…] I don't care for "abstract expressionism"… and it's certainly not "nonobjective" and not "nonrepresentational" either.

I'm very representational some of the time, and a little all of the time. But when you're painting out of your unconscious, figures are bound to emerge. We're all of us influenced by Freud, I guess. I've been a Jungian for a long time…

Painting is a state of being… Painting is self-discovery. Every good artist paints what he is. […]

("Interview with Pollock", in S. Rodman, *Conversations with Artists*, Devin Adair, New York 1957).

Harold Rosenberg

[…] At a certain moment the canvas began to appear to one American painter after another as an arena in which to act – rather than as a space in which to reproduce, re-design, analyze or "express" an object, actual or imagined. What was to go on the canvas was not a picture but an event.

The painter no longer approached his easel with an image in his mind; he went up to it with material in his hand to do something to that other piece of material in front of him. The image would be the result of this encounter.

[…] A painting that is an act is inseparable from the biography of the artist. The painting itself is a "moment" in the adulterated mixture of his life – whether "moment" means the actual minutes taken up with spotting the canvas or the entire duration of a lucid drama conducted in sign language. The act-painting is of the same metaphysical substance as the artist's existence. The new painting has broken down every distinction between art and life.

[…] What gives the canvas its meaning is not psychological data but *rôle*, the way the artist organises his emotional and intellectual energy as if he were in a living situation. The interest lies in the kind of act taking place in the four-sided arena, a dramatic interest.

[…] Since the painter has become an actor, the spectator has to think in a vocabulary of action: its inception, duration, direction-psychic state, concentra-

tion and relaxation of the will, passivity, alert waiting. He must become a connoisseur of the gradations between the automatic, the spontaneous, the evoked. […]
("The American Action Painters", 1959, in *The Tradition of the New*, The University of Chicago Press, Chicago 1960).

Harold Rosenberg
[…] Thus art consisted only of the will to paint and the memory of paintings, and society so far as art was concerned consisted of the man who stood in front of the canvas. The achievement of Action Painting lay in stating this issue with creative force. Art had acquired the habit of *doing*.
[…] The American painter discovered a new function for art as the action that belonged to himself.
The artist's struggle for identity took hold of the crisis directly, without ideological mediation. In thus engaging art in the life of the times *as the life of the artist*, American Action Painting responded positively to a universal predicament.
[…] Painting became the means of confronting in daily practice the problematic nature of modern individuality. In this way Action Painting restored a metaphysical point to art. There was not in Action Painting as in earlier art movements a stated vanguard concept, yet it carried implicitly the traditional assumptions of a vanguard.
[…] Another vanguard assumption taken up by Action Painting with fullest intensity was that which demanded the demolition of existing values in art.
[…] The total elimination of identifiable

subject matter was the first in a series of moves – then came doing away with drawing, with composition, with color, with texture; later with the flat surface, with art materials.
[…] In a fervor of subtraction art was taken apart element by element and the parts thrown away. […] Each step in the dismantling widened the area in which the artist could set in motion his critical-creative processes.
("Action Painting: Crisis and Distortion", 1964, in *The Anxious Object*, Collier Books, New York 1966).

Kazuo Shiraga
[…] When I discovered my true nature, I decided to bare myself, freeing myself from the burden of pre-existing forms. The figures leapt away crackling, and the technique was split in two, liberated by my spatula. To push originality forward by running hard without the fear of possibly losing my balance, I also got rid of my spatula. In the end, I tried with my bare hands, with my fingers, and then with my feet. Yes, by running forward more and more, I reached my feet. I painted with bare feet.
("Pure action", in the bulletin *Gutai*, Osaka, 20 October 1955, no. 3).

Kazuo Shiraga
[…] The first thing that a man must do is grasp the material that is his from the moment of birth. This material explicates the difference between him and other individuals through experienced sensations, spoken words, paintings, sonority, and whatever else he may express. He must therefore create a way to feel, speak, and paint that is his alone.

21

The normal custom today, which tends to limit and brake free expression, weakens the faculty of self-representation to such a degree that one cannot even admit to himself the fact that he is different from others.

If, from the very beginning, one only did the things one liked, without refusing any of them, then the image of one's own material qualities would gradually take form. In this way, these qualities would be recounted in every one of our actions.

But innate gifts are not enough for creating an interesting condition; they must be forged and reshaped assimilating whatever phenomenon surrounds them. I believe that when we express our qualities through the way we act, the force of our will is already in action. Man's force of will consists in his ability to give the intellectual maturity he has acquired precedence over his innate gifts. The latter grow thanks to the contribution of individual characteristics, the fruit of a constant plundering of all the things, individuals included, that are around us. But the expressive force is what is important in doing this. And I believe that a discussion of this type can only be made when action becomes expressive consciousness. I mean an expression that has been rendered conscious through the activity of thought, and is the same if one deals, for example, with an immaterial expression, or a material expression obtained by means of physical action.

[…] Ever since I began to represent my qualities by painting with my hands, feet, and entire body, my gifts have grown, digging a kind of furrow, a path to follow that expresses itself work by work.

("The foundation of an individual", in the bulletin *Gutai*, Osaka, 1 July 1956, no. 4).

Michel Tapié

[…] Given the infernal rhythm of the current era in which series are quickly exhausted, only ambiguity can save art from the academic traps that are inexorably tied to the attitude that every ongoing adventure suggests to us, however invigoratingly anarchic it may have been at the beginning. The perspicacious Georges Mathieu had already shown in his calligraphy that when form left all its possibilities of creative liberty of Non-Form to the artist, Art Informel had a new possibility of transcendence in the Non-Non-Form. Thus an infinite number of new doors were opened onto an inexhaustible, indefinite formalism that could now be exploited apart from any possible academicism, since there was no longer a possibility for any gratuitousness or for any action. The entire adventure would be experienced every time and in every work by those who were thoroughly committed to it, and whenever the creator was faced with the vertigo of Nothingness, and apart from all those attitudes that are nothing but the life preservers of cowards for whom art is nothing but a mania and an honourable imposture that they wish to drag the collective stupidity into for they have become the laughing stock of their nullity.

Within the hazardous limits of ambiguity, the transcendental form, filled with the possibility of becoming, will be fully

elaborated. It will be proposed to us as the wonderful subject of what will always be the most intoxicating of mysteries for man: that of the "vivacious" with nothing but its entire becoming, the human condition with all that is fantastically wonderful in tests of strength where the intoxication of the dynamic can reach the transfinite limits of ecstasy where the notions of beauty, mystery, eroticism, mysticism, and even aesthetics are completely expressed. Art, then, can only be an extremely momentous magical operation that leads us consciously to the magnificent vertigo of a test of sublime violence beyond any of the considerations of "art criticism".
[...]
(*Un art Autre*, Giraud, Paris 1952).

Lorenza Trucchi

[...] Art Informel is not an avant-garde movement, it is much more like a subversive, protesting anti-movement, and, generally speaking, one that is intolerant of any models inherited from the past. Paraphrasing a nicely put declaration of Dubuffet – "Revolutions overturn the hourglass, protests break it" – we might say that while the historical avant-garde movements have overturned the hourglass, Art Informel has broken it. Indeed, Art Informel actually does break the convulsive yet consequent routine of contemporary art with its anti-formalistic and anti-historicist attitude. Thus, although references exist between Art Informel and Impressionism, and Expressionism and Surrealism, there is, however, no real historical continuity, and no intentional connection to tradition or the innovative work of the pioneers of

the non-figurative even if their techniques have been adopted in some cases. Art Informel has divided the century: a fracture that is irrational, emotional, instinctual. It originated with the crisis at the end of a war, a war as cruel as all wars are, as the psycho-physical man's rebellion and revenge against the reasons of history and ideologies that are so often fallacious. Art Informel came forth with new values which had not been programmed, values which until then had been forgotten, opposed, or put aside. It was a denunciation, a protest, a loud cry, not a proposal, nor a project, and never a solution. These first observations clearly indicate that the indirect, if not actually unconscious, influence of two philosophical theories can be detected behind Art Informel: phenomenology and existentialism.

Phenomenology, and it may be superfluous to repeat it here, studies phenomena as they appear through experience. Husserl's phenomenology in particular was a description of the immediate data from awareness: an incarnate awareness, that is to say, one that was always the awareness of something.

Existentialism is the theory that asserts the primacy of *existence* over *absence*, and therefore is poles apart from the rational, mathematical spirit. Through existentialism, which is, for the most part, an applied philosophy which is expressed through artistic works – theatre, literature, painting – man again becomes aware of life as he once again acquires the astonishing wonder of existence: "Existence – said Gabriel Marcel – is inseparable from wonder." For the existentialists, to exist did not mean *to be*

23

but to be *in a situation*. And so, returning to Art Informel, we can see how properly it qualifies as an act of existence, free from any intentionality. An act that registers or reproduces the flow of life, at times even before the mind intervenes with its own logic or even with its own doubts, criticism and analysis. If anything, the Informel artist should, as Kierkegaard said, "let his thoughts appear with the umbilical cord of the primitive journey". [...]

("L'Informale in Europa", conference of 14 January 1973, in *Situazioni dell'arte contemporanea,* Librarte, Rome 1976).

Jiro Yoshihara

[...] Gutai art does not transform the material. Gutai art gives life to the material. In Gutai art, man's spirit and the material shake hands. The material is not subjected to the spirit. The spirit does not force the material, it does not subordinate it to itself. The material remains what it is and, when urged, it reveals its properties, it begins to tell its story, even to shout it. Infusing the material with a full life is a way of infusing life with spirit.

[...] As far as we are concerned, for what it is worth, abstract art has lost all its fascination, so much so that at the moment our group was formed we chose the term Gutai (concreteness) as our name. We desire above all to be open to the outside, in contrast with the centripetal force of abstraction.

[...] It surprised us to see how it was possible to give life to a space heretofore unknown, a kind of melting pot of automatism in which human and material gifts blend. Automatism inevitably transmits the author's image. We count a great deal on personal methods of creation.

[...] Kazuo Shiraga heaps the paint on an enormous sheet of paper and then spreads it violently with his feet. This new process has attracted the attention of journalists who have spoken about "corporal art". The author did not intend to turn his way of expressing himself into what has been interpreted as a spectacular exhibition, but only to achieve the synthesis we have been talking about between his particular material chosen in function with his character and mood. [...]

("Manifesto of Gutai art", in *Geijutsu shincho*, Tokyo, December 1956).

Bibliography

M. Tapié, *Un art Autre*, Giraud, Paris 1952.

F. Arcangeli, "Gli ultimi naturalisti", in *Paragone*, no. 59, Sansoni, Florence 1954.

F. Arcangeli, "Una situazione non improbabile", in *Paragone*, no. 85, Sansoni, Florence 1957 (also in *Dal Romanticismo all'Informale*, vol. 2, Einaudi, Turin 1977).

T. Sauvage, *Pittura italiana del dopoguerra*, Schwarz, Milan 1957.

XXIX Biennale Internazionale d'Arte di Venezia, exhibition catalogue, Venice 1958.

G. Dorfles, *Il divenire delle arti*, Einaudi, Turin 1959.

XXX Biennale Internazionale d'Arte di Venezia, exhibition catalogue, Venice 1960.

C. Brandi, *Segno e immagine*, Il Saggiatore, Milan 1960.

P. Restany, *Lyrisme et Abstraction*, Apollinaire, Milan 1960.

H. Rosenberg, *The Tradition of the New*, The University of Chicago Press, Chicago 1960.

"L'Informale", in *Il Verri*, no. 3, Feltrinelli, Milan 1961.

XXXI Biennale Internazionale d'Arte di Venezia, exhibition catalogue, Venice 1962.

"Dopo l'Informale", in *Il Verri*, no. 12, Feltrinelli, Milan 1963.

G. C. Argan, *Salvezza e caduta nell'arte moderna,* Il Saggiatore, Milan 1964.

R. Barilli, *L'Informale e altri studi*, Scheiwiller, Milan 1964 (also in *Informale Oggetto Comportamento*, Feltrinelli, Milan 1979).

M. Calvesi, *Le due avanguardie*, Lerici, Milan 1966.

H. Rosenberg, *The Anxious Object*, Collier Books, New York 1966.

D. Vallier, *L'Art abstrait*, Hachette, Paris 1967.

M. Ragon, *25 ans d'art vivant*, Casterman, Tournai 1969.

E. Villa, *Attributi dell'arte odierna '47–67*, Feltrinelli, Milan 1970.

E. Crispolti*, L'Informale. Storia e poetica*, vol. 4, Carucci, Rome 1973.

C. Brandi, *Scritti sull'arte contemporanea*, vols. 1–2, Einaudi, Milan 1976.

C. Cerritelli*, L'arte del paesaggio essegi*, Ravenna 1991.

L. Trucchi, *Arte per tutti*, La Cometa, Rome 1992.

H. Bergson, *Creative Evolution*, Dover, Mineola (N.Y.) 1998.

Nouveau Réalisme
Objects placed in artworks

The first years of the decade of 1960–70 were a period particularly rich in passions and inventions during which time visual art movements like Op Art in Europe, Pop Art in the United States, and Nouveau Réalisme in France burst onto the scene. The role of the art critic also changed during those years, becoming one that was marked by a more direct and parallel participation.

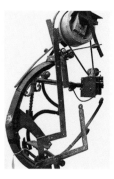

Jean Tinguely, Gay Machine, 1964

While the figure of the theorist was delineated in Giulio Carlo Argan with fascinating demiurgic connotations, it was with Pierre Restany that the role of the militant critic originated, that catalyser and organiser of artistic forces. The way of making art changed as did that of being a critic. With Restany, the critic became a person whose entire existence was dedicated to becoming part of the artistic events he was witnessing.

Restany did not identify himself with Nouveau Réalisme, sensitive as he is to experiments in far corners of the world, as well as in major international centres, but Nouveau Réalisme, as an itinerant nucleus, certainly owes its birth, and survival, to the sagacity of a mentor like Restany.

Let us examine what the movement that formed between '58 and '59 actually was and what it intended to be.

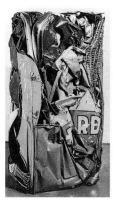

César, Compression of an Automobile, 1962

The various personalities who participated in it continued to desecrate the image by practising Dadaist exorcism, which had become part of the history of art in the meantime. The *picture* was everything, yet at the same time it was no longer simply a picture for the Nouveaux Réalistes: they collected everyday objects (advertising posters, musical instruments, newspaper clippings, used car parts, etc.), and elaborated them so as to draw the viewer's attention to the now privileged object and the morphology of the single elements. Properties that the objects had once possessed emerged when they were emphasised or accumulated: properties of harmony, quiddity, aggressivity, properties that had, in any case, once been in a latent state.

Daniel Spoerri, Kichka's Breakfast no. 2, 1961

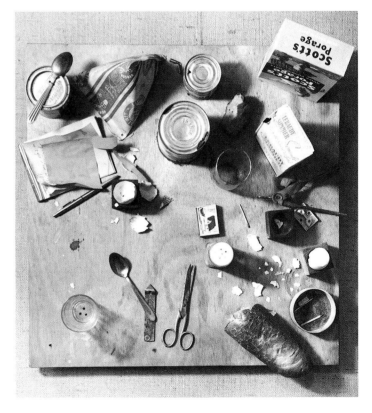

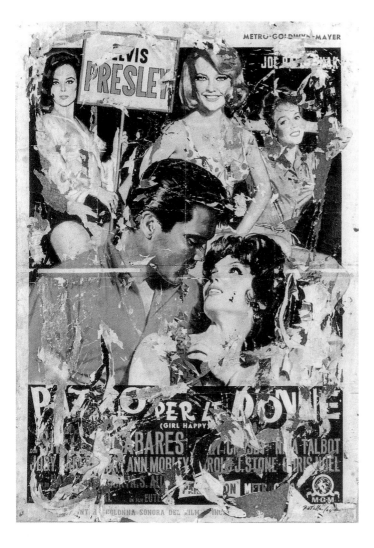

What was important for Duchamp's heirs was the use of irony as an instrument of communication; the stretching of the confines between the world of art and the world of non-art; the irreverent charge of the object; the appropriation of a new nature made up of ingredients from the technological, industrial, and urban scene in order to transform our submission into a reversible and critical act; the idea of looking around and *seeing*, recognising the traces of an aesthetic value even in junk.

Yves Klein explored colour, bright red, ultramarine

Yves Klein, The Space Painter Jumps into Void, 1960

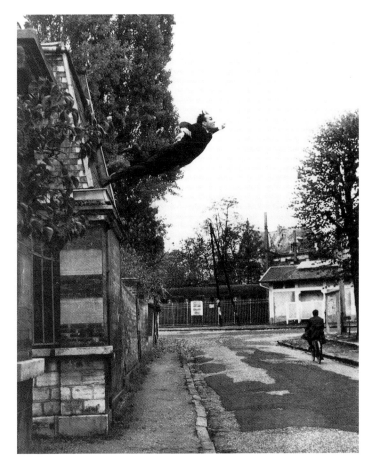

blue, gold, and exalted it as living, significant material in itself. His idea of using the monochrome blue determined a single time of perception, a limitless space. *Pneuma apeiron,* said the ancient Greeks. A conception of space that we could actually define as *zen,* one that is viewed as a positive entity, not just the background for events but rather their generator.

The torn posters of Mimmo Rotella (the only Italian), and Jacques de la Villeglé and Raymond Hains (the conservators of an immense ongoing street museum!) accent the absurd mechanisms of life and daily events. The accumulations of Arman and Deschamps do not liquidate values, but rather consecrate aspects that are disappearing; thus the surreal-terrorist epiphanies of Niki de Saint-Phalle and Daniel Spoerri. "To recognise the expressive autonomy of the sociological reality" is the common denominator for César's compressed vehicles, Dufrêne's collages, Martial Raysse's kitsch provocations, Jean Tinguely's rebellious machines, and Christo's wrapped objects and monuments.

François Dufrêne in front of Brèches for Brecht, 1960

Nouveau Réalisme

Yves Klein

[...] Personally, I would never attempt to smear my body in order to become a living paintbrush; on the contrary, I would rather put on a dinner jacket and white gloves. I wouldn't even dream of dirtying my hands with paint. Detached and distant, it is under my eyes and my orders that the artistic work must be achieved. Then, when the work begins its final stage, I'll stand up, present at the ceremony, immaculate, calm, relaxed, perfectly aware of what is happening and ready to receive the art as it is born into the tangible world.

What led me to anthropometry? The answer lies in the works that I executed between 1956 and 1957, during the period in which I took part in that great adventure that was the creation of immaterial pictorial sensitivity.

I had just cleared out all my previous works from my atelier. The result: an empty atelier. The only thing I could physically do was to stay in my empty atelier, and my activity of creating immaterial pictorial situations manifested itself marvellously. However, little by little, I became mistrustful, as I confided with myself, but never with the immaterial. Starting then, I paid for models as all painters do. But unlike the others, the only thing I wanted to do was work with the models, not have them pose for me. I really had spent too much time alone in that empty atelier; and I didn't want to stay alone any longer in that marvellous blue empty space that was about to blossom. [...]

The shape of the body, its line, its strange colours oscillating between life and death held no interest for me. Only the pure, essential, affective atmosphere of the flesh is important. Having rejected nothingness, I had discovered emptiness. The significance of the immaterial pictorial zones resulting from the depths of emptiness that I had succeeded in dominating in that moment was really of a material order. Maintaining that it was unacceptable to sell these immaterial pictorial zones for money, in exchange for the highest quality of the immaterial, I claimed the highest quantity of material compensation: a pure gold ingot. Strange though it may seem, I have already sold a good number of these immaterial pictorial situations.

[...] Between 1946 and 1956, the monochrome experiments I carried out with colours other than blue never led me to lose sight of the fundamental truth of our time which is that form by now is no longer a simple linear value, but a value of saturation.

[...] Man will only succeed in taking possession of space by means of terrible forces, ones, however, that are imprinted with peace and sensitivity. He will really not be able to conquer space – which is probably his greatest wish – unless he has succeeded in saturating space with his own sensitivity. Man's sensitivity is omnipotent in immaterial reality. His sensitivity can also read the memory of nature, whether it deals with the past, present or future! This is our true capacity for extra-dimensional action! [...]

("Stabilito che...", in Yves Klein, *Il mistero ostentato*, essays edited by G. Martano, in *Nadar*, 6, Martano, Turin 1970).

Lucy Lippard

[...] They held their first Paris exhibition – *40° au-dessus de Dada* (40 degrees above Dada) – at Restany's Galerie J. The title of this show is significant, for the New Realists had made no attempt to break with the strong Dada and Surrealist tradition still existing in Paris. On the contrary, by pointing to Duchamp's ready-mades as their source, they proudly proclaimed their legitimacy, and it is impossible to overemphasize Duchamp's influence on their activities. While a certain blatant iconoclasm and wit allied them to Dada rather than to Surrealism, Surrealism is the obvious predecessor of many New Realist ob-

jects, and its trenchant eroticism is another major legacy. The New Realists rarely let the chosen object speak for itself, as Duchamp's ready-mades, or Johns' ale cans did, but invest it with a soupçon of mystery and elegance by fragmentation, juxtaposition, or slight alteration. It is not the directness, the banality, the refreshing anonymity of urban reality that appeals to them, but the hitherto unrecognised strangeness latent in every common object, old or new.

("Europe and Canada", in *Pop Art*, Thames and Hudson, London 1966).

Pierre Restany

[...] We are today witnessing the exhaustion and sclerosis of all the established words, languages and styles. In opposition to this lack – by exhaustion – of traditional means are individual adventures scattered throughout Europe and America. All of these tend, whatever the breadth of their investigative field, to define the normative basis of a new expressivity.

This is not a matter of an additional formula for the use of an oil colour or paint. Easel painting (like any other classical means of expression in the field of painting or sculpture) has seen its day. Right now it is living the last, and at times even sublime, moments of a long monopoly.

What else has been suggested to us on the other hand? The passionate adventure of reality captured as it is and not through the prism of a conceptual or imaginative transcription. What is the trademark of this? The introduction of a sociological exchange at the fundamental stage of communication. Sociology

comes to the aid of consciousness and chance, both when it comes to the choosing or to the tearing of a poster, the allure of an object, a piece of junk, or leftover food, an outburst of mechanical affectivity, or the diffusion of sensation beyond the limits of its perception. All these adventures (and there are and will be more) annul the abusive distance created by the categorical intellect between the general objective contingency and the individual expressive urgency. It is the entire sociological reality, the common good of the activity of all men, the great republic of our social exchanges, our commerce in society that has been summoned to judgement. There should be no doubt about its artistic vocation, if there were still not so many people who believe in the eternal immanence of self-styled, noble genres, and of painting in particular.

At the urgently essential stage of full affective expression and of the externalising of the individual creator, we are heading towards a new realism of pure sensation through the naturally baroque appearances of certain experiences. This is at least a direction for the future. Very different premises are being set in Paris with Yves Klein and Tinguely, Hains and Arman, Dufrêne and Villeglé. The ferment will be fecund, but still unpredictable as to its final consequences, and certainly iconoclastic (because of the icons and stupidity of their worshippers).

Here we are immersed in direct expressivity, right up to our necks at 40 degrees above Dada zero, without complexes of aggressivity, without any idea of argumentation, or any desire for justi-

fication other than our own realism. And this works positively. Man, when he manages to reintegrate himself into reality, identifies it with his own transcendence, which is emotion, feeling, and lastly, still poetry.

(*I Nouveaux Réalistes*, 1st Manifesto, Milan, 16 April 1960; in Galleria Apollinaire catalogue, Milan, May 1960).

Pierre Restany

[…] Every individual adventure develops its internal logic starting from a borderline position which is the very essence of language, the fundamental impulse of communication. This absolute gesture is an ultimatum to the spectator who is being asked to participate. These ideas inspired my first manifesto of the Nouveaux Réalistes which I published in Milan on 16 April 1960 just before the group exhibition that took place the following month at the Galleria Apollinaire. In addition to Klein, Tinguely and Hains, were the poster artists Villeglé and Dufrêne, and Arman who had just finished his first series of *poubelle* accumulations.

I had therefore launched the term Nouveau Réalisme. It had an immediate coagulating impact. On 27 October 1960, the group of Nouveaux Réalistes was officially founded in the house of Yves Klein in the presence of Arman, Dufrêne, Hains, Klein, Raysse, Spoerri, Tinguely, Villeglé and myself. César and Rotella, although invited were not present, but they participated in the following manifestations of the group that Niki de Saint-Phalle, Deschamps, and lastly Christo later joined.

Once the group had been founded, it

was necessary to agree on a unanimously accepted formula. Thus, Nouveau Réalisme: a new perceptive approach to reality. It was, as has been seen, a general idea which was subscribed to by one and all for particular reasons. The group came into being because of the new awareness of some isolated artists, common concerns and the momentary need for a collective action. What was most important was that people who had reached a culminating and decisive point in their careers were able to meet. More precisely, it was between 1958 and 1960, following a series of events that crystallised the situation, that the movement took its actual direction. In April 1958, at Iris Clert's, Yves Klein held his manifestation of the Void, the departure point for his collaboration with Tinguely which they finished a few months later: *Pure Velocity and Monochrome Stability* (monochrome disks mechanically operated). Starting with his *Métamatics*, Tinguely arrived at the gigantic *Homage to New York*, his first large scale self-destructive assemblage (1960). In 1959, Hains exhibited the *Palisade of Reserved Areas* to the Parisian public, while Arman began his first "accumulations" of objects in Nice after his graphic impressions of stamps and the "allures". 1960 was the year of Arman's *Le Plein*, Spoerri's trap-paintings, Niki de Saint-Phalle's shot, Deschamps' rags, and the new orientations of Martial Raysse and Christo. Rotella selected his torn movie posters, the "new images" of Cinecittà. And lastly, at the Salon de Mai of 1960, César, at the age of forty and at the risk of compromising a brilliant yet more traditional career, presented his new sculp-

tures, automobiles compressed into blocks weighing a ton.

The time was ripe at the end of 1960. The Nouveaux Réalistes had become aware of themselves and their own uniqueness: on several occasions during the following two years they exhibited in salons, at the Galerie J (*40° au-dessus de Dada*, May 1961), and in other private galleries both in France and abroad. A Nouveau Réaliste festival was organised in Nice in July 1961. [...]
("Nouveau Réalisme", 3rd Manifesto, in 2nd Festival Nouveau Réalisme catalogue, Munich, February 1963).

Mimmo Rotella

I remained impressed by the walls papered with torn posters. They literally fascinated me, because even then I thought that painting was finished and that it was necessary to discover something new, vital, and current. So in the evening I started to tear posters, ripping them off the walls, and I brought them to my studio, arranging them or leaving them just as they were. That's how *décollage* came into being.
[...] It was the philologist and art critic Emilio Villa who first discovered the *affiches lacérées*.
[...] The majority of my *décollages* are exactly how I found them, having already been worked over by the man in the street and the elements. [...]
(*Rotella '77* catalogue, Il Collezionista, Edizioni/1, Rome, February 1977).

Bibliography

"Dopo l'Informale", with essays by A. Boatto, R. Barilli, M. Calvesi, in *Il Verri*, no. 12, Feltrinelli, Milan 1963.

P. Restany, *Il libro bianco dell'arte totale*, Apollinaire, Milan 1969.

P. Restany, *Nouveau Réalisme 1960/1970*, exhibition catalogue, Rotonda della Besana, Milan 1973.

P. Restany, *Nuovo Realismo*, Prearo, Milan 1973.

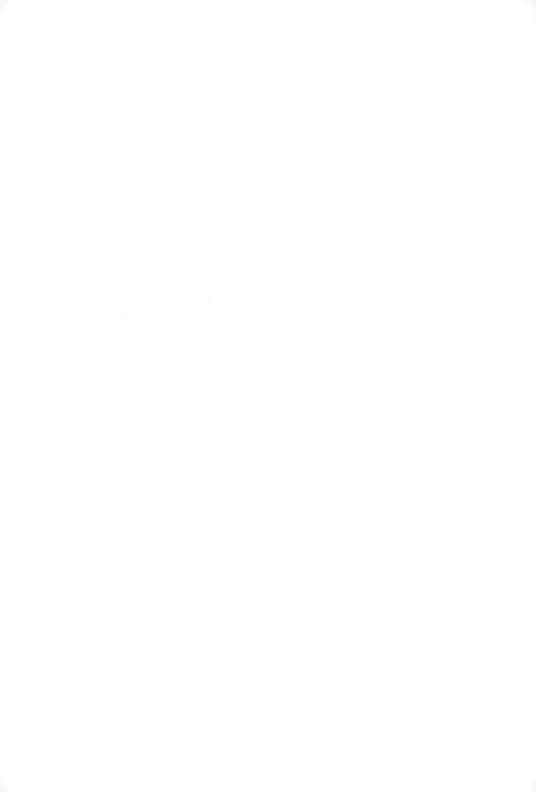

Happening

Actions, sounds, noises

A Happening is something that happens. Often unexpectedly. An American of Russian origin, Allan Kaprow, chose this term for some of his experiences during 1958–59 which were what today would be called multimedia events.

The word "Happening" appeared for the first time in the title of his work, *18 Happenings in 6 Parts*, presented in '59 at the Reuben Gallery in New York. Later on, the generic use of the term created misunderstandings at times when associated with experiences that were often of the behavioural type and very different from one another. The Happening has a certain relationship to the theatre, albeit in a heretical sense. It is an event in which a "compartment structure" is used. Something happens in each compartment: an elementary action performed by one or more actors, a sound, a noise, or the declamation of words.

Each of them can be completely autonomous with respect to the following one; it may be part of a sequence or develop simultaneously to other situations, it does not necessarily have to respect cause-effect relationships and can take on random components. Unforeseeable circumstances can occur at times in a Happening, ones that can change the outcome, like changes in the weather or audience reactions. Any fortuitousness can also be determined by the ac-

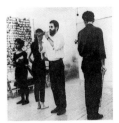

Allan Kaprow,
18 Happenings in
6 Parts, 1959. Part four,
Room no. 1: the
orchestra (Shirley
Prendergast, Rosalyn
Montague, Allan
Kaprow, Lucas Samaras).
A seated spectator can be
seen through the plastic
wall

John Cage preparing a piano, circa 1950

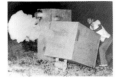

Sadamasa Motonaga, Smoke, 1957

Jim Dine, The Car Crash, 1960. The man in silver is drawing on a blackboard

tors: they can decide to start an action at one point rather than another; they can choose the way they want to move an object, and so on. Although a certain element of chance was expected, there was no improvisation in the first Happenings; the author established the sequence of events, their execution, and often chose to participate himself so as to have greater control over the entire operation. The actor is as important as the other scenic elements; he becomes an object, he does not have to perform, but must only concretise whatever has been decided.

With respect to the spoken word, noises and sounds prevail in Happenings. When words do appear, they are not used in the traditional sense of communication or information, and the laws of probability often determine their selection and distribution in dialogues and monologues.

In the use of such verbal forms, analogies and affinities to the Dadaist representations at the Cabaret Voltaire in Zurich (1916) can be detected which had been structured

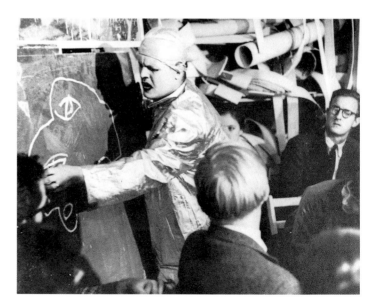

into compartments. The Happening was also related to Futurist experiences like Bruitismo or the "Art of Noise" music (1913) of Luigi Russolo, the work of Kurt Schwitters who made collages of real material that invaded the surrounding area with his series of Environments (the *Merzbau* of 1924 and the *Merz Theatre*), and the various Surrealist exhibitions (from 1938 to 1960).

Consequently, even the work of Georges Mathieu in his *Poetry Evening* in Paris (1950), the *ante litteram* Happening of John Cage's *Concerted Action* at Black Mountain College in North Carolina (1952), and the Gutai Festivals at Osaka (1955–57) can be considered precursors of the Happening, inasmuch as they have many features in common.

In addition to Kaprow, others who made Happenings were Claes Oldenburg, Red Grooms, Jim Dine and Robert Whitman.
(Rosella Ghezzi)

Shozo Shimamoto, Please walk over this, 1956

Claes Oldenburg, Autobodies, 1963. Poem Four: the girl (Pat Oldenburg) collects objects for the structure

Happening

John Cage

[...] A theatre in which we ourselves are in the centre is more pertinent to our daily experience... a theatre in which the action takes place around us. The placement of seats, as I had organised it at Black Mountain in 1952, formed a square composed of four triangles whose vertices converged without joining. The centre was a space big enough to contain the action as were the aisles between the four triangles. [...] There was a cup on each seat and it was not explained to the audience what it had to do – some people used it in fact as an ashtray – but the show concluded with a kind of ritual that consisted in pouring coffee in each cup. At one end of a rectangular room, on the longest side, a film was projected; at the other end, slides. I was on a ladder and I held a conference comprised of silences and there was also another ladder that M. C. Richards and Charles Olsen climbed on several occasions. During periods that I called parentheses of time, the performers were free within certain limits, compartments that they were not obliged to fill like a green traffic light. Not until this compartment started, were they free to perform, but as soon as it had started they could perform for as long as they liked. Robert Rauschenberg played an old-fashioned phonograph with a trumpet and a listening dog; David Tudor played the piano and Merce Cunningham and other dancers moved in the middle and around the audience. Some of Rauschenberg's paintings were hung above the spectators. At that time, Rauschenberg was also painting his black paintings, but it seems to me we used only the white ones. They slanted down at different angles as to form a vault above the spectators. [...]

I can't remember anything else except the ritual of the coffee cups. I do remember that a lady entered at the very beginning: she was the widow of the man who had been the head of the music section. She had come early on purpose in order to get the best seat and she asked me where the best seat was: I told her that they were all equally good. Well, she realised that she hadn't received an answer to her question, so she simply sat where she thought best. On

the other hand, she couldn't, as I couldn't, decide which was the best seat because you saw a different show from each one. [...]

(Translated from Italian – Michael Kirby, Richard Schechmer, "Interview with John Cage", from *Tulane Drama Review*, vol. 10/N2, tome 30, winter 1965, in *Marcatré*, 37–40, Lerici, Milan, May 1968).

John Cage
I BELIEVE THAT THE USE OF NOISE

Wherever we are, what we hear for the most part is noise. When we want to ignore it, it disturbs us; when we are listening to it, we find it fascinating. The rumble of a lorry at ninety per hour. Electrostatics on the radio. Rain. We have a desire to catch these sounds and control them, to use them not as special effects but as musical elements. Every movie studio owns a collection of "sound effects" recorded on film. With suitable reproducing equipment it is today possible to control the frequency and breadth of any sound of this type and supply it with rhythms inside or outside the reach of the imagination. Given four instruments of this type, we can compose and execute a quartet for a piston-engine, wind, heartbeat and landslide.

(Translated from Italian, "The Future of Music", conference held in Seattle, 1937, in John Cage, *Silence*, Middletown, Conn., 1961).

Maurizio Calvesi
[...] The Happening was, and is, the active contemplation of the event in itself for what it is, rather than for its meanings: a thing that happens, that occurs, but in which what counts is the happening, the occurring, and not the thing. [...] An event can be perceived as a suspension of flux or as its passage and development; indeed, these two ways and not others are the natural, inextricably complementary ways of considering a moment in time. The Happening as a cult of something that happens or occurs germinates precisely from this feeling of time: it implies and displays an awareness of time as flux, as succession, but it exalts the occurrence inside this awareness or condition, that is the possibility of securing a small portion of time, of highlighting a suspended moment or a cluster of suspended moments.

[...] In the Happening as in Pop Art, complementary to a time of perception that is minimal, immediate, contracted, and intensive, [...] is a space that is maximum, dilated, dispersive, exuberant, and squandered. The flux, blocked in its natural channel of time, deviates into space, spreading out like an obstructed river. Temporal energy, contracted like a spring, turns into a centrifugal, enveloping spatial energy, and that is when theatricality becomes spectacular.

In this exceptional relationship between time and space, perception is activated like an alarm, and precedes and prevaricates any other dimension of awareness; it absorbs it, and even physiologises thought, the radar that intercepts the interruptions and continuations of the flux. [...]

("Arte e tempo", in *Teatro delle mostre*, Lerici, Milan 1968).

Jim Dine

The visual side of the Happenings was the extension of my painting, but there were other things involved, since I think on two levels. I think on the visual level which has nothing to do with the way one talks. But these things had to get across with talking, too – as literary ideas seen in a visual way – so that there were two levels. […]

I felt that it was the most natural thing to do – to do the Happenings. When I did *The Car Crash*, it related to my paintings only because I was doing a Happening then, and that is what I was painting about, and I thought it would be nice to tie them in. There was no other relationship.

[…] The first Happening I did was called *The Smiling Workman*, at the Judson Church. I had a flat built. It was a three-panel flat with two sides and one flat. There was a table with three jars of paint and two brushes on it, and the canvas was painted white. I came around it with one light on me. I was all in red with a big, black mouth: all my face and head were red, and I had a red smock on, down to the floor. I painted: "I love what I am doing" in orange and blue. When I got to "what I am doing", it was going very fast, and I picked up one of the jars and drank the paint, and then I poured the other two jars of paint over my head, quickly, and dove, physically, through the canvas. The light went off. It was like a thirty-second moment of intensity. It was like a drawing. […]

("A Statement", from a recorded interview, in Michael Kirby, *Happenings*, E. P. Dutton & Co., Inc., New York 1965).

Red Grooms

[…] The structure of my performances came from the idea of building a set like an acrobat's apparatus. The performer's actions would be improvised on the rigging around him. Since the action, or play, was directed by the environment, the sounds came from within, as on the street. The time of the act could take as long as a man's dive from a tower into a flaming tank. And, hopefully, the meaning would be as direct.

From making sets I found the thrill of "3-D-ing" an environment, so that it enveloped the audience, would be something to attempt in my painting.

[…] All of the aforementioned is specifically describing *The Burning Building*. […]

("A Statement", from a recorded interview, in Michael Kirby, *Happenings*, E. P. Dutton & Co., Inc., New York 1965).

Allan Kaprow

[…] The name "Happening" is unfortunate. It was not intended to stand for an art form, originally. It was merely a neutral word that was part of a title of one of my projected ideas in 1958-59. It was the word which I thought would get me out of the trouble of calling it a "theatre piece", a "performance", a "game", a "total art", or whatever, that would evoke associations with known sports, theatre, and so on. But then it was taken up by other artists and the press to the point where now all over the world it is used in conversation by people unaware of me and who do not know what a Happening is. Used in an offhand fashion, the word suggests

45

something rather spontaneous that just "happens to happen". For example, walking down the street people will say, humorously, when they see a little dog relieving himself at a hydrant, "Oh, isn't that a Happening?".

[...] This hostile sense of the "Happening" is unfortunate.

[...] It conveys not only a neutral meaning of "event" or "occurrence", but it implies something unforeseen, something casual, perhaps – unintended, undirected. And if I try to impress everyone with the fact that I really direct a Happening inside out, as most of us do, they do not believe it.

[...] Especially since I wanted people involved rather than as spectators, I had to find a practical way to do this. So I thought of the simplest situations, the simplest images – the ones having the least complicated mechanics or implications on the surface. Written down on a sheet of paper sent in advance, these actions could be learned by anyone. Those who wished to participate could decide for themselves. Thus, when I arrived just before the scheduled event, I already had a committed group, and I could then discuss the deeper implications of the Happening with them as well as the details of performance. [...] My works are conceived on, generally, four levels. One is the direct "suchness" of every action, whether with others, or by themselves, with no more meaning than the sheer immediacy of what is going on. This physical, sensible, tangible being is to me very important. The second is that they are performed fantasies not exactly like life, though derived from it. The third is that they are an or-

ganised structure of events. And the fourth level, no less important, is their "meaning" in a symbolic or suggestive sense.

("A Statement", from a recorded interview, in Michael Kirby, *Happenings*, E. P. Dutton & Co., Inc., New York 1965).

Michael Kirby

There is a prevalent mythology about Happenings. It has been said, for example, that they are theatrical performances in which there is no script and "things just happen". It has been said that there is little or no planning, control or purpose. It has been said that there are no rehearsals. Titillating to some, the object of easy scorn to others, provocative and mysterious to a few, these myths are widely known and believed. But they are entirely false.

It is not difficult to see why these spurious concepts developed. Myths naturally arise where facts are scarce. Those people who have actually attended even one performance of a Happening and have what might be considered first-hand information are relatively few. Individual audiences have generally been small – they have rarely exceeded one hundred and are usually close to forty or fifty. Productions have been limited to a few performances, and almost all of the artists would reject the idea of "revivals".

Many spectators attended Happenings merely as entertainment. Without concern for the work as art, they noticed only the superficial qualities. In others the tendency to view everything in terms of traditional categories, making

no allowance for significant change, made evaluation difficult. Thus, even among the limited number of people who have been able to see Happenings, a primary distortion of judgement has taken place.

Secondary distortion has occurred in the dissemination of information about the Happenings. Once people have heard about Happenings, there is the problem of finding one to see. In this atmosphere where facts are scarce, any information takes on much greater significance. The name itself is striking and provocative: it seems to explain so much to someone who knows nothing about the works themselves. And, intentionally or by accident, there have been incorrect and misleading statements in newspapers and magazines.

[…] Happenings are a new form of theatre just as the collage is a new form of visual art, and they can be created in various styles just as collages (and plays) are.

[…] All of the Happenings – except, of course, the later ones presented outdoors – were put on in lofts and stores, in limited spaces for limited audiences.

[…] Certainly they are not *exclusively* visual. Happenings contain auditory material and some have even used odor.

[…] Nor, like the Munich Artists' Theatre of 1908 that learned from painters and sculptors how to turn a play into something resembling a bas-relief that moved, can Happenings be called "pictorial". They have rejected the proscenium stage and the conceit that everyone in the auditorium sees the same "picture". In many Happenings there is a great difference, in both amount and quality, in *what* is seen by different spectators.

[…] Events are short, uncomplicated theatre pieces with the same alogical qualities as details of Happenings. […] An event is not compartmented. Formally, if not expressively, it is equivalent to a single compartment of a Happening. […] Happenings might be described as *a purposefully composed form of theatre in which diverse alogical elements, including nonmatrixed performing, are organised in a compartmented structure.* […]

("Introduction", in Michael Kirby, *Happenings*, E. P. Dutton & Co., Inc., New York 1965).

Claes Oldenburg

What I do as a Happening is part of my general concern, at this time, to use more or less altered "real" material. This has to do with *objects*, such as typewriters, ping-pong tables, articles of clothing, ice-cream cones, hamburgers, cakes, etc. etc., whatever I happen to come into contact with. The Happening is one or another method of using *objects in motion*, and this I take to include people, both in themselves and as agents of object motion. […]

I present in a Happening from thirty to seventy-five events, or happenings (and many more objects), over a period of time from one-half to one and a half hours, in simple spatial relationships – juxtaposed, superimposed – like those of *The Store*. The event is made simple and clear, and is set up either to repeat itself or to proceed very slowly, so that the tendency is always to a static object. In some pieces, I tried setting up events

into a pattern, a pseudo-plot, more associational than logical.

[...] The audience is considered an object and its behavior as events, along with the rest. The audience is taken to differ from the players in that its possibilities are not explored as far as that of the actors (whose possibilities are not explored as far as my own). The place of the audience in the structure is determined by seating and by certain simple provocations.

The place in which the piece occurs, this large object, is, as I have indicated, part of the effect, and usually the first and most important factor determining the events (materials at hand being the second and players the third).

"Place" may have any extent, a room or a nation, and may have any character whatsoever: old, new, clean, dirty, water or land, whatever is decided.

There is no limit to what objects or what methods may be used to arrive at events. [...]

("A Statement", from a recorded interview, in Michael Kirby, *Happenings*, E. P. Dutton & Co., Inc., New York 1965).

Robert Whitman

[...] Time for me is something material. I like to use it that way. It can be used in the same way as paint, plaster or any other material. It can describe other natural events.

I intend my works to be stories of physical experiences and realistic, naturalistic descriptions of the physical world. Description is done in terms of experience.

[...] A story is a record of experience or the creation of experience in order to describe something. The story of something is its description, the way it got that way, its nature. The intention of these works has to do with either recreating certain experiences that tell a story, or showing them. You can recreate it, present it or show it. You can expose things. All these things have to do with making them available: you can make them available to the observer, so called.

The stories do not come from the objects necessarily. There might not be a story if there were not people. It is in the nature of what we do to listen to people and watch them and see what they are doing, respond to them. If I am making an object, and I want to find the story of that object, one way to do it is to see what people do when they are involved with it, have people involved with it, and be involved with it myself. [...]

("A Statement", from a recorded interview, in Michael Kirby, *Happenings*, E. P. Dutton & Co., Inc., New York 1965).

Bibliography

J. Cage, *Silence*, Middletown, Conn., 1961.

P. Restany, "Les Happenings", in *Domus*, no. 405, 1963.

M. Kirby, *Happenings*, E. P. Dutton & Co., Inc., New York 1965.

C. Tomkins, *Ahead of the game: four versions of avant-garde*, Penguin, Harmondsworth 1968.

Happening & Fluxus, exhibition catalogue, Kölnischer Kunstverein, Cologne 1970.

C. Dreyfus (edited by), *Happening & Fluxus*, exhibition catalogue, Paris 1989.

G. Zanchetti, *John Cage alle radici della seconda avanguardia*, Archivio Nuova Scrittura, Milan 1993.

A. Vettese, "Considerazioni sui rapporti di John Cage e le arti figurative", in *XLV Biennale Internazionale d'Arte di Venezia*, exhibition catalogue, Marsilio, Venice 1993.

Fluxus

The new connections between music, poetry and theatre

"Fluxus existed before having a name and continues to exist today as a form, principle and way of working", declared Dick Higgins, one of the protagonists of Fluxus, when asked to recount his experience, "Fluxus is not a movement, an historical moment, an organisation. Fluxus is an idea, a way of life, a loosely-knit group of people who execute 'fluxus-works'."

In September 1962, the first "Fluxus Internationale Festspiele Neuester Musik" took place at the Städtisches Museum in Wiesbaden. The organiser was George Maciunas, an architect of Lithuanian origin, who had moved to Europe in '61 after having closed his A. G. Gallery in New York. His choice of the name "Fluxus" appeared for the first time in New York in '61 on an invitation to three lectures on "Musica Antiqua et Nova". (The three-dollar contribution would later help publish the *Fluxus* magazine.) The term, of Latin origin, has various definitions: to flow, to undulate freely, infiltration, fleeting. It was Maciunas who had the idea of organising a festival so that American and European artists who were working along similar lines could present their way of making art, by exploiting new connections between music, poetry, visual arts, dance and theatre, thus opening it up to a multiformity of expressions.

In Europe, Maciunas had met Emmett Williams, Nam June Paik, Wolf Vostell, Benjamin Patterson and Ludwig Gosewitz. The first four, together with Alison Knowles, Higgins, and Maciunas himself were among the interpreters of the 14 *fluxus-pièces* that were presented at the festival. They did not receive a warm welcome; as a matter of fact, the *fluxers* were declared *persone non gratae* at the very museum that had offered them hospitality, and the posters publicising the festival throughout the city were covered with sarcastic comments.

Various objects were introduced into the musical compositions and improvisations so as to produce a great variety of noises: whistling teapots, clicking typewriters, ticking metronomes, hissing balloons, and bicycle pumps transported the routine noises of the everyday world into a cultural context where they were isolated and organised into music.

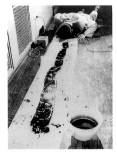

Nam June Paik, Zen for Head, ink and tomato on paper, 1962

In Phil Corner's *Piano Activities,* a piano was demolished and the only sound that could be heard was that of the hammers and saws used to carry out the operation. In *Danger Music No. 2*, Higgins had his head shaved by Knowles as he threw pieces of paper at the audience, provoking reactions that were halfway between perplexity and hilarity. In *Zen for Head*, Paik used his own tie to draw calligrammes on rolls of paper, and then he suddenly stuck his head into an ink-filled chamber pot, concluding his exhibition by writing with this unusual new *paintbrush*.

"In short, the concert created an enormous scandal, as well as a great deal of interest, and it was on that occasion that fluxus became Fluxus and its authors Fluxus-people…", wrote Higgins.

George Maciunas, Venus de Milo, Apron, circa 1970

The Wiesbaden festival followed a series of informal concerts held at the end of the Fifties in New York in Yoko

Ono's loft and, starting in 1960, at Maciunas's gallery. These were elaborations of experiences made in John Cage's experimental composition class at the New School for Social Research in New York. Cage had developed the concept of indetermination and introduced it into contemporary music. In accordance with the teachings of Zen philosophy, he tended to eliminate any personal or emotional involvement. He made use of silence and noise as presences of life, and the laws of probability and chance and the "I Ching"; by throwing dice or coins he established the position of the notes on a score. He did not fix the number or types of instruments necessary for the execution of his compositions, nor did he determine the duration of each musician's performance.

Ben Vautier, Total Art Match-Box, 1965

Many of the future Fluxers, among whom George Brecht, Jackson Mac Low, Al Hansen and Higgins, experimented with Cage with compositions based on sounds and noises. They made use of whatever was available in the classroom including a piano and a collection of Oriental instruments, plus a number of toys, and what they could find in their pockets like combs, coins, etc.

In 1960, when La Monte Young joined the group, he began to gather material relevant to this new way of making art with the idea of starting a magazine. The huge quan-

tity of documents he amassed turned into a book instead, *An Anthology*, which was published in 1963.

Fluxus was composed of people of different nationalities, cultural backgrounds, and artistic experiences; its members entered and exited *fluidly* and they moved *fluidly* between Europe and the United States. After Wiesbaden, the group travelled to Copenhagen, Paris, Düsseldorf, Stockholm, London, and Amsterdam, acquiring new members along the way: Daniel Spoerri, Arthur Køpcke, Robert Filliou, Robin Page, Ben Vautier, Tomas Schmit, Joseph Beuys, Henry Flynt, and Yoko Ono. They were joined later by Toshi Chiyanagi, Yoshimasa Wada, Robert Watts, TakeHisa Kosugi, Charlotte Moorman, Giuseppe Chiari, Gianni Emilio Simonetti, and the Zaj group.

Starting in 1963, concerts were organised in New York: the Yam Festival, with dances by Trisha Brown and Yvonne Rainer and a Happening by Allan Kaprow, and the 1st New York Fluxus Concert. In 1965, one of their biggest concerts was held at Carnegie Recital Hall; on that occasion the chamber orchestra was substituted by a Fluxus-orchestra made up of the instruments that each player brought. The result was

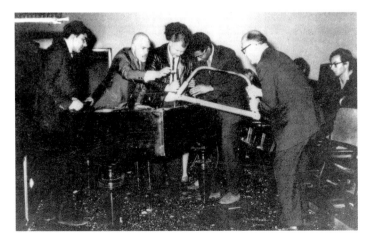

Philip Corner, Piano Activities, 1962. George Maciunas, Dick Higgins, Wolf Vostell, Ben Patterson and Emmett Williams at the Fluxus Festival, Wiesbaden

an enormous collection of toys and Oriental instruments.

In 1963, Maciunas assigned a code in letters to every Fluxus-artist, and he began to collect new materials to publish in the *Fluxus* magazine.

As time passed, the remains of the executions were boxed in the form of multiples and popularised.

Maciunas drew the genealogical tree of Fluxus (1966), showing its connections to other disciplines and its historical origins dating back to Marcel Duchamp and Dada, the Futurist theatre, and to what was termed "Bruitismo", as well as to John Cage, Haiku, Non-Art and Borderline Art, Vaudeville and Charlie Chaplin.

In its free and easy approach, Fluxus meant to create a relationship between art and life. Everyday things, gestures, the simplest of actions like breathing, smoking or sitting on a chair (Brecht) became Fluxus works in the same way that the ready-mades had been extracted from the reality of the routine, the only reality possible in existence, and isolated in the Fluxus event. Everything was possible, and any means permitted. "Everything is art" (Ben Vautier).
(Rosella Ghezzi)

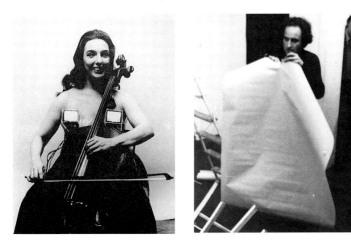

Charlotte Moorman, Opéra sextronique, 1967

Giuseppe Chiari, Little Theatre, 1963

Fluxus

Giuseppe Chiari
(exactly 20 seconds of silence)
you choose the work
that seems to have most implemented
this exigency
then
an orchestra is assembled
and summoned to a great theatre
for the ninth hour of any evening
all the personnel is made to leave
including those people
responsible for security
a special permit will be required for
this
all the doors are closed
there are no posters
on the façade of the theatre
to announce the concert
there has been
no form of publicity
then
in a completely empty theatre
the composition is executed
perfectly

for no one

("A nessuno", 1964, in *Musica madre*,
Prearo, Milan 1973).

Dick Higgins
In fact one aspect of the Fluxus focus is
concretion of all kinds – the interpene-
tration of art and life as well as the in-
terpenetration of the media. But in
terms of the particular cultural environ-
ment in which Fluxus arose, Fluxus was
certainly not unique in its concern with
the tracing of parallel patterns among
media. For instance, it came about in the
late Fifties. But in the late Fifties struc-
turalism was also evolving, with its ap-
plication of linguistic ideas taken from
Saussure and Jakobson to the fields of
anthropology (Lévi-Strauss), psychology
(Lacan), literature (Barthes) and so on.
Whatever the feuds and splits among
those who belong to the older ortho-
doxy of structuralism or those who be-
long to the newer one of post-structural-
ism (Derrida, Deleuze, Eco, Lyotard –
even, way to one side in the Computer
Department, Bense) – they are all influ-
enced by their objects of study into
common concerns with patternings and
conceptual structures which are oddly
analogous to Fluxus considerations,
though without the stripped-down-to-
minimum model quality which Fluxus

57

always demands of its works if they are to exist as Fluxus works. In Fluxus as in mathematics, elegance consists in having enough and only enough to make the essence of a work or presentation absolutely clear. And elegance is a very desirable quality.

Fluxus is then, among other things, a kind of work, a form of forms, a meta-form. As such, a Fluxus thing is something that you can do as an artist – and when you do it you are being a Fluxartist. But you are also free to do other things which may or may not relate to your Fluxus work. The identity which the artist gets from doing a Fluxus work is, then, elusive, transitory as a flower's colours. If one is looking to one's art as a means of extending the personality, Fluxus is a terrible place to look. It always lies outside the ego, except for parody or for metapsychological considerations. Thus the big guns who, over the years, have climbed aboard the bandwagon hoping for prestige and said, "I was Fluxus in 1954 (or 1957, or 1936, or whatever)" have produced virtually no memorable Fluxus work – no work which could project beyond their personal stamp, beyond their charisma or their autograph.

[...] In the first place, Fluxus is not really a movement: its movement aspect is only metaphor, because it did not happen as a result of a group of people consciously coming together with common aims and objectives, with a programme of introducing this or that tendency into the ongoing continuity of the arts. Rather it arose more or less spontaneously, was coordinated primarily by George Maciunas naming it, and its var-ious manifestations (performances and festivals, publications and exhibitions) have been surfacings of an ongoing activity, rather than being the object of a professional and wholly committed, career-oriented strategy. A professional Fluxist would be a bad Fluxist. [...]

("Some Thoughts on the Context of Fluxus", 8 January 1978, New York City, in *Flash Art*, no. 84-85, October-November 1978).

George Maciunas
FLUXUS

1. To purge. A fluid discharge, esp. an excessive discharge, from the bowels or other part.

2. A continuous moving on or passing as of a flowing stream,

3. a stream; copious flow,

4. the setting of the tide toward the shore,

5. Any substance or mixture, as silicates, limestone, and fluorite, used to promote fusion, esp. the fusion of metals or minerals.

(*Fluxus Manifesto*, 1961).

George Maciunas

George Maciunas

ART

To justify artist's professional, parasitic and elite status in society,

he must demonstrate artist's indispensability and exclusiveness,

he must demonstrate the dependability of audience upon him,

he must demonstrate that no one but the artist can do art.

Therefore, art must appear to be complex, pretentious, profound, serious, intellectual, inspired, skillfull, significant, theatrical; it must appear to be valuable as a commodity so as to provide the artist with an income.

To raise its value (artist's income and patrons profit), art is made to appear rare, limited in quantity and therefore obtainable and accessible only to the social elite and institutions.

FLUXUS ART – AMUSEMENT

To establish artist's nonprofessional status in society,

he must demonstrate artist's dispensability and inclusiveness,

he must demonstrate the self-sufficiency of the audience,

he must demonstrate that anything can be art and anyone can do it.

Therefore, art-amusement must be simple, amusing, unpretentious, concerned with insignificances, require no skill or countless rehearsals, have no commodity or institutional value.

The value of art-amusement must be lowered by making it unlimited, mass-produced, obtainable by all and eventually produced by all.

Fluxus art-amusement is the rear-guard without any pretention or urge to participate in the competition of "one-up-manship" with the avant-garde. It strives for the monostructural and non-theatrical qualities of simple natural event, a game or a gag. It is the fusion of Spike Jones, Vaudeville, gag, children's games and Duchamp.
(*Fluxus Manifesto*, 1963).

George Maciunas
*The Flux Wedding of Billie Hutching
& George Maciunas*
February 25, 1978 at 7:30 P.M.
At the loft of Jean Dupuy and Olga Adorno
537 Broadway (near Spring Street), New York, New York
Bride: Billie Hutching (in an antique white wedding dress)
Groom: George Maciunas (in antique white wedding dress)
Father of the Bride: Jon Hendricks (in bride's maid dress & blonde wig)
Best Man: Alison Knowles (in tuxedo/black tie)
Bride's Maids (all in dresses): Olga Adorno, Larry Miller, and Barbara Moore
Monk: Jonas Mekas (in monk's habit)
Ring bearer: Oona Mekas
Minister: Geoffrey Hendricks (in clerical robe)
Ushers: Bracken and Tyche Hendricks
Cupid: Aurora Hendricks
The flowers were arranged by Sara Seagull.
The "ring" of bells was arranged by Alison Knowles.
The rice throwing was arranged by Joanne Stamerra.
Wedding music: Joe Jones at the tape recorder.
The Flux marriage service adapted by Geoffrey Hendricks and "protest" in Lithuanian by Jonas Mekas.
Erotic food events and flux cabaret following the Flux Wedding and also at Dupuy/Adorno loft, 537 Broadway, New York.
The erotic food included a liver paté in the shape of a giant penis by Halla Pietkiewicz, a fish and rice mermaid (sushi) by Yasunao Tone, an aphrodisiac prepared by La Monte Young and Marion Zazeela, and many other dishes. Performances were by Jean Dupuy and Olga Adorno (Olga shaved Jean's head, he took on Maciunas' appearance), Dick Higgins, Joe Jones (inflating a condom at the end of a flute), Nam June Paik, Jackson MacLow, Yoshimasa Wada, Larry Miller (the results of placing an ad "I want a thrill, I think"), and many others.
The high point of the cabaret performances though was the George Maciunas piece, "Black and White", which he did with his new wife, Billie Hutching. George arrived in tuxedo and black tie, Billie in a white satin evening gown. At the end of the piece George was in the evening gown and Billie in the tuxedo. Everything they each were wearing was either black or white, except for the wig, a complete change of identity.
The grand finale of the evening was Bob Watts' revival of the 1964 Ben Patterson piece, "Cover shapely female with whipped cream/Lick… topping of nuts and cherries is optional." Beautiful Olga Adorno was the "shapely female", and the whipped cream was excellent, whipped by hand by Watts from cream he had gotten at local farms in Pennsylvania.
(From *Flash Art*, no. 84-85, October-November 1978).

Henry Martin
[…] George Brecht has made his opinion known, stating that Fluxus is nothing but a group of individuals who happen to appreciate the work that others

did. Emmett Williams was equally non-chalant in 1982 when he observed that "Fluxus has not yet been invented". Philip Corner, at the question "What is Fluxus?", currently prefers to answer "it is becoming more and more difficult to say, and the less we know the better".

Ben Patterson is even more radical: "In the past, almost no one thought he knew what it was. They were wrong. Now, there's a lot of people who say they know exactly what it is. Obviously, even they are mistaken. In any case, there will soon be thirteen people in the whole world known as authentic Fluxus experts. God help us – if they manage somehow to see things clearly." Eric Andersen insists that "Fluxus doesn't mean anything".

[…] Fluxus was called into existence by decree. In the course of time, from the Wiesbaden festival of 1962 to the death of Maciunas in 1978, it succeeded in putting together an ample anthology of all the off-beat and innovative work that Maciunas himself found interesting. Fluxus, in this way, was for the most part the vision or the flicker of creative imagination of a single individual who had a great and obstinate talent for putting people together. He was an organizational genius endowed with energy to sell, totally possessed by an idea of community that seemed to him implicit in the bizarre work of some equally bizarre artists.

Fluxus was something that already existed around him, and he simply gave it a name, attempting then to promote, produce and spread it in terms, forms, and also for reasons that were his own for the most part. And this was not an easy job. […]

(Translated from Italian, "Fiat Lux", in *Fluxers*, exhibition catalogue, Museo di Arte Moderna, Bolzano 1992).

Nam June Paik

Marx gave much thought about the dialectics of the production and the production medium. He had thought rather simply that if workers (producers) OWNED the production's medium, everything would be fine. He did not give creative room to the DISTRIBUTION system. The problem of the art world in the Sixties and Seventies is that although the artist owns the production's medium, such as paint or brush, even sometimes a printing press, they are excluded from the high centralised DISTRIBUTION system of the art world.

George Maciunas' Genius is the early detection of this post-Marxistic situation and he tried to seize *not only* the production's medium *but also* the DISTRIBUTION SYSTEM of the art world. Thus he exposed the new dialectic tension in the Sixties and Seventies, that often the most politically radical artist is supported by the most conservative money.

Is he the last cowboy in the art world? Even a permanent pessimist like me disagrees… I was moved, when I was asked at a small party in Adelaide, Australia all about Fluxus.

I thought, if Fluxus survived so long without any support from the official art world, we MUST HAVE DONE something right… and also I thought that the name Fluxus didn't have to continue… any fresh individual spirit like Maciunas will challenge the power-structure… and

this new man will enjoy success, as much as failure, which has been the most remarkable trait of George.

I wrote to Mrs. Brown that George will come back, as the Red Army came back to Stalingrad. George said in the hospital to Mrs. Brown, "the Red Army never left Stalingrad".

The coming post-industrial age will be the strange hybrid society of the decentralised do-it-yourself kind of distribution and the material necessity of a more centralised, decision-making process in a highly technological area.

As long as we can say "Small is beautiful"… somebody will remember Fluxus… and our GM, who is not General Motors, but its inverse case.

(*George Maciunas and Fluxus*, 23 February 1978, in "Flash Art", no. 84-85, October-November 1978).

Daniela Palazzoli

The concerts of the Fluxus group are really concerts. I mean that they consist of actions made and executed in such a way as to develop in a space constructed by the gesture, but also according to the duration time of the action, the time on which it is based. It is this assumption of the co-ordinates relative to the space-time continuum in which we live that has permitted these concerts to be presented as real situations and not artificial ones; for which each action is qualified as a measurable and definable relationship that gives the spectator the time and material for observation rather than coercing him into contemplation. Unlike the Happening, which is a theatrical version of the Environment – the principle they share being a tested: "the

more you have the more you put in" –, the *event* aims to construct a *real* "physical absolute" – which like all absolutes has strong metaphysical components. In this sense, the theatre-concert is functional since a sort of real metaphysical temptation is manifested in it, a reference to certain unusual yet natural ideas that cannot be fixed in a static work. […] Ben Vautier's Art Total is the most anti-visual of all; intellectually, it means to show by means of paradoxes the need to destroy the concept of art consumed by that of non-art. Oddly enough in his case, *non-art* has nothing to do with the idea of *non-sense* as in the gestural techniques of Dada, but to a nationalistic type of formulation based on observations of a sociological nature. […]

("Concert Fluxus – Art Total", in *BIT*, no. 4, July 1967).

Ben Vautier

Fluxus?

Fluxus est
– une attitude envers l'art
– pour l'importance de la non importance
– les détails de la vie
– le seul mouvement artistique capable de manger sa queue
– plus important que ce que vous croyez
– moins important que ce que vous croyez
– de rater un spectacle
– de lire le journal d'un autre à travers un trou fait dans le sien
– de s'endormir et ronfler lors d'un concert de Stockhausen
– de jeter 20 litres d'huile sur la scène de *Giselle*

– Vostell lorsqu'il explique l'histoire de l'art
– George Brecht quand il evite l'histoire de l'art

Fluxus
is an attitude towards art
is for the importance of what is not important
is for all the details of life
is the only art movement capable of changing its tail
is more important than you think
is less important than you think
is to mess up a show
is to read someone's newspaper during a concert by Stockhausen
is to pour 20 litres of oil on the stage of the ballet "Gisèle"
is Vostell when he explains history of art
is George Brecht when he avoids history of art.
(From *Flash Art*, no. 84-85, October-November 1978).

Bibliography
La Monte Young, J. McLow, *An Anthology*, New York 1963.
Happening & Fluxus, exhibition catalogue, Kölnischer Kunstverein, Cologne 1970.
D. Palazzoli, "L'avventura Fluxus", in *Domus*, no. 522, 1973.
J. Chalupecky, "Tempo zero", in *Data*, no. 18, September-October 1975.
Flash Art, no. 84–85, October-November 1978.
1962 Wiesbaden, Fluxus 1982, exhibition catalogue, Harlekin Art, Wiesbaden 1982.
C. Dreyfus (edited by), *Happening & Fluxus*, exhibition catalogue, Paris 1989.
Ubi Fluxus ibi motus – 1990–1962, exhibition catalogue, Mazzotta, Milan 1990 (in part., *Happenings or Dance Happenings or…* by H. Martin).
H. Martin (edited by), *Fluxers*, exhibition catalogue, Ed. Museion, Bolzano 1992.
In the Spirit of Fluxus, exhibition catalogue, Walker Art Center, Minneapolis 1993.

Pop Art
The new urban scene and the American dream

Prior to 1963, American art was characterised by an urge to invade the surrounding space; in 1964, it actually began to invade it, first with Pop Art and then with Minimalism and, later, with Land Art.

Pop Art did not simply appear; it was rampant, new, amusing, outrageous, paradoxical, and irritating yet joyous. The general consensus was that Pop Art was the first authentically American expression, although hints of Dada and Surrealism were to be detected; that is to say, the presence of European culture was to be felt in it as it was in all the "typically" American movements.

Pop Art substitutes the image of the object with the object itself; it exhibits local folklore with sophisticated vulgarity; it accentuates the grotesque dimension of the American society. Pop also apes the massive, incessant prevarication of the media which cancel any independent judgement, the standardisation and automation of life and choices; an urban scene that looks more and more like some science fiction fantasy; the utilisation of advertising and a certain consumer-related eroticism.

Robert Rauschenberg and Jasper Johns were already well known when the Pop phenomenon began to spread in 1964. Rauschenberg in particular – as the set and costume

designer for the Merce Cunningham Ballet Company, illustrator of Dante's *Divine Comedy*, distinguished photographer, student of Josef Albers (after studying art in Paris), feted by Gaspero del Corso in his Roman gallery L'Obelisco in 1953, and later by Plinio De Martiis at La Tartaruga in Piazza del Popolo in 1959 – showed himself to be a painter of strong European sensitivity in his works in which everyday objects were inserted into informal pictorial schemes.

Rauschenberg was probably the first to break what was then called the "American dream". Soon after, the

most typical Pop artists made their appearance on the international scene: Claes Oldenburg, James Rosenquist, George Segal, Jim Dine, Roy Lichtenstein, Robert Watts, Tom Wesselmann, John Chamberlain, Larry Rivers, Lee Bontecou, Robert Indiana, Allan D'Arcangelo, Mel Ramos, Wayne Thiebaud and the legendary Andy Warhol. Their work was open to all of the popular forms of communication: comic strips, advertising, and the serial reproductions of paintings. What resulted was the new American scene of Coca-Cola bottles, Campbell soup cans, advertising billboards, the atomic mushroom, the electric chair, urban chaos, ice creams, hamburgers, and the American flag; however, together with these were also the recently widowed Jacqueline Kennedy, the tragically destroyed Marilyn, and automobile accidents. In the age of mechanical reproduction in which reiteration is the only recognised value, repetition is fundamental. Pop, therefore, entertains a kind of innocent affability with that great confusion called life. Marked by a sinister brio that can be crude, cruel, and explicit, Pop is not to be mistaken for an easy-going, non-problematic language. By throwing open the doors to anguish and depression, it communicates a terror of the collective

Andy Warhol, Jackie, 1964

Claes Oldenburg, Soft Typewriter – "Ghost" version, model "Ghost" Typewriter, 1963

67

end, and a horror of the homogenization of the individual.

The Californian Edward Kienholz should be mentioned together with the leading Pop artists, for he succeeded in depicting the destruction of society better than anyone else with his clothed plaster casts.

Parallel situations

Outside of the United States other artists were following Pop closely: in Great Britain, Eduardo Paolozzi, Richard Hamilton, Peter Blake, Peter Philips, Allen Jones, Patrick Caulfield, David Hockney, Joe Tilson, and Ronald B. Kitaj; in Sweden, Öyvind Fahlström; in France, Martial Raysse, Hervé Télémaque, Alain Jacquet, Rancillac, Alain Raynaud; in Germany, Peter Brüning, Richard Lindner, Winfred Gaul, Peter Klasen, Konrad Klapheck, in Spain, Juan Genoves; in Iceland, Errò; and in Venezuela, Marisol Escobar.

In Italy, different painters of the "Piazza del Popolo School" in Rome (so-called because La Tartaruga gallery was

James Rosenquist, Waves, 1962

located there) were working in a direction concurrent to the Pop spirit, or so it was thought. Pop was characterised by its use of the object or a copy of it; therefore there was a desire to recognise some sort of similar, yet independent, spirit in the work of the Italian artists, in the nostalgic, ironic recreation of a figuration that was making use of the old pictorial tradition. The "Italian scene" was basically this.

Thus, the Michelangelesque references of Tano Festa, Franco Angeli's Roman wolves in between half-dollars, the movie stars and screens of Fabio Mauri, the silvered silhouettes of Giosetta Fioroni, the Futurist revivals of Mario Schifano, Mario Ceroli's *Novecento*; as well as the works of such artists as Umberto Bignardi, Renato Mambor, and Cesare Tacchi. Valerio Adami, Emilio Tadini, Ugo Nespolo, Gianni Pisani, Aldo Mondino, Concetto Pozzati and Lucio Del Pezzo, albeit quite differently from one another, also used the world of the mass media and that of cultural and figurative myths in an elegant, European-styled provocation.

Eduardo Paolozzi, Wittgenstein at Casino, 1963

Fabio Mauri, Drawer, 1959–60

Pop Art

Lawrence Alloway

[…] The term "Pop Art" is credited to me, but I don't know precisely when it was first used. (One writer has stated that "Lawrence Alloway first coined the phrase 'Pop Art' in 1954"; this is too early.) Furthermore, what I meant by it then is not what it means now. I used the term, and also "Pop Culture", to refer to the products of the mass media, not to works of art that draw upon popular culture. In any case, sometime between the winter of 1954–55 and 1957 the phrase acquired currency in conversation, in connection with the shared work and discussion among members of the Independent Group.

[…] A potent preliminary move in the direction of Pop Art in England occurred from 1949 to 1951, the period in which Francis Bacon began using photographs in his work.

[…] The use of the photographic source, its quotation and partial transformation, is, of course, central to later developments in Pop Art, though Bacon himself is clearly not a Pop artist.

[…] The Institute of Contemporary Art was, at this time, a meeting place for young artists, architects, and writers who would not otherwise have had a place of contact, London having neither a café life like that of Paris nor exhibition openings such as in New York. A small and informal organisation, the Independent Group (IG), was set up within the Institute for the purpose of holding exploratory meetings to find ideas and new speakers for the public programme. It was first convened in winter 1952–53 by Peter Reyner Banham; the theme of the programme was techniques. The one meeting that I was invited to (I didn't go) was on helicopter design. The IG missed a year and then was reconvened in winter 1954–55 by John McHale and myself on the theme of popular culture. This topic was arrived at as the result of a snowballing conversation in London which involved Paolozzi, the Smithsons, Henderson, Reyner Banham, Hamilton, McHale, and myself. We discovered that we had in common a vernacular culture that persisted beyond any special interest or skills in art, architecture, design, or art criticism that any of us might possess. The area of contact was mass-produced

urban culture: movies, advertising, science fiction, Pop music. We felt none of the dislike or commercial culture standard among most intellectuals, but accepted it as a fact, discussed it in detail, and consumed it enthusiastically. One result of our discussions was to take Pop culture out of the realm of "escapism", "sheer entertainment", "relaxation", and to treat it with the seriousness of art. […] Hollywood, Detroit, and Madison Avenue were, in terms of our interests, producing the best popular culture.

[…] In one way or another, the first phase of Pop Art in London grew out of the IG. Paolozzi was a central figure, as were William Turnbull, Theo Crosby, and Toni del Renzio. […]

("The Development of British Pop", in Lucy R. Lippard, *Pop Art*, Thames and Hudson, London 1966).

Giulio Carlo Argan

[…] The art of the past started from a judgement of value and conferred a surplus value on the object; now we start from a non-value so that the increased value can only be a further devaluation, something that degrades the object to just a thing or stuff. The Pop Art of an Oldenburg, a Lichtenstein or a Dine is a process of deterioration that deliberately overturns the declared intention of the technological process.

I have been accused of Manichaeanism. But let us consider one of Oldenburg's kitchens: the steaks and cucumbers are casts, they simulate the false food that shopkeepers put in the windows while keeping the real ones in the refrigerator, they are the copy of a copy. The copying process banalises, the more passages there are the more banal it becomes, and this is the only myth of Oldenburg, this Dalí who did not even have the spirit to make a pact with the devil. Dine gives us the wall of a toilet compartment: he looks at things with the stupid stare of one who is doing other things in the bathroom, he delights in imagining the person (who is not seen, but who sees is seen) in an embarrassing situation. The things are true in Segal's sculptures, only the people are puppets. The moral: people are less authentic than things. Lichtenstein repeats on a grand scale, and pedantically, a square of comic strips or a slipshod advertisement: he means to say that the human manner is infinitely stupid and desperately useless. There are those who find irony in this, but the irony of Picabia certainly does not reappear in Lichtenstein; and even were it to, it would only be to discourage a moral reaction. But it is not there; on the contrary, there is a cynical satisfaction in presenting a disgusting situation as unchangeable. We are undoubtedly at the opposite pole of Gestalt, but Gestalt cannot do without Pop Art, the Pop Art of Gestalt. On the one hand, a project that does not make things, on the other, things made without a project: order without reality, reality without order. The men who are stunned by the artificial storm of information and mass culture are the same ones who control precision equipment and produce technology for seven hours a day, dressed in overalls that the machines do not dirty. It seems that there can never be an equilibrium between these two states; not only would the men not be the same, but they would no longer be men.

[...] Gestalt and Pop Art are two categories of non-ideological art, yet do not deal with the same issue. It takes but a little to see that if Gestalt is a typical "third force", then Pop Art is right-wing anarchy of a reactionary, noncommittal character. This political qualification is not arbitrary: neither of the two tendencies has set itself up as a real aesthetic, one that implies a global conception of art, and both present themselves as unilateral, partisan solutions. I myself, in this essay, tend to refer to them as two football teams on the field. I do not pretend to be a fan for one or the other, I do not pretend because it deals more with being a fan than making a judgement. [...]

("Progetto e destino", 1964, in *Progetto e destino*, Il Saggiatore, Milan 1965).

Roland Barthes

[...] Pop is an art because in the very moment in which it seems to renounce all significance, accepting to reproduce things only in their banality, and by using certain procedures proper to it alone which constitute a style, it brings an object onto the scene that is neither the thing nor its meaning, but is its signifier, or better yet, the Signifier. Art (it does not matter which kind, poetry, comics or eroticism) exists from the moment in which the viewer has the Signifier for an object. Naturally, in the productions of art there is usually the signified (in this specific case, mass culture), but in the end this signified is presented in an "indirect" position, skewed, if it can be put like this. Proof of this is that the meaning, the play upon the meaning, and its abolition and reappearance is nothing but a "question of place". On the other hand, when the work of a Pop artist comes into the sphere of art, it is not only because the artist has brought the Signifier onto the scene, but also because that work is looked at (and no longer only seen). Pop Art may well depersonalise the world, flatten objects, dehumanise imagery, and substitute the traditional artisan of the canvas with a mechanism, but in the end "a little subject" always remains. What subject? The one that looks, in the absence of the one that makes. Certainly, a machine can be fabricated, but whoever contemplates it is not a machine, it is someone who desires, fears, delights, becomes bored, etc. And this is exactly what happens with Pop Art. [...]

Not only is Pop Art an art, and not only is this art ontological, but, what is more, its reference is the same one as in the good old days of classical art – nature. Certainly, it is no longer the vegetational nature of landscape or human, psychological nature; today, nature is a social absolute, or better yet (since it does not deal directly with politics) gregariousness. Pop appropriates this new nature and criticises it, whether it wants to or not, indeed whether it says so or not. [...] A cold anxiety threatens the consistency of the gregarious world (the world "of the masses"); the vacillation of the viewer's look is as "opaque" as what is depicted – and perhaps so much more terrible because of it. A doubt looms in all the (re-)productions of Pop, one that asks: "What do you mean?" (the title of an Allen Jones poster). It is the millenary doubt of this very old thing known as Art.

("L'arte, questa vecchia cosa…", in *Pop Art. Evoluzione di una generazione*, catalogue, Electa, Milan 1980).

Alberto Boatto

[…] For his choice of the United States flag as the subject of a series of paintings, Jasper Johns is to be acknowledged for having reinstated the commonplace in painting from which it had been so resolutely banished. Man, the social, and today anonymous, animal who had been put aside by the Abstract Expressionists can now reclaim his role. Now that he can grasp a utensil, feel a cover, perceive the elasticity of a tennis ball with his hand, pause in the middle of a messy room, walk by shop windows and heaps of rubbish in a street; or better yet, determine how inseparable life is from these experiences and everyday reality, all this ceases to appear extraneous to matters of art. And in the same way, to perceive public symbols, the pressure of advertisements, the force of the visual attraction of popular mythology, and the violence sensed in the visual and physical panorama of a city like New York. Hence the conviction that what is really important is sharing the same life and experiences. That is to say, the entire impersonal, socialised aspect of experience made up of habit, conditioning, the aggressive intrusion of objects, a submission to commercial languages as extraordinary creators of imagery, in conclusion, living in a technological and standardised urban universe that is above and beyond the power of the single individual. For the artist, it now seems to be unproductive and senseless to stubbornly oppose the rest of the world and mankind with the grievous privilege of his own singularity. A concrete prospect for getting out of this state of uncertainty and for recharging the creative forces that have been threatening to wear out in the prolonged exercise of action painting is to plunge into the brash vulgarity of the energies of society. Consequently, the artist's point of view is rectified: the objective now is not to frame the encounter of the artist's gesture with the white of the canvas as in Abstract Expressionism, but rather the effective, tactile or perceptive encounter of the artist with his own environment, that small or large slice of reality that he encounters. There is a need to consider beforehand all the materials and methods of ordinary experience (a familiarity with the objects and their uses, the perception of artificial images based on what is today a congested rhythm) in terms of their aesthetic potential or simply as a place for a meaningful encounter between the artist and his world.

[…] The entire question of the relationship with Dada was tackled by Rauschenberg in a statement which, although skewed closely to his own work, underlined the basic points with figurative exactness. He said that it seemed to him that the spirit was completely different. For Dada it was a matter of excluding. It was a censorship of the past, it meant to cancel it. For us, he continued, it was a matter of integrating a movement by introducing the past into the present, the totality into the moment. The entire difference between exclusion and inclusion was here.

The term New Dada, on the contrary,

suggests a reductive interpretation of this return to the object, confining it more to a cultural and philological circle than a truly creative one. On the other hand, the term was initially restricted to Johns on the occasion of his first one-man show at the Leo Castelli Gallery in New York in January 1958, but later included other artists who were working with found objects like Rauschenberg, Stankiewicz, and Chamberlain, and even later, Dine and the French Nouveaux Réalistes.

The January 1958 issue of *Art News* which had Johns's 1955 target on its cover, was already talking about New Dada. When New Dada later became part of the critics' vocabulary, it went beyond this initial claim, and tended to become absorbed under the label of Pop Art which, in our opinion, was thoroughly unjustifiable, except for the fact that it did signal the development of this new American art. Like any other definition, even that of New Dada is strictly utilitarian and only valid in that it indicates a moment in American art and a convergence of the object and historical Dada, rather than being a real tendency or a cogent aesthetic. [...]

("Dal neo-dada alla Pop Art", in *Pop Art in USA*, Lerici, Milan 1967).

Maurizio Calvesi

[...] Its unconditional appropriation of the mass media has proven to be the flashiest and most scandalously attractive feature of Pop Art, and what really qualifies it, albeit superficially, as Pop. It directs critical investigation by determining approval or condemnation, thus stimulating the necessary sociological interpretations which, however, leave one with the sterile doubt as to whether Pop is a matter of protest, criticism, adaptation or something else. It is our opinion that while this appropriation of the mass media is obvious and undeniable, it is not the fundamental driving element behind the Pop aesthetic. It is rather one consequence (which in time and also in future works may turn out to be less flashy), one of the implications of a new, closer way of looking at the world. Another is the heart, the driving force behind the Pop operation; still others may be the implications, in a problematic line of considerable breadth that goes from Rauschenberg's limitless production to the new perceptive concentration of Lichtenstein's imagery, which is already now showing signs of extending well beyond the apparently obligatory theme of the comic strip.

[...] Be they soft or hard, opaque or coloured, banal or extravagant, [Oldenburg's objects] intend to replace those they imitate, as if creating another reality, spreading forth in an endless chain. Instead of being hard, angular, repellent, the world could become cosy and as pliable as rubber; in fact, these objects display a dreamlike pliability on contact.

[...] In Segal, the conception is substantially concordant, although his is a moment of instantaneous arrest: an arrest that is a standstill in the flow.

As for Dine, he has inherited the conditions of static confrontation between image, word and object from Johns, but [...] has tried to resolve the dissension (which has become such because of the loss of that contemplative-ironic Dadaist

75

something that is so characteristic of Johns) with an action element inherited from Rauschenberg. As in Warhol, the action element is manifested in Dine as a declaration of the instability of the image, as a virtual *déplacement*. That is, it verifies the topographic essence of the image, and therefore its temporary location (it is then this purely topological, a-spatial dimension of the image that allows for its reunion with the object).

[…] The problem seems remarkably different with Lichtenstein, or rather it is presented in other terms. What is this return to the "picture"? A precise frame is reconstructed around the image. It is true that Lichtenstein's action is also in some way, like that of Segal, an analytical action aimed at synthesis. While Segal fixes the images, Lichtenstein cuts his enlargements and frames them analytically. The explanation does not belie the fact that once again we are back at the picture. Lichtenstein contrasts the centrifugal thrust of Rauschenberg and the other Pop artists with a centripetal one.

[…] It is evident, however, that Lichtenstein is primarily a formalist. Among the Pop artists, he is perhaps the most involved in an attempt to "re-qualify" (as we have already seen with Warhol) the mass media, that is, to elevate them to the level of formal values.

However, the totally insignificant cannot be "re-qualified", only that which carries the embryo of a positive significance within it can, as in the case of a frame of film for Warhol or a comic strip for Lichtenstein. […]

("Un pensiero concreto", 1964–66, in *Le due avanguardie*, Lerici, Milan 1966).

Jim Dine

[…] My great favourites are Jan van Eyck and Rogier van der Weyden. What interests me is their particular way of handling space.

And I like the eccentricity of Edward Hopper, the way he introduces the sky into the painting. I find him more exciting than Magritte as a Surrealist. He's a bit like a Pop artist: there are gas stations, Sunday mornings and miserable streets in his paintings, but without their becoming social realism… I believe that whoever is interested in Hopper's painting in some way also has to be interested in Pop Art.

[…] People mix up social facts with Pop Art. Well, if it's art, does it matter whether it's a critical comment or not? If someone writes a stupendously obscene phrase on a wall, it may even be a superior critical comment, but I'm not sure that it's art. I'm involved in formal elements: I have to, I can't help but be. But any work of art, if successful, is in itself a critical comment about its own content. Right now I am making a series of palettes. Well, anything can happen inside these palettes – clouds could pass over them, people could walk on them, I myself could hang a hammer in the middle. […]

(Translated from Italian, "Interview with Gene Swenson", in *Art News*, no. 7, New York, November 1963).

Lucio Fontana

[…] Pop Art represents a gesture of rebellion against a figuration; it is a wonderful thing, very American, and extremely acceptable, but it has been launched with millions [of dollars] in

such a form... But Rauschenberg is derivative of Duchamp, a bad derivative of Duchamp because he hasn't understood him: there is mystery in Duchamp, while in Rauschenberg there is a mess of colours and nothing else. Vice versa, Lichtenstein and Oldenburg have really done something American and have put an end to art by means of a figuration, but they are stuck there... Vice versa, you see that another idea is moving ahead, there is another opening in another sense. And, now, they are doing cinema: movie-making is old stuff, you have to go there, put the film on, and project it... What's cinema? Cinema is like making a fourteenth-century painting today. These artists think they're discovering how to make films, the art of cinema, it's the dumbest thing that could ever be, it doesn't have any dimension, only movement, and it doesn't have volume. Now, in America, I read that they are already projecting, for television, forms in space: well then, I could already do something, not that I would transmit figures, I would invade coloured environments, I would make projections, I would make what I wanted to, but arriving through a space and through really new elements. But to do cinema, in art, is really stupid. [...]
(*Carla Lonzi: autoritratto*, De Donato, Bari 1969).

Roy Lichtenstein

The majority of people actually consider me a comic strip artist and nothing else. It doesn't bother me even if I haven't drawn any real comic strips since 1965. My use of the comics was (and remains) an ironical language about a major art

and about what is considered "vulgar art". After all, this is the art that surrounds us. We certainly don't live in an impressionistic painting, the architecture that we see in our cities is not Mies van der Rohe, but McDonald's. I started from here and I still today continue to use the signs of the old comic strips: dots and diagonal lines, to give the impression of second-hand works, machine made reproductions. But in my latest works, large interiors taken from the "Yellow Pages" in which mirrors and female images also appear, there is a substantial difference from what I did thirty years ago. However, I wouldn't know how to define it. When I try to explain my work, I can never manage to take myself seriously.
[...] I don't think Pop Art is eternal. When an idea has been understood, it is also finished. In the history of art, Pop Art is going to be considered as a natural evolution of art towards lower languages, ordinary subjects. The difference between Daumier's *La Laveuse* and my weeping heroines is in the irony. Daumier had no intention of entertaining, I instead do. But I haven't invented anything new. Picasso was already looking ironically at Velazquez. To imagine an evolution of Pop Art for me is difficult now. But you never know...
Madonna is undoubtedly a Pop icon. Especially, with her sexual provocation, but above all she has modified its outlines with precise stylistic elements. And art? I haven't the vaguest idea, but Madonna amuses me.
[...] If I knew what would revolutionise the art world, I would appropriate it immediately. I am almost seventy years

old, but the hunger for something new is the same as when I was twenty. However, the situation seems to be stagnant to me, there is always the sensation that everything has already been done. But I must admit that I myself, at first, felt crushed between Malevich on the one side and Pollock on the other. What is there left to do?, I asked myself. Instead.

(Translated from Italian, "Interview with Marina Conti", in *L'Espresso*, 17 October 1993).

Lucy R. Lippard

Pop Art is an American phenomenon that departs from the cliché of big, bold, raw America that became current when Abstract Expressionism triumphed internationally. It was born twice: first in England and then again, independently, in New York. At its second birth, Pop proved instantly appealing to young people the world over, who reacted enthusiastically to both the hot and the cool implications of such a direct idiom; it attracted a middle-aged generation that looked anxiously to youth for its excitement in the arts and entertainment, as well as those of all ages who recognised its formal validity.

[...] Pop Art has more in common with the American "post-painterly abstraction" of Ellsworth Kelly or Kenneth Noland than with contemporary realism. When Pop first emerged in England, America, and Europe, raised eyebrows and indignation were accompanied by a profound disappointment on the part of many artists and critics. This unexpected outcome of a decade of Abstract Expressionism (or *Tachisme, art autre, l'art informel*) was hardly a welcome one, since it dashed hopes for the rise of a "new humanism", known as the "New Image of Man" in America and "New Figuration" in Europe. Man might make an occasional appearance in Pop canvases, but only as a robot remotely controlled by the Consumers' Index, or as a sentimentalised parody of the ideal. For other observers, however, such a brash and uncritical reflection of our environment was a breath of fresh air.

At first, largely unaware of their colleagues in the same city or in other countries, several isolated New York artists hit upon a common style by accident. It was in the air. They had not heard of their British counterparts, and the European developments seemed to have little bearing on their activities. John Coplans is correct in saying that Pop Art devices "derive their force in good measure from the fact that they have virtually no association with a European tradition". Despite the eventual rapport between artists in Europe, America, and England, the mature Pop idiom is special to America – particularly New York and Los Angeles. Hardcore Pop Art is essentially a product of America's long-finned, big-breasted, one-born-every-minute society, its advantages of being more involved with the future than with the past. [...]

("Introduction", in *Pop Art*, Thames and Hudson, London 1966).

Claes Oldenburg

I am for a politico-erotic-mystical art that does everything but sit in a museum. I am for an art that develops with-

out knowing it is art, an art that has the luck to start from zero.

I am for an art that interweaves with everyday life and at the same time jumps out of it. I am for an art that imitates, that is comic, if necessary, or violent, or anything else, if necessary.

I am for an art that takes its forms from life and twists and stretches impossibly and accumulates and spits and drips and is sweet and stupid just like life.

I am for an artist that disappears and turns up with a white cap to paint signs and billboards.

I am for an art that comes out like a plume of smoke and dissipates in the sky.

I am for an art that flows from an old man's coin purse when it is hit by a passing fender.

I am for an art that comes out of a puppy's mouth and falls to the ground from the fifth floor.

I am for an art that the child licks after having taken off the paper.

I am for an art that moves like people's knees when a car goes over a hole.

I am for an art that smokes like a cigarette, that stinks like a pair of shoes.

I am for an art that waves like a flag. Or that helps us blow our noses with a handkerchief.

I am for an art that you can put on and take off like pants, that gets holes like socks, that you eat like a piece of cake, that you abandon scornfully like a piece of shit.

I am for an art covered with bandages. I am for an art that limps, rolls, runs, jumps. I am for an art that comes in a can or pours over the shore.

I am for an art that rolls up and unrolls like a cigarette paper. I am for an art that loses its hair.

I am for an art you can sit on. I am for an art you can hit your nose against or trip over with your feet. […]

(Translated from Italian, "I am for an art…", in *Environments Situations Spaces*, exhibition catalogue, Martha Jackson Gallery, New York, May-June 1961, and in C. Oldenburg, *Store Days*, The Something Else Press Inc., New York 1967).

Robert Rauschenberg

[…] *If you didn't have critics and buyers who helped you materially and intellectually, if you were totally alone, would you continue to paint as you do now? Alone like a van Gogh for example. Is painting intimately and rigorously essential to you?*

Evidently. It always begins more or less this way. At first I missed the push to work in the way I now work. I can be rebuked for employing materials that are considered extraneous to the content of the painting. Now I intend to paint without the physical presence of objects that I have included in my paintings; or to do so in such a way that they can no longer be called paintings, but which constitute an environment, something that surrounds us. There is no reason for not considering the world a gigantic painting. Uselessness is the nobility and the liberty of the individual.

[…] *What do you want to communicate with a painting?*

If you were to ask me if I wanted to please or displease, provoke or convince, and if you were to give me another dozen alternatives, I would be oblig-

79

ed to say that it is exactly all of this and everything together. Half of my reasons would be negative and the other half positive. But the effort of concentrating my energy on a message would limit me and I prefer to go towards the unknown.

Do you mean to insinuate that you don't know what you mean and that you are not looking for anything that is claimed to be found in your canvases?

If there were a specific message, I would be limited by my means, by my ideals and by my prejudices. In short, what interests me is a contact and not to express a message.

What difference is there, for you, between automatic painting and your painting?

I can't see any difference between automatic painting and other painting. As far as I'm concerned, I deliberately try to go over and beyond the message. I would like to make a painting that creates a situation that leaves as much space for the viewer as for the artist.

Do you consider your work as an intimate experience or as a work of art? What plastic value do you give it?

Painting is the most important thing for me. It may have the same importance for other people. One doesn't exclude the other. There is no frontier between the intimate value of painting and its plastic value.

[...] *What's the difference between the current painting in New York and Paris?*

In France, there's a continuity, a bond between the landscapes, the streets and the painters. Everything is immersed in the same patina. In America, painting is defined by the breaking force that the painter must possess. There is no conti-

nuity, only opposition. To be a painter means to break.

(Translated from Italian, "Interview with André Parinaud", in *Arts*, no. 821, Paris, 1-16 May 1961).

Harold Rosenberg

[...] On Halloween in 1962, Sidney Janis, whose gallery represented de Kooning, Rothko, Guston and other top Abstract Expressionists, opened a two-locations exhibition of "factual" (i.e., illusionistic) painting and sculpture. Under these auspices, and after fifteen years of the austerity of abstract art, the New Realism hit the New York art world with the force of an earthquake. Within a week, tremors had spread to art centres throughout the country.

[...] Coupled with the sudden availability of language was the sense that art history was being made, in that it was from the leading emporium of American abstract art that these appetite-wrecking collations and misplaced home furnishings, advertisements, and comic strips were peeking. Exhibitions with much the same content had been given one or two years earlier by the galleries of Pops and the style had been covered by the Museum of Modern Art in its massive *Assemblage*. The visual puns of Rauschenberg and Johns, Larry Rivers' adaptations of playing cards and cigarette packages, and long before these, the refined associationism of Joseph Cornell's "boxes" had connected the American illusionist vanguardism with the "ready-mades" of Duchamp, Schwitters, Man Ray, and other artists of the First World War period.

[...] Most of the European exhibits,

amounting to more than half the total, and a few of the American had no connection with the theme set for the show by the new United States anti-appeal art packages. Some, like Enrico Baj's *Style Furniture*, Mario Schifano's *Propaganda*, and Tano Festa's *New Shutter* (these artists are all Italian), merely employed everyday images and surfaces to create works of art in the conventions of Cubism, Expressionism and Neo-Plasticism.

[…] Among the Americans in the show, the most imaginative and critically conscious were Oldenburg, Jim Dine and George Segal. All three use paint and modelling materials to cause the idea of art to abut upon commonplace objects without lending glamour to them. Oldenburg's plaster-steeped ladies' underwear brought to Fifty-seventh Street shoppers an atmosphere not very different from that induced by windows on Fourteenth Street. The essential distinction between the gallery objects and the store objects considered as objects was the art reference of the Oldenburgs, provided by the identification of their maker as an artist and the place of exhibition as an art gallery.

[…] Dine incorporated a lawnmower into art by leaning it against a canvas marked with some Impressionist strokes of green paint, which had also splashed down on the mower. Similarly, carpenters' tools, soap dishes, and a lead pipe become art by hanging or jutting from painted surfaces.

[…] Segal's plaster family sat around a wooden dining-room table, one member holding in his plaster hand a beat-up aluminium coffeepot. The imprecisely realistic creatures seemed to suffer physically from the fatiguing weight of actual wood and metal, and in this group and in his strangely anguished *Bus Driver*, flanked by a genuine coin receptacle, the game of illusion reached a pitch of pathos that belongs equally to sculpture and the theatre. Segal was the only exhibitor who used the new illusory combinations to create a new feeling rather than as a commentary on art.

[…] The new American illusionist contrivances have a deeper identification with commercial art than the plagiarism or adaptation of its images. They share the impersonality of advertising-agency art-department productions. They are entirely cerebral and mechanical; the hand of the artist has no part in the evolution of the work but is the mere executor of the idea-man's command, though in this case the artist himself is usually the idea-man (sometimes the idea for a work comes from friends or sponsors). Nor is the self of the artist engaged by the process of creation.

If, as some have maintained, there is terror in this art, it comes from its irremediable deadpan: a grin in porcelain.

("The Game of Illusion: Pop and Gag", in *The Anxious Object*, Collier Books, New York 1966).

James Rosenquist

[…] Therefore I did these canvases, pretty big ones… I'd like it to be understood that since I grew up during the Fifties, I was bombarded by media advertising, the radio and television, etc., which had a dazing effect. And then when I was painting billboards, here, I was depicting the structures of those

enormous, bright ads, painting them as realistically as I could, and my nose was barely half a metre from the wall and I was working in this daze in a sector in which you could distinguish all the colours but certainly not see the image. So I thought that I could work in this area, and do something specific, a shape that wouldn't be mistaken for an eagle or a crucifix or anything, because it would be explicitly what it was, only enormously enlarged, out of sight. So I painted another painting with a pair of jeans, a person in a pair of jeans, not only the jeans, a hot dog, a life saver, parts of a face, and everybody said "Oh, this is Pop Art, this is a popular image. I can recognise it." Well, this was not the underlying idea at all. The idea was to use some fragments of something recognisable, but that was also just a little old, a little old-fashioned, and this came from the time of the Beat Generation. Here, I was adopting images that were really not old enough to be nostalgic, but not even new enough to arouse passions in a materialistic sense, therefore I made use of things that had passed maybe three, four, five years ago in a definite period. […]

(Translated from Italian, "Exalt everything", James Rosenquist interviewed by David Shapiro, in *Pop Art*, Electa, Milan 1980).

George Segal

My first sculpture dates back to 1958; at that time my everyday problem was to find my pictorial space. I was tired of all the academic formulas. What would happen if I really penetrated real space? I decided to do it; I created a space; that is to say I occupied the space with a volume, and that's what is called sculpture. But what was my first reaction in front of this volume? For a long time I have been interested in the representation of life size figures: and this is still so today in sculpture.

I reacted to the contact of my sculptures as to the presence of man in his everyday life. On the farm where I live I used to raise chickens, but it was a fiasco. So I changed my profession, keeping the farm just as it was. When I painted some big paintings, two metres by three, my wife asked me: "Why don't you paint smaller pictures so they'll be marketable?" I answered: "But what difference does it make if I paint them big or small, I don't sell them anyway." My wife raised her arms up to the sky: "But if you weren't able to sell big paintings, how are you going to sell enormous sculptures!" None of this had any importance for me because I never thought that my art would bring me money. If I find someone who buys, so much the better. In any case, I'll continue to do what I want to do. I have become a drawing teacher and I could stay one in spite of all the fuss that has been raised around me. I decided, at that turning point in my life, that my job as a teacher enabled me to buy the material I needed for my work and, after I had failed at raising chickens, I had a farm at my disposal where I could work freely. Wasn't it Brancusi's dream to fill the space he lived in with sculptures? And why not? As soon as I said this, it was like pulling a tooth: I felt good right away, I had a moment of happiness. It surprised me to realise then as I looked around that peo-

ple began to be interested in my new work.

I am surprised like others at the reaction my works create, and in spite of everything, I remain skeptical. I'm as suspicious as an old farmer; but as you can see, people are inconvenienced but they make room for these big gadgets. I can't explain other people's reactions; but as far as I'm concerned I am completely taken by this change which makes me see my space and say: "Why don't you really enter it?"

(Translated from Italian, exhibition catalogue, Ileana Sonnabend Gallery, Paris, October-November 1963).

Alan Solomon

[...] The objects were first used in this new way by Robert Rauschenberg, Jasper Johns and later by Jim Dine and (with a slightly different technique but identical objectives) by Claes Oldenburg. Their sources were in part the modern currents of Dada, Surrealism and Constructivism, maybe more particularly the late sculptures of Picasso which were made of objects, but above all the art of Marcel Duchamp which they knew directly from the few examples in museums and, more vaguely, from illustrations contained in books like Motherwell's *Dada Painters and Poets.* Only later and almost by surprise did they discover that the flesh and blood Duchamp lived in New York, and still later that there was a great affinity between his work and point of view and theirs.

For that reason, Duchamp is really the mentor of one part of the contemporary movement of New York, notwithstand-

ing our tendency to tie it to Paris and the past. [...]

(Translated from Italian, "New York: la nuova scena artistica", in *New York: arte e persone*, Longanesi & C., Milan 1965).

Calvin Tomkins

[...] Something absolutely "horrible" was happening for the conservative critics: it certainly wasn't the "return to figurative", that was loudly claimed as an antidote for Abstract Expressionism; and for some time this new tendency did not even have a name. Karp described it for a while as "Commonism"; but the term was not suitable. Finally, the definition of the English critic Lawrence Alloway in the mid-Fifties seemed exact: Pop Art. Until then, Warhol had exhibited his paintings with cans at the Ferus Gallery in Los Angeles; images of commercial products invaded the paintings of Jim Dine, Tom Wesselman, Robert Indiana, and many others. Sidney Janis gave the movement his imprimatur in the spring of 1962 with a show entitled *New Realists* which included American and European artists. Not long after, all the Abstract Expressionists left Janis's gallery except de Kooning, who stayed on for another ten years. They felt betrayed by Janis who had taken on Oldenburg, Dine, Wesselman and other Pop artists, but they felt betrayed even more by their old friend Castelli. "Give Leo Castelli two empty cans of beer and he'll sell them for you", said de Kooning one night at the Cedar Tavern. Jasper Johns, when he heard this, made a bronze sculpture of two cans of Ballantine Ale that were exactly like the real ones. Castelli sold it for nine hundred

83

and sixty dollars to Scull (who in turn sold it at an auction in 1973 for ninety thousand dollars). Johns recalls that he had no intention of demonstrating anything at all. At that time he was making small sculptures of light bulbs and electric torches and other common objects, and de Kooning's comment just gave him "the idea for a subject in tune with what I was trying to do".

(Translated from Italian, *Vite d'avanguardia*: *Leo Castelli*, Costa & Nolan, Genoa 1983).

Andy Warhol

[…] *Is Pop an ugly name?*

The name is really ugly. Dada must have something to do with Pop – it's funny, the names are really synonyms. Does anyone know what these names mean or what they have to do with? Johns and Rauschenberg, Neo-Dada for all these years and considered by everyone derivatives of Dada, unable to transform the things that they used; now they are called the forerunners of Pop. It's amusing how things change. […]

What influence have you felt in your work from Dada?

When I ran into it for the first time, I considered it with respect and thought that it was good enough, but it had nothing to do with me. As my work started to evolve, I began to understand – not at a conscious level, in fact it was a surprise – that maybe it had something to do with my work.

[…] I am more and more aware of how bold the act of painting is. One of the reasons why I started to make collages was because I didn't feel involved in what I was painting. I wasn't interested

enough in a rose to paint it. One of the reasons for this, I think, comes from the fact that I'm painting at fifty, I mean a love of flowers has already gone for a painter by then. I don't like roses or bottles or things of that type enough to want to sit and paint them with love and patience. And now, with these big images… Well! there isn't enough space around for advertising and I have to paint a cup; but cups don't say anything to me, I really don't know how they are. I only know that I have to have a cup in this painting. Here, I put this simple blue cup in the painting that I'm working on and then I understood that I had to do something on it. I had to invent a cup and, God, I didn't realise how daring that was. Even that is frightening – to paint something without really being convinced of how it should be. […]

(Translated from Italian, "Interview with Gene Swenson", in *Art News*, no. 7, New York, November 1963).

Andy Warhol

[…] An artist is someone who produces things that people don't need but which – for *some reason* – he thinks is a good idea to give them.

[…] I think very often about space writers, those who are paid on the basis of how much they write. I have always thought that quantity was the best measure of all (because you always do the same thing even if you seem to be doing something else), so I got the idea of becoming a "space artist". When Picasso died, I read in a magazine that he had made four thousand masterpieces in his life and I thought: "Jesus, I could do that in a day." And I started. And then I

discovered that: "Jesus, you need more than a day to make four thousand paintings." Because, given my way of making them and my technique, I really thought I could make four thousand in a day. And they would all have been masterpieces because they all would have been the same picture. I started, and I got to making about five hundred, and then I left it there. [...]
(Translated from Italian, *La filosofia di Andy Warhol*, Costa & Nolan, Genoa 1983).

Bibliography
H. Rosenberg, *The Tradition of the New*, The University of Chicago Press, Chicago 1960.
V. Rubiu, *La materia dell'informale è esplosa nell'oggetto, Collage n. 3–4*, Denaro & C., Milan 1964.
M. Amaja, *Pop as Art*, Studio Vista, London 1965.
G. C. Argan, *Progetto e destino*, Il Saggiatore, Milan 1965.
G. Dorfles, *Nuovi riti, nuovi miti*, Einaudi, Turin 1965.
M. Calvesi, *Le due avanguardie*, Lerici, Milan 1966.
E. Crispolti, *La pop art*, Fratelli Fabbri, Milan 1966.
L. Lippard, *Pop Art*, Thames and Hudson, London 1966.
H. Rosenberg, *The Anxious Object*, Collier Books, New York 1966.
New York: Arte e Persone, text by A. Solomon, photographs by Ugo Mulas, Longanesi, Milan 1967.
Pop Art in USA, Lerici, Milan 1967.
M. Calvesi, "Arte e tempo", in *Teatro delle Mostre*, Lerici, Rome 1968.
M. Volpi, *Arte dopo il 1945. USA*, Cappelli, Bologna 1969.
Depuis – L'art de notre temps, vol. 2, La Connaissance, Brussels 1970.
P. Barozzi, *Il sogno americano*, Marsilio, Padua 1970.
M. Calvesi, "Il Neo-dada", lecture of 28 January 1973 at the Galleria Nazionale d'Arte Moderna, in *Situazione dell'arte contemporanea*, Librarte, Rome 1976.

Programmed [Op] and Kinetic Art
Phenomena of visual perception

The New Tendency movement was founded in Zagreb in 1961 by the Brazilian painter Almir Mavignier, the Serbian critic Matko Mestrovich, and the director of the Gallery of Contemporary Art, the Croatian Bozo Bek. An exhibition held that same year in Zagreb was the first opportunity for sculptors and painters from different countries – their Concrete, Surrealist, Dadaist, *tachistes* matrices were evident – to unite in order to divulge the new word.

In Italy, the Group N had already formed in Padua (Manfredo Massironi, Alberto Biasi, Ennio Chiggio, Toni Costa, Edoardo Landi); the Group T in Milan (Giovanni Anceschi, Davide Boriani, Gianni Colombo, Gabriele De Vecchi and later Grazia Varisco); and in Paris, the GRAV (Groupe de Recherche d'Art Visuel) with Julio Le Parc, Horacio García-Rossi, François Morellet, Francisco Sobrino, Joël Stein, and Yvaral. Some five years earlier, Enzo Mari, Enrico Castellani and Piero Manzoni had attracted interest (the latter in a different direction); and before them, Victor Vasarely with his *Yellow Manifesto*, and Bruno Munari.

Therefore, the Zagreb initiative provided the opportunity to bring together some of the already existing researches and researchers. Before the scandal exploded over what was referred to as a profane, technological and para-

87

scientific exercise, other European exhibitions were held: in Italy, the Olivetti show of 1962, later held at the Olivetti offices in New York, and the San Marino Biennial, *Oltre l'Informale*, in 1963.

What were these young artists, who came for the most part from the European and Latin American Academies of Fine Arts, and were backed by the Paris dealer Denise René, and in Italy by Munari and Umberto Eco, looking for? They wanted to systematically analyse the phenomena of perception, to make a science of art, to demonstrate that the implications of cognition and communication were not the only things that counted in the work, that the project of the work *is* the work of art independent from its realisation. Convinced that this new research could be associated with a new way of life, they once again proposed – as the historical avant-garde movements had – the myth and utopia of a correspondence between the new form and a new society.

Programmed Art (when you programme, you foresee,

Eusebio Sempere, Gouache, 1953

Jeffrey Steele, Ghostly Form, 1963

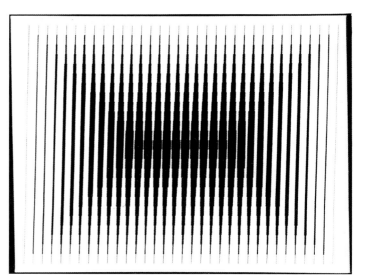

predetermine and prefigure) has represented a substantial renewal in the making and the understanding of the aesthetic, inaugurating a new stage of visualisation and amplifying, among other things, that sphere of perceptivity which until now has been considered to be the exclusive domain of the scientific disciplines. The practice of interpretation has been substituted by the technique of observation and methodical investigation. There was a desire to provide society with a method for structuring the phenomenal environment in which man lived. The Programmed artists wanted to: promote an interdisciplinary methodology; explain the perceptive structures supporting the images and messages tied to the images themselves; explain the relationships between (already existing) primary data and constructed data; promote the work as a typological example (that is, as a model); and combat the commodification of art, by moving their activity into a didactic dimension.

Programmed Art – also called Optical Art and Gestalt Art – explored the phenomena produced by the natural

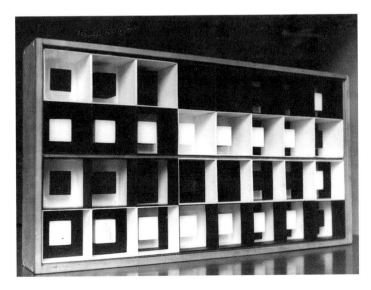

Enzo Mari, Project 305, 1956

processes of things; it proposed a plastic analogy of their intrinsic dynamism through realisations rich in multiple perspectives. The materials employed were different from the traditional ones for merely functional reasons. Their works required artifices to move, motors and electric machinery, various devices, lamps (the intermittent quality of light creates movement), transparent surfaces that were graphed, superimposed or reflecting (the perceptive ambiguity created provided the viewer with a broader reading, one extended in time). Circles, squares, triangles, black and white shapes, void and full, they eliminated any representation in the painting. When painting is like this, that which determines painting, quality, is removed so disposition and sensitivity are lacking and it becomes painting *without quality*.

Manfredo Massironi,
Untitled, 1964

François Morellet,
Woven Spheres, 1962

90

Neither delirium, nor a combination of candour and exasperation are extraneous to these works, nor for that matter do they lack an ingenious pedantry and a devoted deductive madness. There is a cold fascination, at times a logical terrorism, at times a concentration between the didactic and the demential, together with the interminable ambiguity of a systematic aseptic clarity that bring to mind Giorgio Manganelli's words, "to be right is the natural vocation of madness".

The protagonists had already stepped or were stepping aside between 1963 and 1965, trying to find a way to get round the impasse, once the plethora of imitators and goodwill followers had made their appearance. In the wake of enthusiasm that Giulio Carlo Argan's words had aroused on the occasion of the San Marino Biennial in 1963, several groups formed in Italy, only to dissolve within a short period of time, for as the results of a practical nature slowly emerged, it turned out to be more and more difficult for the group members to share personal recognition. Even Groups N and T came to an end after a neurotic agony.

*Getulio Alviani,
Surface with a Vibratile
Texture, 1961–62*

The interest created through their team work did lead to a series of different approaches of which at least three should be mentioned: Group 1 which formed at the end of 1962; Group '63; and the Operativo R, in Rome. The difference between these and the Groups N and T was that the former suggested a dynamic conception, maintaining that the time dimension, by passing from the stage of the possible to the stage of existence, became important through movement (headed in the same direction was the Group Mid of Milan which was established at the end of 1964 as a studio of visual research that designed environments and objects, experimenting with the possibility of the communication of artificial life, especially in the field of

stroboscopic phenomena, and investigated the properties of cold light illumination). Meanwhile, the members of the Roman groups were still painting pictures and constructing two-dimensional objects in which movement was only illusory and the idea of time did not intervene.

But the provincial degenerations accumulated in the field of experimental psychology exercises, the optical divertissements, and the blatant decorative quality were overworked to the point of determining the nauseating banality that made the Optical a fashion in the western world, the obtuse ecstasy of Kitsch, and the junk of designer trinkets. It had started out in the scientific laboratory and it ended up in the boutique: the stoical longing for the golden proportion had given way to Biedermeier.

Programmed Art was not destroyed and disrupted by its adversaries – except for the usual exceptions – as much as it was by its supporters (critics, journalists, dealers) who misunderstood its intentions, by those who talked about

Enrico Castellani,
Striped Surface, 1961

the scientific when it would have been better to talk about suppositions, that is, about something that precedes even the formulation of a hypothesis, and by those paladins who, after having made use of all its most ephemeral opportunities, definitively undermined the credibility of the tendency by reducing what had started out as being revolutionary to amusement park trash. Therefore, it did not fade away because it was too politicised, rigorous or rigoristic, as many have said, but because it was not politicised or rigorous enough. And so the Diaspora was reached. By the time the exhibition *The Responsive Eye* was held in New York it was quite clear that the game was over.

Jesús Rafael Soto,
Spiral, 1955

Among the most representative figures of Programmed Art were the Venezuelan Jesús R. Soto, the Spaniards Eusebio Sempere and Francisco Sobrino, the British Jeffrey Steele, the Swiss Paul Talmann, Karl Gerstner and Christian Megert, the German Ludwig Wilding, the Croatian Ivan Picelij, the Argentinian Ugo Demarco, and the Italian Getulio Alviani.

Among those who conducted researches that were along the same lines though different in their pragmatic aims were the Brazilian Abraham Palatnik, the Croatians Julije Knifer and Vlado Kristl, the Belgian Pol Bury, the Swiss Jean Tinguely, the Italians Mario Ballocco and Dadamaino, the Argentinian Antonio Asis, and the German Otto Heinz. Also working in the same direction during the Seventies, their paths and exhibitions intersecting, were the Austrian Jorrit Tornquist, the German Dieter Hacker and the Italians Nanda Vigo and Marina Apollonio.

Programmed [Op] and Kinetic Art

Umbro Apollonio

[…] That a real, incommensurable or absolute world has always existed has undoubtedly already been announced, but when this does not enter history and therefore become alive, and not just remain an object of contemplation, then it is like any tyranny that can neither be discussed nor envisaged. So much so that the elemental forms adopted in the aesthetic researches under discussion are no longer the symbol of an ideal or idealised harmony, as in the case of the geometric artists. They have, on the contrary, become a way of being in a society where methodical rigour is the law and thus cannot be inverted by a formal rule that eliminates its chance attractions. In the same way as in a filmed work or in a theatrical or musical show in which the various creative spheres communicate with one another and form an entity in which they are no longer distinguishable because they are homogenised, it is right to experiment with a possible co-operation between science and art, technique and fantasy, seeing that total participation is what determines a situation. The accidental then is no longer improvisa-tion, nor speculative rationalism-formu-lation because the ideated correlate makes use of exponents of fantasy that imprint their own characterisation on the product. […]
("Ipotesi su nuove modalità creative", 1962, in *Occasioni del tempo*, Studio Forma, Turin 1979).

Giulio Carlo Argan

[…] To make constructive intention once again the beginning of every cre-ation until it makes its first contact with the world through perception means re-turning the form or aesthetic value to first place on the scale of values, at the level of abstract concepts; and to analyse the constructive procedure, by revealing all of its passages in precise formal terms, means to affirm the need for and provide an example of the clarity and resoluteness of the intention that opens and accompanies (or should) the cyclic development of the human operation from its ideation and project to con-sumption. […]
But it also must be acknowledged that the Gestalt trend, with the occasionally ingenuous scientism of its research, is the

only one today that has assumed a positively critical position, one that is no longer of resigned subordination or of a disappointed, furious protest, against an historical situation characterised by industrial technocracy. It is also the only one that by finally revoking the dogma of universal form, the supreme intuition of natural laws, has clearly posed the question of its genesis in the mind and its development in the human operation, thus showing that, just as liberty is always liberation in the moral order, form is always formation in the aesthetic order, and Gestalt is always Gestaltung.

("Forma e formazione", in *Il Messaggero*, 10 September 1963).

Giulio Carlo Argan

[…] Programmed Art uses pure industrial technology as its field; Pop Art the entire spectrum of imagery that the groups in power adopt in order to condition consumer behaviour. The first, with its strong axiological emphasis, tends to separate the industrial technique from the capitalistic superstructure; the second, which has a broad horizon but no axiological emphasis, not only rejects the distinction, but devaluates the technological method with respect to the system of conditioning. Therefore, at the risk of being charged with Manichaeanism, I consider Gestalt positive and Pop Art negative. […] Given the state of things between Gestalt and Pop Art, between project and non-project (someone else, however, projects for us), I think it is taking shape as an antithesis between utopia and cynicism: or between a weak [political] left and a dangerous right. […]

("Testimonianze sulla XXXII Biennale", in *Il Ponte*, August-September 1964).

Umberto Eco

Contemporary art had accustomed us to recognising two categories of artists. On the one hand, are those who search for new forms, trusting in an almost Pythagorean ideal of mathematical harmony; they invent configurations sustained by secret relationships, and in order to reach the poetic pass through geometry, be it Euclidean or not. On the other hand, there are those artists who have recognised the fecundity of chance and disorder, and are certainly aware of the re-evaluation – made by the scientific disciplines – of random and statistical procedures, who have accepted any suggestion that might originate freely from the material. They spray tubes of colours on virgin canvases, and strike, tear, and pierce holes or burn cloth, wood and metal, and then stick the broken and juxtaposed scraps of real objects on them.

These two approaches do not seem to have any points in common, save one that is historically quite plausible. In both cases there has been an attempt to negate the accepted, acquired conception that a society is made up of "beautiful forms", in order to suggest other methods of formation, other possible configurations of the real; on the one hand, by discovering the poetic quality of geometrising forms, and on the other, by discovering the formal possibilities of the unformed, in an attempt therefore to give a form, a new form, to that which was usually considered disorder in its pure state.

Therefore, although they have gone their separate ways, the maniacs of the mathematicising programme and the "howlers" of plastic laceration have basically been pursuing the same end: that of broadening the field of the perceptible and enjoyable for contemporary man. More than any other difference in school or tendency, and more than the above-mentioned divergence of intentions, the mystics of the complete, moderate form were really setting off to integrate the forms of their invention in an industrial society that was accepted without reservations, while the anarchists of the disintegrated, abused form were really protesting against an established order that they could not accept. But does a similar dichotomy hold up? Haven't the former actually succeeded, by passing from the abstract painting to the very concrete form of the fork or the whisk, in reintegrating the art of their times into a social context, initiating one and all democratically to an appreciation of the new relationships between form and use? And haven't the latter, now that they have retreated into the stronghold of their indignation to celebrate a very individual protest, in the last analysis become the model artists that society dreamed of, and which the revolutionary, anguished artists were apparently protesting against, but in their own homes and without any connection to the others?

These are problems that, with the exclusion of individual "bets", will have to be considered in an historical perspective. But there is no doubt that both sides have pursued the idea of man's liberation from his acquired formal habits.

There was a need to break with the schemes of perception. And if perceptive habits encouraged us to enjoy a form whenever it was presented as something complete and concluded, well then, the time had come to invent forms whose appearance was constantly changing and that never let one's attention relax. And so while the Informel artists were elaborating a "movement" of the painting on the two-dimensional plane of the canvas, configuring a space and a dialectic of signs that would incessantly lead the eye to re-examination, the inventors of mathematical forms were testing the paths of three-dimensional "movement" by constructing immobile structures that appeared variable and changing when seen from many perspectives, or even by constructing mobile, "kinetic" structures. And so, while the former were constructing "open" works in the sense that they were arranging constellations of multi-related elements, the latter were constructing works that were not only "open" but actually "in movement". But an object that moves, either moves according to a set scheme and is powered by a motor (at which time it is reduced to a mechanical pretext, immediately excluding any possibility of "improvisation"), or is moved by natural forces that in themselves are unpredictable, or vaguely probable given the dynamics of the object as a structure subject to certain physical laws. The old dichotomy exists here, too, either the mathematical rule or chance. But is it really true that the mathematical rule and chance exclude one another? It so happens that natural phenomena occur by chance and yet their course can be

predicted on the basis of statistical rules which measure the disposition of random events with a sufficient margin of mathematical certainty. Therefore, some kind of programme, a posteriori, can be identified in chance events; as a matter of fact, there are methods for winning at roulette.

Therefore it will be possible to programme, with the pure linearity of a mathematical programme, "fields of occurrences" in which random procedures may be verified. We will thus have a singular dialectic between chance and programme, mathematics and hazard, planned conception and free acceptance of what will come, however it comes, given that it will come anyhow according to precise, predisposed, formative lines that do not deny spontaneity, but do impose barriers and possible directions.

We can speak then of Programmed Art, and so admire the kinetic sculptures that people will keep in their homes in the near future instead of old prints and reproductions of contemporary masterpieces. [...]

(In *Arte programmata*, exhibition catalogue, Olivetti Store, Milan 1962).

Guido Ballo

[...] It need be said that kinetics represents only one of the aspects, but not the fundamental one, of Programmed Art research, based primarily on a relationship between imagination and science, in which the work methods remain unaffected by uncertainties of mood. This rigour originates principally from Neo-Plastic abstraction and the developments of Constructivism. Actually, in addition to Munari [...] another young

artist, Enzo Mari, whose experiments on volume and colour were close to Munari's, has been exploring Programmed Art of Gestalt origin.

It is well-known that the term Gestalt dates back to the time of Neo-Plasticism when Mondrian designated the Neo-Plastic movement in one of his writings (1920), which he had previously described as a "new form" (in German, "neue Gestalt"), which another Dutch painter, Theo van Doesburg, had already announced in 1916 with the foundation of the review *De Stijl*. *Gestaltic*, as a new form, refers therefore to the Neo-Plasticists, and regards art as the invention of pure relationships based on geometric rhythms which are indicated as making or producing. Hence the invention not of images that could also have an allusive character, but of "objects" that go beyond the old kind of sculpture and painting. Programmed Art (a term coined by Umberto Eco in the catalogue of the exhibition held at the Olivetti Store in Milan in May 1962) thus indicates a concept of continuous experimentalism with scientific methods, but also with industrial, but not artisan, production. Hence the possibility of multiples, with variations in series, in which the new form, pure becoming, the Gestalt, has value and not the individualistic expression of Romantic origin. [...]

(*La linea dell'arte italiana – Dal Simbolismo alle opere moltiplicate*, Edizioni Mediterranee, Rome 1964).

Karl Gerstner

[...] Today more than fifty artists adhere to the New Tendency movement. The Zagreb exhibition has become a Bi-

ennial whose second edition took place in 1963. Other exhibitions have been organised in Germany and in Italy, but none, till today, has been as important as that held at the Musée des Arts Décoratifs in Paris. [...]

What is the aim of the New Tendency?
We will have achieved a great deal if we find the path that leads through our creations to you.

We are tired of making pictures for the dusty eternity of museums. Ours is everyday art, so much so that some of you would like to qualify it as socialist. In any case, it is social. Up to now, we have not yet reached perfection, but we are sure that our art is feasible in social conditions, in large series and – why not? – on an industrial basis.

Every new material, every new procedure, every new instrument is acceptable as long as it is necessary to our work.

We do not recognise any convention; we do not have to know how and what a painting should be.

We want to be free from all conventions – even from the one we ourselves may have elaborated in spite of ourselves. Our movement is not revolutionary. We have not formed a front against anyone or anything.

We have opened our doors and our programme grows with each experience.

What has the New Tendency achieved?
Don't measure our efforts by our theories but rather by our achievements and our researches.

We want the idea to be subjective, that is, new; and the realisation objective, that is, anonymous.

(In *Nouvelle Tendance*, exhibition catalogue, Musée des Arts Décoratifs, Paris 1964).

GRAV

Today, the undersigned announce the foundation of the Groupe de Recherche d'Art Visuel (Research Group of Visual Art). With the creation of this centre, they want:
– to compare their personal or group researches in order to intensify these;
– to combine their artistic activities, efforts, capacities and personal discoveries in an activity that will be one of teamwork;
– in such a way to dominate the traditional approach of the single, brilliant painter, the creator of immortal works.

By departing from their individual artistic activities and by means of organised research and by making comparisons of their work and concepts, a solid theoretical and practical base of their collective experience will slowly be established.

To that end: the Groupe de Recherche d'Art Visuel declares that the centre will be free from any aesthetic, social or economic pressure.
– The character and scope of the researches carried out by the members of the Groupe de Recherche d'Art Visuel will be submitted for analysis by the centre which will express its opinion on the subject.
– Such research may constitute the departure point for other researches that will be carried out by the same members who initiated them or by other members of the centre.
– Each member of the Groupe de Recherche d'Art Visuel will have to submit his own individual work, when it re-

gards the centre, to the centre itself, so as to obtain the most suitable solutions for any problems that may arise.

– A register will be kept in which the centre's activities will be noted down, the history of its research and any possibilities for development, be it of a theoretical or practical nature.

– Classifications will also be established regarding the origin of the research, its objectives, and any relationships or contradictions that may exist in the research projects.

– The members of the Groupe de Recherche d'Art Visuel have created specific regulations for the functioning of the centre, and they will abide by the above-mentioned general principles.

Demarco, Garcia Miranda, García-Rossi, Le Parc, Molnar, Morellet, Moyano, Servanes, Sobrino, Stein, Yvaral.

(*The GRAV Act of Foundation*, Paris, July 1960).

Group N

The letter "N" designates the group of "experimental designers" who are united in their need to do collective research. They know (perhaps) where they come from; they do not know where they are going, and their objects, studies and paintings are the result of experiences that are difficult to catalogue because they lie outside of any "artistic" tendency. They are certain (?) that rationalism and Tachisme are finished, but that they were necessary; that Art Informel and all the Expressionisms are useless subjectivisms.

They recognise in the new materials and machines a means of expression for the "new art" in which there can be no sep-

aration between architecture, painting, sculpture and the industrial product. They deny the spatial and temporal dimensions in which man has lived deterministically until today.

They seek an objectivity in the indetermination of inter-phenomena necessary for concretising the new light-space-time entity.

They reject the individual as a determinant element in history, experience, iteration and any perfection that does not arise from an innocuous need for "regularity". They refuse all religious-moral-political fetishism. They defend an ethic of collective life (?).

("Manifesto del gruppo Enne", September 1961, in *n. 1 scritti dal 1959 al 1961 del gruppo enne*, mimeographed pamphlet, Padua 1962).

Group T

Each aspect of reality, colour, form, light, geometric spaces and astronomic time, is a different aspect of the concept of SPACE-TIME or, better yet, different ways of perceiving the relation between SPACE and TIME.

Let us therefore consider reality as *phenomena* in a continual state of becoming which we perceive in their *variation*.

Ever since such a reality has taken the place of a fixed unchangeable reality in the consciousness of man (or only in his intuition), we have noticed a tendency in the arts to express reality in terms of becoming.

Therefore, if we consider the work as a reality made of the same elements that constitute that reality that surrounds us, the work itself must vary continually. By this, we do not intend to reject the valid-

ity of means like colour, form, light, etc., but we are re-dimensioning them by introducing them into the work in a real situation such as we recognise them in reality, that is in continual variation, which is the effect of their reciprocal relationship. *Giovanni Anceschi, Davide Boriani, Gianni Colombo, Gabriele De Vecchi.*
("Dichiarazione", in *Miriorama 1*, manifestation of the Group T, catalogue, Galleria Pater, Milan 1960).

Enzo Mari

"New Tendency: Ethic or Poetic?" The New Tendency has been understood by all those who have been involved in its development as a movement directed towards the individuation and divulgence of what cannot be described in any other way than the ethical values of the so-called artist's profession-condition. Right now such ethical values are identified with the need to systematically verify artistic phenomena by using procedures analogous to those of scientific research. And subsequently to undertake didactic action so as to demystify the entire apparatus of aesthetic conventions which still today, instead of clarifying their own functions (and thus be within everyone's grasp), continue to be the instrument of a bourgeois culture (even in the socialist countries) that seeks not knowledge but its own recognition. The most dynamic moment of the New Tendency coincided with its foundation when, together with the interest in its new experimentation, there was enthusiasm and, in some, a sincere desire to renew what were considered outdated structures.
But as we have observed, the task has

not been so easy. Indeed, those processes of objectification generally – and necessarily – led to an over-simplification of the perceptive model and the development of its variations (often obtained with kinetic devices) which were, and are, reduced to a mythical exaltation of themselves, so that the research declined into that very same operation of recognition that was to be contested.
Thus, a tendency that was determined by ethical finalities was turned into one of the many movements of aesthetic expression that, as we know, serve as publicity for artistic merchandise.
[...] If, as we have maintained until now, the goal of the New Tendency should be to demystify artistic phenomena (which can also be obtained through a knowledge of the most appropriate contemporary techniques), the experience of these years has shown us that unless we can define the socio-economic reality of the new situation clearly for ourselves and for the public, there will never be the necessary conditions to conduct research in non-mystifying terms. [...]
("Foreword", in *Nova Tendencija 4*, exhibition catalogue, Zagreb 1969).

Filiberto Menna

[...] Programmed Art tends to conciliate the opposite terms of the rule and chance; that is, it establishes a relationship between freedom and necessity, producing objects that contain within themselves the rule for a free and unpredicted manifestation. I would therefore suggest these objects be considered not only as a metaphor for the categories of the indetermination and the statistical

distribution of contemporary science but also and even more as a metaphor (for the particular realisation and, if one so wishes, reduced one) of that "game instinct" that the Romantics viewed as the place where freedom and necessity met and combined.

Perhaps Programmed Art is really this, an art that is an entertainment and a game, in the strictest sense of the term, that is, as a form of liberation and redemption, if not of the "tragic", then of the "daily necessity". For at the most these objects and devices seem to preserve within them the stimulating, infinitely "open" sense of a new utopia; as in a microcosm they enclose the sense of a future society, a society assimilable to a great, perfect machine that moves with a rhythm that is necessary, yet still new and unpredictable.

("Attualità e utopia dell'arte programmata", in *Film selezione*, January-March 1963).

François Molnar

We do not want to make a science out of art, nor make a scientific art. Nor do we want to depend on blind intuition. Of course, there is no work of art without intuition. It seems that even all the creations, science included, contain a part of intuition. But we are trying to control our intuition. We do not have unlimited faith in our reason. We know that it is far from being a perfect instrument; on the other hand, it's the best we have, and so we might as well make use of it.

Our paintings are simple because we love simplicity. But this is not a "reason". Simplicity is an unprivileged aesthetic category, but it permits us to control our works. By facing our problem not only with intuition, but systematically, as far as possible, one realises that it presents analogies with those that some new sciences are attempting to resolve. Topology, game theories, and combinatory analysis, etc. enable us to find a variety of combinations of forms that is much broader than that offered by intuition.

We are thinking about using the results of these sciences, because our works can only benefit by them. When the theory of information uses the notion of order and chaos, we are delighted because the artwork is located exactly between these two extremes. A renewed aesthetics, a science of art, will say just where that is. In the meantime, we are only trying to do what we can understand, even though we must make great sacrifices.

(Paris, 12 May 1960).

Denise René

[…] In 1955, 100,000 copies of the *Yellow Manifesto*, a pamphlet printed on yellow paper, served as an introduction to the exhibition of "Le Mouvement". The idea for this exhibition arose from a need to show what was happening in the experimental field. Vasarely was obsessed by kinetics. Starting in 1954, his first paintings in black and white confronted the problem of optic movement on a surface. It was only a step away from this to real movement. Vasarely, who loves theory, had written a manifesto-essay to serve as an introduction to the exhibition. We asked for another essay from Roger Bordier, and yet another

from Pontus Hulten who was living in Paris. It was necessary to set the date, and give the green light. Without much preparation, we assembled seven artists: Agam, who since 1954 had been showing works that required the participation of the spectator in order to be transformed; Tinguely, whose *Métamécaniques* I had presented; Soto, whom I had discovered at the Salon des Réalités Nouvelles and who had adopted Mondrian's theory; and lastly, Pol Bury, who was working on his first articulated and manipulable elements. Completing their works were Duchamp's *Machine optique*, and some works by Calder and Vasarely.

The group split after this exhibition. The younger artists refused to remain under Vasarely's banner. They would have liked to adhere to the manifesto but at first I did not know if these artists had a theory to propose. [...]

("Interview with Catherine Millet", in *Art Press International*, December 1978).

Victor Vasarely

[...] *We possess, therefore, the utensil and the technique, and lastly the science in order to attempt the plastic-kinetic adventure.* Geometry (the square, circle, triangle, etc.) and physics (the co-ordinates, spectrum, intensity of colours, etc.) constitute *constant* parameters. We consider them as quantities. Our moderation, our sensitivity, our art make quality out of them. (We are dealing here with neither Euclidean geometry nor that of Einstein, but rather with the geometry of the artist that functions wonderfully without exact knowledge.)

The animation of the "plastique" is developed these days in three distinct ways:

1) Movement in an architectural synthesis, in which a monumental spatial plastic work is conceived in such a way that its metamorphoses are carried out following the real movement of the viewer.

2) Automatic plastic objects that serve primarily as a means of animation at the moment of the projection. Lastly,

3) *The melodic intervention of the cinema domain through the abstract dimension. We are at the dawn of a new era. The era of plastic projections on flat or deep screens, during the day or when twilight begins.* [...]

(In *Le Mouvement*, exhibition catalogue, Galerie Denise René, Paris 1955).

Bibliography

W. Köhler, *Gestalt Psychology*, Liveright, New York 1929.

H. Bergson, *La pensée et le mouvant*, F. Alcan, Paris 1934.

K. Koffka, *Principles of Gestalt Psychology*, Harcourt, Brace, New York 1935.

G. Kepes, *The Language of Vision*, Theobald, Chicago 1944.

D. Katz, *Gestaltpsychologie*, Benno Schwabe & Co., Basel 1948.

R. Arnheim, *A Psychology of the Creative Eye*, Berkeley 1954.

M. Bense, *Aestetica*, Baden-Baden 1965 [1954].

Le Mouvement, exhibition catalogue, Galerie Denise René, Paris 1955.

A. Moles, *Théorie de l'information et perception esthéthique*, Flammarion, Paris 1958.

Konkrete Kunst…, exhibition catalogue, Helmhaus, Zurich 1960.

C. Belloli, "Animazione e moltiplicazione plastica", in *Opere d'arte animate e moltiplicate*, exhibition catalogue, Galleria Danese, Milan, 1960.

E. H. Gombrich, *Art and Illusion*, Phaidon, London 1960.

Nove Tendencije, exhibition catalogue, Galerija Suvremene Umjetnosti, Zagreb 1961.

B. Kluver (edited by), *Rörelse I Konsten*, exhibition catalogue, Stockholm 1961.

A. Moles, "La notion de quantité en cybernétique", in *Les Etudes Philosophiques*, no. 2, 1961.

Nova Tendencija 2, exhibition catalogue, Galerija Suvremene Umjetnosti, Zagreb 1963.

Oltre l'Informale, exhibition catalogue, IV Biennale Internazionale d'Arte, San Marino 1963.

G. C. Argan, "La ricerca gestaltica", in *Il Messaggero*, 24 August 1963.

I. Tomassoni, *Per un'ipotesi barocca*, Edizioni dell'Ateneo, Rome 1963.

Atti del XII Convegno internazionale artisti, critici e studiosi d'arte, Rimini 1964.

Documenta III, exhibition catalogue, Kassel 1964.

Nouvelle Tendance, exhibition catalogue, Musée des Arts Décoratifs, Paris 1964.

U. Apollonio, "Ricerche di ristrutturazione dinamica della percezione visiva", 1964, in *Occasioni del tempo*, Studio Forma, Turin 1979.

M. Calvesi, in *XXXII Biennale Internazionale d'Arte di Venezia*, exhibition catalogue, Venice 1964.

Nova Tendencija 3, exhibition catalogue, Zagreb 1965.

Perpetuum Mobile, exhibition catalogue, Galleria Dell'Obelisco, Rome 1965.

G. C. Argan, *Progetto e destino*, Il Saggiatore, Milan 1965.

W. C. Seitz, in *The Responsive Eye*, exhibition catalogue, Museum of Modern Art, New York 1965.

Atti del XIV Convegno internazionale artisti, critici e studiosi d'arte, Rimini 1966.

Il Verri, no. 22, Feltrinelli, Milan 1966.

Lineastruttura, no. 1, Naples 1966.

F. Menna, *Arte cinetica e visuale*, Fabbri, Milan 1967.

G. Rickey, *Constructivism: Origin and Evolution*, Studio Vista, London; Braziller, New York 1967.

E. Crispolti, *Ricerche dopo l'Informale*, Officina, Rome 1968.

F. Popper, *Origins and Development of Kinetic Art*, Studio Vista, London 1968.

C. Barrett, *Op Art*, Studio Vista, London; The Viking Press, New York 1970.

E. Mari, *La funzione della ricerca estetica*, Edizioni di Comunità, Milan 1970.

La scienza e l'arte, Mazzotta, Milan 1972.

M. Massironi, *Ricerche visuali*, lecture at the Galleria Nazionale d'Arte Moderna, Rome 1973.

E. L. Francalanci, "Note su alcuni materiali teorici dalle avanguardie storiche agli anni '60", in *Arte programmata e cinetica 1953/63 – L'ultima avanguardia*, exhibition catalogue, Mazzotta, Milan 1983.

L. Vergine, *Arte programmata e cinetica 1953/63 – L'ultima avanguardia*, exhibition catalogue, Mazzotta, Milan 1983.

R. L. Gregory, *Eye and Brain: The Psychology of Seeing*, Princeton University Press, Princeton 1990.

A. Vettese, *Milano et Mitologia*, Bellora, Milan 1990.

Visual Poetry
Painting to read and vice versa

Painting *to read* or poetry *to observe* has changed the significance of media-diffused information by its ironic reuse of popular imagery and slogans. A critical retaliation is underway against the obsessive panorama of advertising signs, symbols and figures. "Return goods to sender", wrote Pignotti.

In 1963, in Italy, a great deal of attention was paid to the Technological Poetry of the Florentine group that included Lamberto Pignotti, Eugenio Miccini, Lucia Marcucci, Ketty La Rocca, Luciano Ori, Malquori, and the Neapolitan one of Stelio Maria Martini (and later, Luciano Caruso, Giovanni Rubino, Felice Piemontese, Carlo Nazzaro). Almost simultaneously to it were the "collagist" and graphic experiments in Rome of Nanni Balestrini, Alfredo Giuliani, Renato Pedio and Antonio Porta, as well as the indications of Emilio Villa and Mario Diacono, the inventors of the magazine *Ex*.

Episodes like those signed by Patrizia Vicinelli and Roberto Sanesi, in Bologna and Milan, are also worth recalling.

The contributions of others were instrumental in arriving at a proper definition for Visual Poetry: Ugo Carrega, Adriano Spatola, Martino and Anna Oberto

(founders of the review *Ana*, etc.), Vincenzo Accame, Emilio Isgrò, Luciano Caruso; and also Mirella Bentivoglio, Franco Vaccari, Rolando Mignani, Rodolfo Vitone, Liliana Landi, Vincenzo Ferrari, Corrado D'Ottavi, Giulia Niccolai, Maurizio Nannucci, Magdalo Mussio, William Xerra, Michele Perfetti, Sarenco (the organiser, together with the Belgian Paul de Vree, of the Amodulo editions and the review *Lotta Poetica*).

Letters of the alphabet, ideograms, italics, arabesques, images, hieroglyphics, combined in such a way as to shake up the usual way of using language and reading, are the "materials" of Visual Poetry. Signs signify themselves yet refer to something other than themselves, thus allowing for a variety of interpretations. At times, there is an antithesis of the sign and the figure in order to express an idea more arrogantly and increase the impact of its message. This is where these proposals differ from those made by the turn of the century avant-garde movements: these constitute a distinctive language, not some typographical artifice. Writings of a provocative nature are placed alongside the images; they act as a stimulus in view of the associative process that

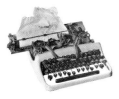

Giulia Niccolai, Poem and Object, 1973

Emilio Villa, Collage, 1961

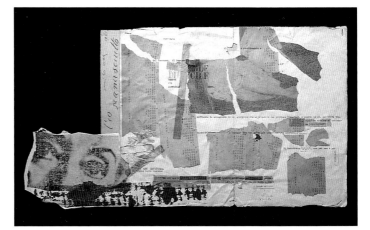

occurs in the observer. In this way, the viewer realises that the significance attributed to that written or printed word or to that image that is usually seen in a totally different context is, in the end, only the result of a conditioned association established by the mass media. Other times, instead, it is a question of how the sign material is organised: for example, in the works of Franz Mon, Yasuo Fujitomi, Adriano Spatola, Václav Havel, Ladislav Novák, Jirí Kolár, and Furnival, both the writing and the printed characters maintain their format and are proposed as objects. In still others – Tom Ulrichs is one to remember – the typographic-ideogrammatic component generates a kind of page-painting that contains linguistic references. This is very close to the poetics of the concrete poets. But before discussing Concrete Poetry and the way it differs from orthodox Visual Poetry, if it can be so described, the name of Ugo Carrega must be mentioned. Carrega founded the Centro Tool in Milan which since January 1971 has systematically provided information internationally about the visual poets and their work. Carrega (who edited for the Edizioni Tool six *Notebooks of symbiotic writing* between '65 and '67) maintains that it is not a matter of giving the words a mimetic conformation, but using the spatial forms as signifiers. In other words, everything that is put on the page must respond to a need for a relationship between the signs.

Jirí Kolár, Homage to Brancusi, 1962

The roots of Concrete Poetry lay in the Lettrism of Isidore Isou. According to Isou, the founder of the Lettrist movement in 1946, the letters of the alphabet had a value in themselves, separate from the word. However, it was with Decio Pignatari, the brothers Augusto and Haroldo De Campos, Carlo Belloli, José Grünewald, Jirí Kolár, and Eugen Gomringer that poetic research became identified with the visual possibility of the word-sign.

109

During the Sixties, Ilse and Pierre Garnier spoke about a new phonetic poetry; related to this minor heresy were also Henri Chopin, François Dufrêne and Diter Rot. In Italy, Arrigo Lora Totino was its principal exponent. Together with Max Bense, Heine Gappmayr, Ferdinand Kriwet and Diter Rot, they produced a para-ideogrammatic form that made prevalent use of geometric-symmetric modalities.

A simple typewritten line provokes reflection about the aesthetic qualities of the letters, regardless of their intrinsic meaning. The typescript is almost fetishistically imposed.

It can thus be concluded that the operations have been carried out in different fashions: one in which the verbal element has a visual, cognitive value; another that adopts a typographic element in order to compose forms; still another that uses the signs of the alphabet; and lastly, one for which the letter of the alphabet has a linguistic intentionality and breaks the dimension of painting.

Stelio Maria Martini, from the visual romance, Neurosentimental, 1963–64

Ugo Carrega, Little Liguria, 1965

All these phenomena have their roots in late nineteenth-century culture, when a certain pleasure was taken in digging up of the works of Bernowinus, Scotus, Maurus, Da Fiore and other Medieval authors, as Luciano Caruso did. The antecedents – excluding the *carmina figurata* of the Alexandrines – were Apollinaire, Mallarmé, Kassak, Breton, Tzara, Picabia, van Doesburg, Balla, Morgenstern, etc.

During the Sixties and Seventies, at which time Visual Poetry had become a kind of testimonial, many painters made their contributions in the way of *writing*. Among these were Gastone Novelli, Gianfranco Baruchello, Irma Blank, Betty Danon, Mimmo Rotella, Bruno Di Bello, Luca Patella, and Claudio Parmiggiani.

Among those who made episodic appearances in Visual Poetry circles were the musicians Paolo Castaldi, Sylvano Bussotti, Franco Battiato, Walter Marchetti, and Juan Hidalgo, and Fluxers like Giuseppe Chiari and Ben Vautier.

Roberto Sanesi,
Page 6, 1964

Isidore Isou,
The Journals of
the Gods, 1950

Visual Poetry

Vincenzo Accame

Just how did poetry manage to find itself in a world of "signs" and no longer simply in the restricted hierarchy of words, sounds, and meanings? The historical process passes through linguistic subversion, the annulment of "common sense", the elimination of the hierarchies of meanings, and the imposition, or more simply the proposal, of freedom, plurality, and possibility as "logical" cases, or better yet, ones that are equally logical to the traditional ones: real, natural, "human" cases, and infinitely advantageous, moreover, with respect to expression. Poetry has gradually become aware of its own configuration as a world of signs by looking around. Painting as such offered it nothing, music as such offered it nothing, nor did science as such offer it anything, but all together, arts and sciences, helped poetry to understand itself, and therefore to become.

To discover the (mental) mechanisms that lead a poet to combine one word with another one, or a painter to place one mark next to another, means to imagine a new reality. When the painter's mark and the musician's sound are not yet mark or sound, they have a particular resemblance to the poet's word. At that point, at that moment, anything is possible: before the "signal" is discerned, before it is differentiated into the graphic mark, sound, word, gesture, etc. An intervention at this point, at this very instant, in this first moment of creation has an immediate influence on language.

("Lo spazio della poesia", in *Scrittura visuale in Italia*, exhibition catalogue, Galleria Civica d'Arte Moderna, Turin 1973).

Max Bense

This is poetry that does not produce the semantic sense or the aesthetic sense of its elements, for example words, in the usual formation of linearly and grammatically ordered contexts, but plays on visual and surface connections. It is not the juxtaposition of the words in the mind but the way they are interlaced when perceived that is the constructive principle at the basis of this kind of poetry. The word is not only used to convey meanings but also as a material element of figuration, so that meaning and figuration are conditioned and expressed reciprocally. The semantic and aesthetic

113

functions of the words are simultaneous for they are based on the contemporary utilisation of all the material dimensions of the linguistic elements, which may also be divided into syllables, sounds, morphemes or letters in order to express the aesthetic conditions of the language, given its dependency on their analytic and synthetic possibilities. It is only in this sense that the principle of concrete poetry can coincide with the material richness of language.[…]

(In *Rot*, edited by M. Bense and E. Walther, printed by H. Mayer, Stuttgart 1965, no. 21).

Ugo Carrega

1. everything is language
2. I therefore do not see why poetry must continue to make use only of words
3. my senses reject a theory that is not operative
4. I write what I think in the moment in which I write and think
5. we need an art like the science of art
6. what I write must be presented like I write it
7. a stone is a word
8. a sign on a page is a graphic stone
9. I cannot write anything about what I do since I do it
10. language is everything

(*10 propositions for material poetry*, contribution at the Biennial of Poetry of Knokke le Zoute, 1968).

Augusto De Campos, Decio Pignatari, Haroldo De Campos

[…] Concrete poetry communicates its own structure: structure-content. Concrete poetry is an object in and for itself, not the interpreter of external objects and more or less subjective sentiments. Its material: the word (sound, visual form, semantic charge). Its problem: a problem of the functions-relations of this material. Factors of proximity and similarity, and Gestalt psychology. Rhythm: the force of relationship. Concrete poetry, by using the phonetic (digital) system and analogical syntax creates a specific linguistic area – "verbivocovisual" – which takes advantage of non-verbal communication without renouncing the virtuality of the word.

The phenomenon of meta-communication exists with concrete poetry: the coincidence and simultaneity of verbal and non-verbal communication; keeping in mind that it deals with the communication of forms, of a structure-content, and not of the usual communication of messages.

Concrete poetry aims at the lowest common multiple of the language. Thus its tendency to use nouns and verbs: "the concrete means of language" (Sapir) […]

("Pilot Plan for Concrete Poetry", 1953–58, in *Noigandres*, São Paulo 1958, no. 4).

Eugen Gomringer

[…] The aim of the new poetry is to give back to poetry an organic role in society, and in so doing re-establish the poet's position in society. Only by bearing in mind therefore the simplification both of the language and its written form, is it possible to speak about an organic role of poetry in terms of a given linguistic situation.

[…] The constellation is the simplest

possible poetic configuration, and the word is its basic unit; it includes a group of words as if they were stars that are gathered to form a cluster.

The constellation is an order and at the same time a playing field with established dimensions.

The constellation is ordered by the poet. He determines the playing area, the field of strength, and suggests its possibilities. The reader, the new reader, grasps the idea of the game and uses it.

In the constellation something is brought inside the world. It is a reality in itself and not a poem about some thing or another. The constellation is an invitation.

("From Line to Constellation", in *Augenblick*, Agis Verlag, Baden-Baden 1954, no. 2).

Emilio Isgrò

[…] The poet is known to be an explorer of words, but what is to be done when the word no longer is presented in its pure state, and tends to combine more and more with the image? Words and images are together in advertising and newspapers, at the cinema and on television. Yet the poet can still not give up his exploration.

The visual poet does not idolise the contents nor does he reject them: on the contrary, he is continually stimulated by them; however, at the creative moment, the only laws of any worth for him are those of composition. The visual poet is like someone who is about to resolve a crossword puzzle. He answers the specific questions, his only concern being to observe the number of prescribed letters; but his answers, in the end, will be legible horizontally and vertically like

autonomous linguistic structures with respect to the basic questions. Nonetheless, it cannot be denied that those structures will always refer to something else, to the initial stimulus.

This time, the market analysis (another exercise that the modern operator must fulfil) has not been totally unfavourable to the poet; perhaps it has been the introduction of new signs in what was once the sacred precinct of the word that has multiplied the meanings and recharged what seemed to be definitively exhausted. In fact, it so happens that all these signs refer the viewer, even with violence, to just as many objects. However, it is not up to the poet to say how this is possible: he turns the question over to linguistic science for verification. Now there can only be one conclusion, and what is more it is relative: poetry as the exclusive art of the word is no longer possible. The new poetry intends to be the general art of the sign.

(*Statement no. 1*, contribution at the Congressi internazionali di poesia di Abbazia di Gorizia, May 1966).

Eugenio Miccini and Michele Perfetti

Visual Poetry transforms mass media into mass culture.

Visual Poetry, therefore, persistently stresses the problems related to the theories of communication and information.

As we have mentioned, it took its start from the "spurious" matrices and models of communication, that is, from the codes – in the area of the channels – used in interlanguage. It has introduced by the use of dilatations, deviations, regressions, overlaps, interruptions, etc.,

115

an awareness, a structuralist (and therefore critical) re-thinking, a deviation of senses, an ironic inversion of meaning, and lastly, surprise and unpredictability which have raised its quotient of information. The "deplacement" of what has been found, let us say of the entire linguistic and iconographic archaeology of mass communications, does not annul the relation to its own references, but it does make them ambiguous so that significances (significances-truth) emerge alongside a linguistic-formal regeneration.

[…] Visual Poetry is therefore guerrilla warfare, and as such makes use not only of the word or the image, but also of light and gesture, in short, of all the "visible" instruments of communication. It must therefore transform its own means (in the event these may be hypothesized and realised through a clandestine circuit) into those of mass communications and master them (as Burroughs wished) in order to transform society itself "with" them.

It is true that at times heroes are pathetic. But we do not think there is anything pathetic in this "maniacal" historical dimension that the entire avant-garde culture is living through. Visual Poetry acts in the heart of a system that exorcises everything and renders it, at the most, contradictory and precarious. But there is a force in it that comes from its utopia, from its ideological prevision of a new anthropological dimension, from an attempt therefore to bring together and re-unite – by acting on man's consciousness – aesthetics and life.

(Communication given at the 5th BITEF int. in Belgrade on the subject *New as-*

pects of the international Visual Poetry, 1971).

Abraham A. Moles

[…] There may be a theory of poetic communication which constitutes a particular field of application for the "Theory of Information". Such a communication is presented for an analysis of the global message at each level of our perception according to the semantics and aesthetics of the linguistic and sound messages. Two dialectics are established between these distinct parts, in a permanent struggle inside the two dimensions of the messages whose "measure" is *complexity* or *information*. Poetic pleasure arises from a more or less sharp perception of the structures on different planes; the pleasure of form is accompanied on each of these planes by a more or less subtle adjustment between the message that is given and the receiver's capacity for acceptance. In this way, fundamental organic structures emerge which underlie every poetic message. These structures may be grasped separately, for written poetry is based on a symbolic form and on certain capacities of evocative association in a kind of game with the "constellations of attributes". This poetry may also be perceived as a rhythmic sonorous message, more or less independent from its meaning, as when we listen to a poem or a chorus in a language we do not know so that intelligibility is consciously relegated to second place inasmuch as sonorous sensuality is deliberately given precedence.

[…] In its current state, the only thing that the "poetics" can aspire to is to suggest problems, pose questions, and re-

new a vision blurred by habit, routine and commonplaces. However, it may be possibile to establish in poetry and literature, following the example of the other major arts such as music that have preceded them in this direction, an *experimental poetry* that systematically moves towards the realisation of new ideas. The character of art has changed profoundly with the advent of the means of mass communication; by now a poem, a slogan, an image, or a leitmotiv belong through the magic of the press, radio and cinema to millions of people, shaping their thoughts, passions and the colour of their times. And it is useful that a "poetics" offer us a means as powerful as scientific thought to renew our imaginations in a modern world that is based on the axiom: "We have invented the means to invent."

("Analisi delle scritture del linguaggio poetico", 1960, in *Il Verri*, no. 14, Feltrinelli, Milan 1964).

Renato Pedio

Of course, everyone had his own ideas: as for me, thanks to the great mother art of architecture and also to semiotics, I went back to perception. It was man not nature who came up with codes, most likely for simplification: vision, music, words, etc. But things *are never* like that: they arrive together by very different channels. The brain then reunites them into a lump of its own that is called "limbo" curiously enough. Once that is done, the mind can imagine and it does. Dante, for example, invented sculpture, motionless sections *on the* blocked time of absolutes, and yet recited *in the* fluid time of dialogues. In the other world

though, "this visible speaking / …is not found"; hence he was forced to base himself only on the linguistic code + (not with) its handmaidens, sound and vision, the metre and graphics. But the aim of ideographical writings was to combine vision and word *semantically* in order to multiply the sense of the multidimensional signs. The Chinese succeeded admirably. Cf. Scheiwiller's old, small Confucius-Pound. It is not "beautiful calligraphy", but fused polysemies, and the mind can take off in flight. This has not been surpassed, certainly not by us. However, Schwitters knew what he was writing about with "ANNA you are beautiful in front and behind", because he meant "the graphic image of the name ANNA is equally beautiful from the right and from the left", making use of the ancient mode of boustrophedonic writing. And Apollinaire knew.

And so, in my opinion, there is nothing new in Visual Poetry, nothing that isn't thousands of years old. What is new is that one continues to try, and that the instruments have increased enormously, although the expanded, combined meaning is defective. However, this is a given, and in this way there are always overlaps but never fusion. And… but I have already said too much.

(Letter to L. V., 7 September 1994).

Lamberto Pignotti

[…] Visual Poetry is a form of expression that experiments with the various levels of the relationship between words and figural images, pursuing a finality and combining results in a single context. At least from a theoretical point of view, it represents an extension of the

117

possibilities of poetry, which institutionally depends only on verbal material and its combinatorial, significative and communicative properties (that is, syntactic, semantic, and pragmatic), since it also brings up problems that until today the visual arts, especially painting, have always confronted. *However, Visual Poetry is neither painting with words, nor poetry with figures.* In other terms (when Visual Poetry has really succeeded) the words must never comment visual images that are self-sufficient, nor must the latter illustrate a text that in itself is complete. In order for Visual Poetry to be what it is, an effective relationship, true interaction, must exist between words and visual images in a single context (which usually assumes the aspect of a collage, or more rarely, relies on painted or drawn elements), and not simply their cohabitation. The verbal and visual components should not be suggested nor used separately, unless there is a misunderstanding, or a wish to misunderstand the meaning of such an experience. […]

(*La poesia visiva. Istruzioni per l'uso degli ultimi modelli di poesia*, Lerici, Rome 1968).

Adriano Spatola

[…] The numerous forms in which experimental poetry has been appearing are nothing but various aspects of the same problem. According to an "inventory" drawn up by Anna and Martino Oberto, experimental poetry may be: visual, concrete, aleatory, evident, phonetic, graphic, elemental, electronic, automatic, gestural, kinetic, symbiotic, ideographic, multidimensional, spatial, artificial, permutational, found, simultaneous, casual, statistic, programmed, cybernetic, semiotic, and the list goes on. In any case, many of these definitions refer to isolated attempts or to the work of groups which have been of short duration. Furthermore, it is typical of experimental poets to "transmigrate" from one group to another, and from one research to a contrasting or complementary one.

[…] The new experimental poetry can no longer be interpreted exclusively as an effort to modify the customary instruments for making poetry, or as a need to overcome national linguistic barriers in order to create an explicitly international poetry. Today it is trying to become a total medium, to avoid all limitations, to absorb theatre, photography, music, painting, typographical art, film techniques, and all other aspects of culture, in the utopian aspiration of returning to its origins. This aspiration will eventually be fulfilled by means of a series of metamorphoses in the "genre" of poetry that has not yet been exhausted.

[…] The task of the new poetry seems to be therefore that of rendering sociologically active a linguistic reality that risks remaining "private" and without any contact with the world. The triumph of the means of mass communication may coincide with the increased impotence of the arts, but it may also be the acid test of their capacity for renewal. […]

("Poesia sperimentale ed esperimenti di poesia", in *Verso la poesia totale*, Paravia, Turin 1978).

Bibliography

I. Isou, *Introduction à une nouvelle poésie et à une nouvelle musique*, Gallimard, Paris 1947.

H. Heissenbuttel, "Per una storia della poesia visiva", in *Il Verri*, no. 16, Feltrinelli, Milan 1964.

Modulo, Edizioni Masnata Trentalance, Genoa 1966.

Segni dello spazio, exhibition catalogue, Edizioni Azienda Autonoma di Soggiorno, Trieste 1967.

L. Caruso, C. Piancastelli, *Il gesto poetico. Antologia della nuova poesia d'avanguardia*, Portolano, Naples 1968.

P. Garnier, *Spatialisme et poésie concrète*, Gallimard, Paris 1968.

L. Pignotti, *La poesia visiva. Istruzioni per l'uso degli ultimi modelli di poesia*, Lerici, Rome 1968.

V. Horvat Pintarič, in *Bit International*, no. 5–6, Galerije Grada Zagreba, Zagreb 1969.

A. Spatola, *Verso la poesia totale*, Paravia, Turin 1978 (1st edition, Rumma, Salerno 1969).

D. Palazzoli (edited by), "I denti del Drago", in *L'uomo e l'arte*, exhibition catalogue, Milan 1972.

Scrittura visuale in Italia, edited by L. Ballerini, exhibition catalogue, Galleria Civica d'Arte Moderna, Turin 1973.

Poesia sonora, edited by L. Caruso and L. Marcheschi, Schettini, Naples 1975.

L. Ballerini, *La piramide capovolta*, Marsilio, Venice 1975.

V. Accame, *Il segno poetico*, Edizioni d'Arte Zarathustra, Milan 1981 (1st edition Munt Press, Samedan 1977).

M. D'Ambrosio, *Bibliografia della poesia italiana d'avanguardia*, Bulzoni, Rome 1977.

H. Chopin, *Poésie sonore internationale*, Paris 1979.

Il colpo di glottide, catalogue, Vallecchi, Florence 1980.

Poesia Visiva 1963/1988, 5 Maestri, exhibition catalogue, Verona-Florence-Naples, Edizioni cooperativa La Favorita, Verona 1988.

Archivio della Grazia di Nuova Scrittura, Milan 1989.

V. Accame, *Quale Segno, arte scrittura comunicazione*, Archivio di Nuova Scrittura, Milan 1993.

Minimal Art or Primary Structures

A taste for gigantic geometry

Primary Structures appeared in North America (from California to Canada) as a direct descendant and at the same time a negation of Pop Art and Op Art; it was also known as Minimal or Cool Art, Anti-form, ABC Art, Topological Art, and Shaped Canvas.

This new tendency was presented in the exhibition *Primary Structures*, held in the spring of 1966, at the Jewish Museum of New York. It borrowed Pop's gigantic, overblown dimensions and Op's predilection for geometry, but while Op led to an analysis of signs, Primary Structures aimed more at the organisation of large, sleek, formal shapes.

These were sculptures that were elementary in form and colours, abstract solids that were so large they disturbed and invaded the surrounding space. They were not intended as models, but finished works that created a synthesis between architecture (the environmental scale, foreshortening), painting (broad application of pure colours, large monochromatic zones of magnetic attraction), and the environment (the viewer could not ignore them, but was forced to walk round, cross over or move away from them).

Their surfaces were tranquil, but not amicable: disquiet passion was chastised in their mysteriousness, and all vivacity was dismissed in the tranquil, austere distance they

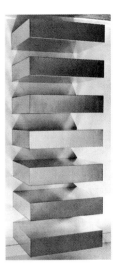

Donald Judd, Untitled, 1965

established that kept the frenzy of life (and contemporary art) at bay.

Space, geometry, order. Space as the placement of one element among others, as occupation and absence at the same time, as circumscription and measure, and as enclosure and dilation together, as the order of co-existences. Geometry as the metric relationship of multiform and variable wholes, as the triumph of the solid typography, as a continual quantity. Order as the rule that explains the relationship between the objects, masses and lines, as the reciprocal disposition of the parts of a whole, as an equilibrium but not a hierarchy, as the natural law of proportion and symmetry.

Barry Flanagan, Rack 2, 1967-68

Robert Morris, House of Vetti, 1966

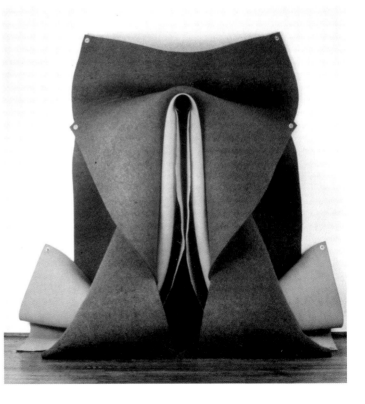

The Americans Tony Smith, Bob Morris, Dan Flavin, Donald Judd, Carl Andre, Robert Grosvenor, Walter De Maria, Sol LeWitt, Larry Bell, Tony De Lap, John Mc-Cracken, and the British, Anthony Caro, William Tucker, Philip King and Richard Smith were the first representatives of this new idiom (De Maria, Morris, Andre and Le-Witt shortly thereafter went off in other directions, like Land or Conceptual Art, together with Barry Flanagan and Richard Serra).

King and Andre present a linguistic universe that is closed, compact, seraphic, and intimidating in its cold concision. A dry, impassioned skill is evident in the emotional rigidity of the works of Judd and Flavin: they appear im-

Robert Grosvenor, Tapanga, 1965

Philip King, Through, 1965

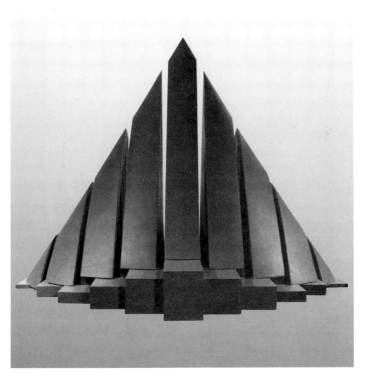

123

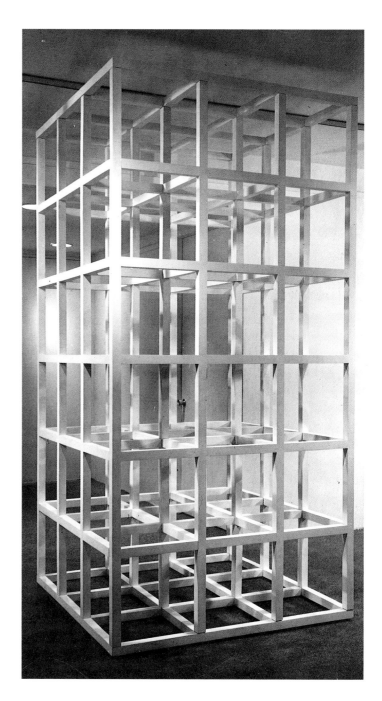

Sol LeWitt, Modular Piece, 1966

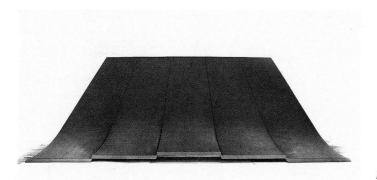

Richard Smith, Plum Meridian, 1968

practicable and ungovernable (to the user) as they entice the public with a "classicality" that is difficult to make use of at times.

One detects a latent anguish in the works of Flanagan and Serra, a nostalgia (or a harbinger?) for the old aesthetic rules (harmony, balance, juxtaposition, the golden proportions, etc.) that is held in check by the exacting perfection of the forms and materials.

The American painters Frank Stella, Robert Ryman, Richard Tuttle, Brice Marden, and Robert Mangold were the precursors of all of this in many ways. And even before them, Agnes Martin and Ad Reinhardt with the purism of their monochrome surfaces, as well as Clyfford Still and Barnett Newman. Last but not least (chronologically speaking) was the German Maria Nordmann, that singular artist who made use of the refractivity of natural light.

In Italy, Rodolfo Aricò also worked in the same direction, while many works of Maurizio Mochetti, Gianfranco Pardi, Renato Barisani, Nicola Carrino have also been interpreted in this same key.

Minimal Art or Primary Structures

Lawrence Alloway

[…] Definitions of art as an object, in relation to geometric art, have too often been consolidated within the web of formal relations. The internal structure purified of all references has become the essence of art. Its quality as an object has been emphasised in paintings by way of shaped canvases, but without a corresponding recourse to idealism. When the traditional rectangle is dented on the inside or pressed on the outside, the viewer obviously acquires a greater awareness of the environment. The wall may seem in the centre of the painting or may intersect the painted surface. Notwithstanding the environmental space of the shaped canvases, however, it also has great internal solidity, usually accentuated by thick stretchers (Stella, Williams). The volume of the painting is physical and uncomfortable, not a pure essence of art. On the contrary, its marked borders are extremely ambiguous: the equilibrium between external space and internal space is held in suspension so that connections are created between painting (colour), sculpture (real volume and form) and *métier* (the basic carpentry). The shaped canvases tend to associate these possibilities.

[…] The change is not a movement from a limited world towards one full of possibilities. Simplicity in art is as fundamental as elaboration. It is more likely that the new work has been pushed aggressively as a renewal of the problems, since the change in style has occurred at a time when an aesthetics for cold, Minimal art or ABC (therefore the previous work was important) was an open chapter. The new paintings are a kind of image on two levels, with a fixed stretcher providing one kind of definition and the painted forms, suggested by the stretcher but not bound to it, constituting another one. The colour is rendered uniformly by the painted stripes or the canvas edge, which produces the effect of mixing the spatial levels of the painting. […]

(Translated from Italian, "Systemic Painting", in *Systemic Painting*, Solomon R. Guggenheim Museum, New York 1966).

Carl Andre

ESSAY ON SCULPTURE 1964

arc

arch	plane
aisle	hull
bridge	car
bench	lens
ball	plank
bin	square
beam	range
booth	line
flange	peg
cairn	mast
bell	ridge
cam	stance
cone	scale
chair	pole
groove	pit
chord	pyre
crux	spike
cog	strake
dike	spine
crypt	rack
ground	rib
depth	rail
disk	spire
cup	throat
dome	spool
ditch	roof
height	rim
field	room
door	stair
hub	throne
edge	stake
floor	sill
length	rod
frame	slab
gate	stile
keg	trench
grid	stool
joint	slot
source	sun
mound	tomb
hill	truss
log	trough
hole	waist
notch	wall
sphere	urn

(B. Rose, "ABC Art", 1965; in *Art in America*, New York, October-November 1965).

Maurizio Calvesi

[...] After the revolution of Programmed Art, the perceptive bombardment of Op Art, and above all the great events of Pop Art, a stasis would have been more than logical. As a rule, strong impulses are followed by moments of perplexity or absorption. But polemics cannot wait. The different, contrasting factions of what is new, the apologists, belittlers, and detractors, desire confirmation urgently.

Everyone, in short, has noticed that something big is at stake: not just the future of art, which has been revolutionised at its foundations, but also the artistic future of Europe, in particular, Paris. The Biennale des Jeunes has given the word to the young, but first and foremost it has given it to Paris. Paris is betting on the miracle of its renewed youth, but miracles are rare. What concerns America, on the other hand, which trusts in its new artistic leadership and indeed the signs are many, is that these promising youths may only mature but not blossom.

Pop Art opened the horizons, pointing out an almost infinite number of new resources in the exchange of techniques with the mass media, causing art to expand like an oil stain, flooding towards life, and making blood alliances with Happenings, cinema and spectacle. The "environment" (which comes from "to environ" or surround) is in fact an artwork that invades an entire area to the point of becoming a spectacle. But one is under the impression that the centre has been lost. There is a risk that the artistic experience no longer has a backbone. With a severity that was unex-

pected by many, the American artists tried to palpate the backbone of this monstrous expanding organism, and came up with the so-called "primary structures": a very original and naturally mastodonic backbone worthy of a bizarre body, but a backbone, an essential, anatomical-didactic, inner structure, a mainstay.

Even the Primary Structures have taken note of the "thing" operation in Pop Art and its consequences. However, they do not invade the space externally and totally like the environments; they are inserted rather than absorbed into the area. While space is an agglomerate of places, that is, only a topographical entity, the Primary Structures intend to designate these places in some way, to establish points and connections. They probe the framework of that purely negative Pop spatiality with designations that are positive, physically corporeal and visually essential, since even the topographic space of Pop must necessarily have a structure of its own which must be investigated, and it will be a structure that coincides with the perceptive action of whoever moves in this space and confronts its depths.

Sculptures have always allowed for points of view. The primary structures give the viewer free rein, leaving a wide margin for his capacity for suggestion; they are something more or less than sculpture, they are architecture and even urbanism potentially.

[…] Visually the Primary Structures descend from Pop Art in the very fetishism of their dimensions, although they are abstract forms. The monumental toothpastes of Oldenburg are recognisable behind the reclining parallelepiped with a sloping profile, while behind the cubes and rectangular blocks are the repeated boxes of Warhol (the inventor of the serial image), and the rigid volumes of Lichtenstein (the painter of comics). Undoubtedly they constitute a reduction of Pop language, and open in the direction of architecture and urbanism, although it may seem to the contrary. In fact, they tend to close the conversation in painting as in sculpture, they obstruct, they paralyse formalising, they disappoint the more anxious fantasies a little. Above all, in America as in Europe, they have given the go ahead to the facile academicism of abstraction. […]

("Obelischi da camera", in *L'Espresso*, Rome, October 1967).

Clement Greenberg

[…] Minimal Art still remains too successful as an idea and not enough as something else. Its idea remains an idea, as inferred but not felt and discovered. The geometric modular simplicity may announce and mean something more far-out in art, but the fact that its reasons are understood for what they are betrays them artistically. In Minimal Art there is little aesthetic surprise, while there is a phenomenon of surprise that functions just once as in the new art. Real aesthetic surprise lasts forever – it is still in Raphael as it is in Pollock – and ideas alone cannot create it. Aesthetic surprise derives from inspiration as well as from artistic updating. Apart from the expected and self-annulling proclamations of the maximum far-out, almost all the Minimal Art works that I have seen

129

reveal a more or less conventional sensibility at work. The substance and the artistic reality, unlike the programme, on the other hand, always reach a sure sense of taste. I find myself here in the realm of good design, where Pop, Op, Assemblage and the rest of the New Art live. The Primary Structures are transformed into stylistic effects by the way they are used. What confuses me is how mere size can produce a soft, captivating, yet at the same time, superfluous effect. At this point, the question of the phenomenal as the opposite of the aesthetic and artistic comes into the picture. In any case, I accept Minimal Art at a more serious level than that obtained by the other new forms. [...]
(Translated from Italian, in *Che fare*, no. 2, 1970-71).

Sol LeWitt

[...] There are forms of art around called Primary Structures, reductive, hermetic, cold, and mini-art. And yet no artist that I know claims them as his own.

[...] When three-dimensional art begins to assume the characteristics of architecture, like the formation of useful zones, it weakens its own role as art. When the viewer is made smaller by the huge dimensions of a piece, this dominion emphasises the emotional and physical power of the form at the cost of the loss of the idea of the piece.

The new materials are one of the great calamities of contemporary art. Certain artists confuse the new materials with the new ideas. There is nothing worse than seeing art wallowing in the middle of nonsense. Most of the artists who are attracted by these materials lack the rigour of reasoning that would permit them to use these materials positively. You need a good artist to use new materials and transform them into a work of art. The danger, I believe, is in making the physical aspect of the materials so important as to become the idea of the work (another kind of Expressionism).

I gather that this is part of a secret language that the art critics use in order to communicate with one another through the art journals. Mini-art is the best because it brings to mind mini-skirts and long-legged girls. It must refer to very small works of art which is an excellent idea. Maybe the mini-art exhibitions could be sent around the country in match boxes. Or maybe the mini-artist is a very small person, let's say under five feet. If this is so, many good works will be found in the primary schools (primary school, primary structure). [...]
(Translated from Italian, "Paragraphs on Conceptual Art", in *Artforum*, June 1967).

Kynaston McShine

[...] Many of the sculptors of the Sixties have been the most critical and radical among artists, in relation to work of the recent past. Their activity has become purposely more philosophical and conceptual in content. They are anxious to find out what sculpture is and to discover how to make it. Most of the sculptors are university-trained, have read philosophy, are quite familiar with other disciplines, have a keen sense of history, express themselves articulately, and are often involved in dialectic. The work is ex-

tremely sophisticated and intellectual, of difficult and problematical content if not form, and sometimes polemical with its implied criticism of past modes.

The generally large scale of the work and its architectural proportions allow the sculpture to dominate the environment. At times the sculpture intrudes aggressively on the spectator's space, or the spectator is drawn into sculptural space. Often the structure acts ambiguously, creating a spatial dislocation for the spectator with complex meanings.

Since most of these sculptures have been made for the indoors, their immense size and assault on intimate scale carry an implicit social criticism. Collectors and even museums generally do not have the physical space these works demand.

[…] The work is often architectonic, if not architectural. Most of the sculptures do not use base or pedestal, some are oriented to the walls, and some even to the ceiling. The artist feels free to utilize and activate the space of a room or the outdoors according to the necessities of the work.

Generally, bright, vibrant color is in evidence, and when color is not applied, the intrinsic color of the sculptural material asserts itself. The sculpture rejects patina and embellishment; color acts like a skin on a surface which is always smooth and never worked by hand or textured. The surface takes on the role of extending the interweavings of the shape and clarifying the image; color and shape often lose their distinctions in new unity of tangible form and illusion. Most of these works contain irony, paradox, mystery, ambiguity, even wit, as

well as formal beauty, qualities which have always been considered positive values in art. Recent characterizations such as "minimal" or "cool", are inadequate; they are not descriptive of the experience and only partially of the means. Simplicity in the structure allows for maximum concentration and intensity, and does not necessarily imply vacuity; it usually, in fact, connotes a rich complexity of formal relationship and of experience.

Central to many of the principles upon which many of these artists […] work are the structures of Buckminster Fuller. Fuller's theories […] have been insights into the dynamic structure of nature, and into the interrelationship of physics, mathematics and philosophy. […]
(*Primary Structures*, exhibition catalogue, The Jewish Museum, New York 1966).

Robert Morris

[…] In the art object the process is not visible. The materials often are, and when they are, their reasonableness is usually evident. Rigid industrial materials pair up with right angles with great facility. But it is the evaluation a priori of a good construction that determines the materials. The well-constructed form of objects precedes any consideration of means. The materials themselves have been limited to those that efficiently achieve the general form of the object. Recently, materials different from the rigid industrial ones have started to appear. Oldenburg was one of the first to make use of these. Direct research is underway on the properties of these materials, which implies a revision of the use

of instruments in relation to the materials. In many cases, these researches have shifted from the making of the objects to the making of the material itself. Sometimes, the direct manipulation of a given material is experimented without using any instrument. In these cases, the considerations about the force of gravity become as important as those about space. The localization on material and gravity is explained by forms that have not been planned ahead. Considerations about order have to be accidental, imprecise and lacking in emphasis. Disorderly heaps, random stacks and suspensions create accidental forms for the material. Chance is accepted and indeterminacy is implied from the moment the replacement results in another configuration. The breaking away from preconceived, permanent forms and orders for things is a positive vindication. It is part of art's refusal to pursue the aesthetic form by entering in relationship with it as a prescribed conclusion.

(Translated from Italian, "Antiform", in *Artforum*, New York, April 1968).

Barbara Rose

In sculpture, the repetition of standard units may derive in part from practical considerations. But in the case of Judd, Morris, Andre and Flavin such repetition seems to have more to do with the introduction of a measured, rhythmic beat to the work. Judd's most recent sculptures, for example, are mural reliefs formed by transverse metal bars on which are suspended, at equal intervals, identical bars or components of bars.

[…] If on seeing some of the new paintings, sculptures, dances or films, you are bored, that was probably the intention. To bore the public is a way of putting its engagement to the test. The new artists seem to be extremely prudent. Approval, they know, is easy to obtain in this market of culture retailers, but engagement is almost impossible to obtain. In this way, they make their art as difficult, remote, distant and indigestible as possible; a way to obtain this is to make art boring. Some artists, often the most talented ones, end up by finding art boring. (Translated from Italian, "ABC Art", in *Art in America*, New York, October-November 1965).

Marisa Volpi

The Primary Structures have already made a first division obligatory: the Americans, prevalently employed with serial or modular repetition, the grandiose scale and the specificity of the materials, were very different from the English, who were more interested in bringing the allusive elements of a plastic-architectonic fantasy to light (King and Tucker, for example), or in penetrating and modulating space lyrically or formally (Caro).

[…] The iconographic aspect of the Primary Structures and Minimal Art is at first fairly common: solid trapezoidal cubes, irregular tetrahedrons and octahedrons, an entire gamut of prevalently angular solid geometry of invasive proportions has occupied museum and gallery space to contrast with the Op imagery or that of post-Informel abstraction, vaguely reminiscent of pre-war abstraction, which originally absorbed the attention of the American critics and public.

[...] The fear of losing the impact of that typically American experience characterised by Pollock and the other artists of the Fifties has led a hyper-critical artist like Judd to a deductive condensation of the characteristics that had been heralded by American abstraction and which he considered to be essential. These were: a) a tendency to a non-hierarchical totality of the composition: a whole composition without details and subordinate elements; b) a tendency to get away from the inevitably illusionistic character of the painting as a rectangle of light that opened on a background and forms which were framed by it: he was thus posing the same exigency that Vladimir Tatlin had expressed some fifty years before: "Real material in real space."

He has written: "The materials vary in a wide range of possibilities and because they are materials – Formica, aluminium, cold-rolled steel, Plexiglas, red and common copper, and so on – these are specific, and when used directly they acquire still more specificity. Moreover, they are usually aggressive. There is an objective value in the hard identity of a material. Naturally, the qualities of materials like hard mass, soft mass, thickness, pliancy, fluidity, brilliance, opacity... may also have non-figurative uses. The form and materials of a piece are intimately related. Instead, in previous art the structure and the *imagerie* were realised with neutral, homogeneous materials."
("Strutture primarie e minimal art", 1973, in *Situazioni dell'arte contemporanea*, Librarte, Rome 1976).

Bibliography
K. McShine (edited by), *Primary Structures*, exhibition catalogue, The Jewish Museum, New York 1966.
R. Morris, "Notes on Sculpture", in *Artforum*, February 1966, October 1966, April 1968, April 1969.
VI Biennale di San Marino, exhibition catalogue, 1967.
Documenta IV, exhibition catalogue, Kassel 1968.
M. Volpi, *Arte dopo il '45 in USA*, Cappelli, Bologna 1970.
D. Judd, *Complete Writings 1959-1975*, Halifax Press of Nova Scotia, 1975.
G. Battcock, *Minimal Art. A Critical Anthology*, E. P. Dutton & Co., New York 1984.

Land Art

Interventions on the territory and proposals for the environment

In the autumn of 1967, a certain Michael Heizer looked up Bob Scull, the king of the New York taxis and a wholesale collector of Pop Art, and persuaded him to underwrite the most paradoxical operation of an "artistic" nature that had ever been carried out: to finance his flight over the Nevada desert so that he could find a place to drill. Heizer succeeded, and dug a fifteen-metre-deep and ten-metre-wide ditch that was more than half a kilometre long and which required moving sixty thousand tons of earth. (Heizer would later make gigantic circles with his motorcycle, this time at Dry Lake in Nevada.) Thus right after Primary Structures, Land Art (or Earth or Ecological Art) made its appearance on the scene as the anti-form.

The gallery dealers Virginia Dwann and John Weber embraced this new experiment and promoted shows; at the huge exhibition of 1968, *Earthworks*, in New York, the Minimalist Bob Morris presented an enormous heap of dust, scraps and machine grease.

Other Minimal artists joined the new movement: the well-known drummer Walter De Maria, for example, who made a film based on the presence of the ground as such, or who traced a four-hundred-metre long cross using chalk dust on Jenny Lake in Nevada. Then there was Hans

Haacke who worked on the processes of condensation and evaporation, and the germination of different natural elements; Robert Smithson who, with earth and stones, constructed a four hundred and fifty metre spiral on the surface of Great Salt Lake in Utah or who went to Yucatan where he placed fragments of mirrors among the trees and rocks, or submerged abandoned houses with tons of earth used as artificial landslides.

In New York, the new figure of a publisher-curator, Seth Siegelaub, became interested in promoting interventions on the territory. The universities of the United States became the official patrons and clients of Land Art. A European from Berlin also became involved, Gerry Schum – the first video-gallery owner – who filmed a short documentary, *Land Art* (showing the nature works of De Maria, Smithson, Heizer, Richard Long, Flanagan, Oppenheim, Boezem, and Dibbets), which he then sold to German television. This was the introduction of film and slide projections as art objects at important international exhibitions.

The United States avant-garde began asking such ques-

Richard Long, England, 1967

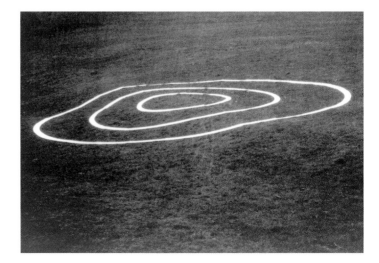

tions as why not occupy all the space somewhere? Why not become part of the environmental flow of energy? Why not intervene in the great ecosystems of the coastlines and the forests? Why not design on lakes and deserts? The interest was no longer in constructing a small natural world of one's own, as in Arte Povera, or in the epiphanic space of the representation, or the heuristic one of Programmed Art, nor was it in the Pythagorean forms of the Primary Structures.

Land Art came from America and this was of significance. It did not represent a reaction against the mechanisation of life, industrialisation or hyper-urbanisation, or the need to raise consciousness about overlooked value of our habitat – brought to our attention because of ecocatastrophes. It did not mean to be a journey of a Heraclitean character back to our origins, nor did it mean to be a recovery and transformation of nature into liberty and the joy of life after technological alienation and "civil" repression. What was evident was a certain humanist optimism of a pure "made in USA" stamp which left it up to culture alone to automatically correct the scandalous situation brought to light.

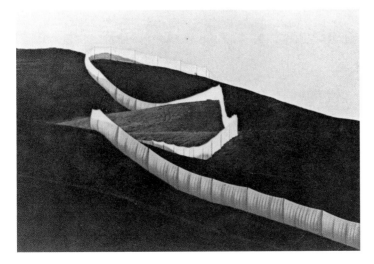

Christo, Running Fence, 1972–76. Sonoma and Marin Counties, California

137

Land Art was not a return to naturalism in the sense of the eighteenth-century philosophical doctrine, a religious cult of nature, or a distancing from the artificial structuralisations of contemporary society; on the contrary, it was some kind of magic technique dedicated to making sure that there would be some guarantee of salvation for man with respect to these forces. When it first appeared, Land Art was interpreted as an alternative or counter culture, a proposal for a non-violent, non-competitive way of life, the socialisation of emotional values, a theorisation of good nature, a concentration of the creative and not the destructive qualities of man, and a re-education almost of those faculties of ours that had been estranged by consumer society. Above all, it appeared to be an attempt to combat the traditional commercialisation of the art object (the elimination of galleries, museums, vernissages, collectors, etc.).

It was therefore meta-physical and empirical in its approach for it proposed keeping as close as possible to the original in an attempt for an integral experience, an act of apprehension in the hope of coinciding with the object.

Robert Smithson, Spiral Jetty, 1970

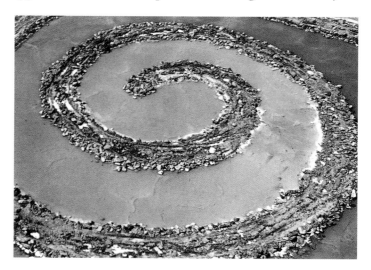

The emotional intentionality which led the author to identify with the landscape and lose himself in it, however, frustrated the ego and did not reveal it. The new *modus amoris* towards this *res extensa* showed itself to be elusive in the end, and yet this "space of love" served to share the noetic-aesthetic-emotional content with the viewer.

What exactly does the "ecological" artist do, how does he superimpose his work on this given external reality that turns out to be like any other instrument that is used for creating a hypothetical, imaginative world that he invests with all his affective energies? He makes use of nature as an excerpt of the landscape, as a place simply that is different from the usual one; he carries out modifications – and is unconcerned about their conservation – which require large spaces and thus represent a return to the old American dream of infinite expanses. A super-space for an artificial paradise. The Land artist arbitrarily delimits a space that had previously been abstract, he establishes the value of the signs, and at that moment the factors of the game and ritual come into play. It is the space that speaks (as the temporal system

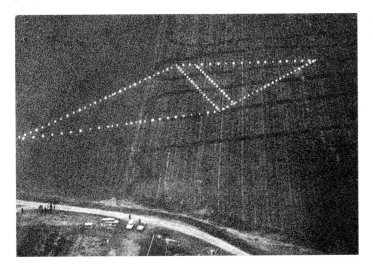

Dennis Oppenheim, Polarities, 1972

139

speaks), the magic, the *hortus conclusus*, the anxious pretence in which both self-humiliation and self-exaltation have parts.

This phenomenon in which the artist binds himself to natural events in a relationship of mutual protection could almost be described as totemism. The ancient myth of the domination of the original chaos by man who identifies with God comes to mind. The hunger for primitive physical contact, the sensory privation, the narcissist inanity of searching beyond ourselves for what is within us: all these are eliminated through the recognition of a certain empathic fusion, or a sharing that is a taking possession of, an appropriation. The intervention in the desert or on the lake is a way to gain control of the landscape, a transaction perhaps between man and his environment in which both converge in a determinate measure, but the external is certainly subordinate to the author's ego, and subject to the fascination of any extension of the self that may be reproduced in a different material.

Michael Heizer, Rock Piece

Giannetto Bravi, Love of Vesuvius, 1974

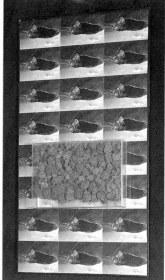

When sold as slides, Land Art therefore is not about to determine urban revolutions or increase an awareness of our personal identity causing the man-human to be restored to himself. It, too, has been a compromise – a fascinating and spectacular one – and a compensation for the mutilation and the amputation of our ego by our narcotic society. An interpretation, a reply to the stimulus of the loss of reality, an attempt to avoid the commonplace constriction of the routine and that of separation, a sort of maniacal spatiality or invasive expansiveness.

Germano Olivotto,
Substitution 10/6, 1971

In addition to the United States and Britain – with the extraordinary formal tension of the young Richard Long – other artists have attracted the critics' attention: the Israelis Georgette Battlle, Joshua Munstein, Avital Geva, and Gerard Marx; the Canadian Hamish Fulton; and the Bulgarian Christo, the former star of Nouveau Réalisme.

Examples of Ecological Art in Italy are to be found in the works of Livio Marzot, Luca Patella, Eliseo Mattiacci, Germano Olivotto, Emilio Prini, Giuseppe Penone, Giuliano Mauri, and Giannetto Bravi.

Land Art

Gillo Dorfles

[…] There already were – let us not forget – the Zen sand gardens, the gardens of moss and the Japanese ikebana that made these "natural" activities a form of art unto itself. There were the Swedish cemeteries with their enclosures of pebbles raked into geometric designs. And there were the infinite varieties of Italian or English-style parks, as well as those interventions on nature that are generally made to accompany the architectonic or urban arrangement of a territory.

What is particular about Land Art, however, is that it does not intervene on nature and in nature for hedonistic or ornamental reasons but for what might be defined as a new awareness of man's intervention on elements of a natural order and which are upset and compromised by that intervention.

To trace a furrow on a frozen river or to dig a ditch in the ground and then fill it with earth taken from somewhere else does not lead to an "aesthetic" result; it leads to one that is almost exclusively intellectual and conscious of the *telos* that has been reached.

Here too, however, a distinction must be made between those "operators" whose aim was to create true artefacts of a more or less permanent nature and of some aesthetic importance, and those instead whose only aim was to materialise an abstract concept of theirs. Therefore, more often than not, these operations must rely exclusively on photographic or cinematographic images of themselves and a description of the same that is catalogued by means of tracings, topographical maps, and the written word, and so a great deal of their effect is lost. Moreover, there has been a new commercialisation of these works which is something that was not intended at all originally. […]

When, for example – let's take the case of Richard Long – in *Sculpture for Martin and Mia Visser*, he actually conceived of the operation only in terms of its photographic reproduction – "The collectors Martin and Mia Visser acquired Richard Long's work as a photographic reproduction for publication in an edition of 500 issues" – it is obvious that the commercialisation of such a photographic reproduction is total, inasmuch as very little of the initial "artistic" or

creative impulse will be conserved in a photograph that is reproduced in 500 copies and sold at a high price for the simple reason that it has been declared an "artistic work". And it does not matter very much that the author has declared that "the photographs do not have the function of a documentation; it is the sculpture made for M. and M. Visser". Those who "earn" the most are obviously the candid Visser couple who end up by having made an excellent self-publicising deal (in their name) and perhaps also a commercial one.

[…] It is important to recognise that the operations carried out by these artists are entirely different from those of the recent or remote past. There are two basic reasons for this. Never before today has man found himself facing a situation of total "de-naturalisation"; for the first time the technological civilisation has destroyed and overturned the normal man-nature relationship, and so it was logical that some artist would notice the unease and danger. Secondly, after the excessive objectification of Pop Art on the one hand, and Op Art on the other (with their relative subsets of primary structures), the artist felt that the time had come to return to a natural object, or at least to one that came directly from the natural environment.

("Arte ecologica (Land Art e Earth Art)", in *Ultime tendenze dell'arte oggi*, Feltrinelli, Milan 1973).

Piero Gilardi

The first symptoms of a micro-emotive art appeared in 1965, and these were confused and mixed up with other artistic experiences. It was to be seen in the work of some American and European artists, for example in the *Loucht show* of Joseph Boezem (Amsterdam), in the compressed organic objects of Gary Kuehn (New York), in the *Cubitenairs* of Jean Sanejouand (Paris), in the articulated sculptures of Mark Di Suvero (Los Angeles) and in the organic fragments of Paul Thek (New York); Bruce Nauman (San Francisco), who already in 1965 was working along these lines with extraordinary lucidity and clarity, held a particularly prominent position.

[…] European micro-emotive art is manifested in a great variety of formal approaches; its most important secondary feature being its constant attention to the "environment".

It particularly differs from the corresponding American tendency in its openly "objective" character, and its significant use of automatic, elementary construction procedures of a technological nature; for example, the expansion of plastics, chemical reactions and even pneumatic constructions.

While choosing their materials in a significant fashion, the American artists employ the traditional formal schemes of artistic language, and often use formulations that derive from Duchamp. Environmental Art is particularly widespread among the West Coast artists.

[…] The approach that first expressed a "micro-emotive" idea is the one that has produced purely sensorial imagery: biomorphic forms, tactile surfaces, the tension of interlacings, and so on.

This was the most influential approach both inside and outside of all micro-emotive art: for example, it is related to Funk Art through a group of Californ-

ian artists known as "Cool Funk"; and what is more, it has constantly been present in all the latest technicalised European expressions.

[...] Another approach is that of the artists who represent the new emotivity with the scheme of a "tension of co-presence" in which abstract and organic elements are arranged in a static, yet open, evocative action.

[...] A third is that which involves a trace of the author's constructive gesture or physical behaviour in the work.

[...] Lastly, there is that of those artists who employ materials, physical or chemical phenomena, or mechanisms which reproduce a movement that is foreseen but free and sensorial; the artist simply arranges for a practical or visual contact, and starts the phenomenon. [...]

("Microemotive Art", 1968, in *Precronistoria 1966–69*, edited by G. Celant, Centro DI, Florence 1976).

Richard Long

My art is a portrait of my being in the world. A footprint as a portrait and as the trace of this passing through; every work of mine (the visible) exhibited in a gallery or museum echoes another work (invisible) left in nature.

[...] It is important for me to be able to use both spaces, landscape and urban context. The natural world and the urban world are complementary, and the work itself along with the exhibition of the work and the publication of books are all necessary for me.

[...] I can make a sculpture of stones in a river, the stones remain in the river, they existed before my intervention and they will exist after it; the sculpture may therefore be invisible to the eyes of the passer-by. You can see the stones as sculpture with photography. One of the important things in my work is the possibility of making anything at any moment. So I use photography to show my ideas: a place suggests the idea for a sculpture to me; with photography I can show it and share my experience with others. [...]

(Translated from Italian, "Conversation with Floriana Piqué", in *Flash Art*, no. 151, 1989).

Gerry Schum

[...] The majority of the new videotapes are sold without any restrictions. Each tape comes supplied with a numbered certificate signed by the artist. This guarantees that the tape was authorised by the artist, and that the latter will receive the percentage due him for the sale of each work. This system prevents unauthorised people from making copies. Without the certificate the tape has no value. "Video-recorders" can already be found in some museums like the Stedelijk in Amsterdam, the Van Abbe in Eindhoven, and in Germany, in Krefeld, Nuremberg, Stuttgart, and in the near future in Mönchengladbach.

Some collectors are interested in our system and they will certainly be future buyers. This beginning looks hopeful; the most interesting feature of the videotapes is that they have eliminated the problems that came up with the 16mm films which had been unsuccessful. A film necessitates both a dark room and a person to project it. The television system is part of everyday life, and does not

145

imply problems because we are familiar with it. Our sales system is special.

We start with very low prices: from 500 DM to 1000 DM for each single piece; the length does not influence the price which is based on production costs and the artist's market. By starting with low prices we can guarantee an annual increase of 20–30%. There are two reasons for raising the price: 1) the artist has the right to ask for higher prices depending on his market, and we think that this system is better that that of Seth Siegelaub. The artist receives a percentage of all sales which are always based on market variations; 2) we try to avoid inflation and give young collectors who buy the tape today an opportunity to sell the tape in the future. This is only possible if the prices go up, therefore by increasing the sales price we make a future sale possible for the collector. [...]

("Videogalerie Gerry Schum", in *Flash Art*, no. 28–29, December 1971 – January 1972).

Gerry Schum

[...] In 1968, I began to organise and produce the first international TV exhibition. Some of the artists that had worked on this show later became known as Land artists or, as they are called in America, Earth artists. I found that the word Land Art was more effective than the word Landscape Art and I used it as the title of the Exhibition TV I. After the Exhibition TV I was broadcast nationally by the German TV in 1969, art historians and critics started using the word Land Art to describe all of the artists' outdoor and landscape activities. As far as I know, it was the first

TV art exhibition that consisted solely of works created expressively for the film medium. The works for this exhibition were created by the following artists:

Richard Long and Barry Flanagan (England), Marinus Boezem and Jan Dibbets (Holland), Mike Heizer, Walter De Maria, Robert Smithson and Dennis Oppenheim (USA).

[...] There is a very important difference between film-makers and artists who use the film medium. Contrary to film-makers, these artists were not interested in the formal problems of films. They did not have any particular interest in the film language.

[...] For them, film was only a suitable medium for transmitting their ideas. They were interested in their idea or concept and not in the formal aspect.

[...] The TV medium was the only one possible for returning these works to the communication system. Jan Dibbets' work is still the best example of the use of the TV medium. Dibbets' basic idea is perspective correction. An idea that can only be achieved with film or photography. Dibbets drew a gigantic trapezium on the sand of a beach with the help of a bulldozer. It is a known fact that if you look at two parallels in perspective, they seem to touch at the farthermost point. This was the phenomenon that Dibbets used in his perspective correction. The angle of the trapezium was chosen in relation to the angle of the local length of the camera. The result was that the trapezoid seemed a perfect square when seen in film or on TV. This square existed only in the film. Similar works had already

been made by Dibbets by using photography. Film added a new possibility. Dibbets could show a process – the trapezium was made by a bulldozer and then disturbed and cancelled by the arrival of high tide. […]
("Video tappa Gerry Schum", interview with Gerry Schum, in *Data*, no. 4, 1972).

Bibliography
R. Barilli, "Minimalismo, Land Art, Anti-Form", in *L'Arte Moderna*, no. 106, Fabbri, Milan 1967.
G. Celant, "Sensorio, sensazionale, sensitivo…", in *Senzamargine*, no. 1, 1969.
K. Hoffmann, "Die Expansion der Künste", in *Kunst*, no. 35, 1969.
G. Schum (edited by), *Land Art*, exhibition catalogue, Fernsehgalerie, Berlin 1969.
T. Trini, "L'immaginazione conquista il territorio", in *Domus*, no. 471, 1969.
T. Trini, "Trilogia del creator prodigo", in *Domus*, no. 478, 1969.
G. Celant (edited by), *Conceptual Art – Arte Povera – Land Art*, exhibition catalogue, Galleria Civica d'Arte Moderna, Turin 1970.
P. Restany, "New York '70", in *Domus*, no. 487, 1970.

Conceptual Art
Art questions itself

At the end of the Sixties it was generally agreed – in tribute also to Kosuth's often quoted words, "art as idea as idea" – to use the term Conceptual for anything that was an investigation of the idea itself of art. Not all the works containing components of a diary-like, literary, metaphoric, and, in particular, emotional nature came under this rubric. Catherine Millet, the most indefatigable European supporter of Conceptual Art, showed herself to be inflexible in this respect.

Diatribes and *querelles* are still going on regarding the pertinence of calling artists like On Kawara, Sol LeWitt, Douglas Huebler, David Lamelas, Dorothea Rockburne, Carl Andre, Robert Barry, Lawrence Weiner, Mel Bochner, Emilio Prini, Vincenzo Agnetti, Giulio Paolini, Zvi Goldstein, Laura Grisi, Hanne Darboven, Franco Vaccari and others to the great international exhibitions of Conceptual Art.

However, amongst its indisputable representatives are the American Joseph Kosuth (from as early as 1966–67), the English artists and publishers of the magazine *Art-Language* (Atkinson, Bainbridge, Baldwin, and Hurrel); and Victor Burgin, Bernar Venet, Ian Burn and Mel Ramsden. The group connected with the English magazine *Art-*

WITH A RELATION TO THE VARIOUS
THINGS BROUGHT TO LIGHT.

HAVING BEEN LAID BARE
() LAID BARE
() BARE
HAVING BEEN LAID OPEN
() LAID OPEN
() OPEN
HAVING BEEN LAID ON
() LAID ON
() ON

[PERHAPS WITHIN THE REALM]
[OF ILLUMINATION]

Lawrence Weiner,
1974

Analytica (Pilkinton, Rushton and Willsmore) seems to be leading an operation that is analogous but not totally coherent with the orthodox one.

"Analysis", said Descartes, "demonstrates the real reason for the methodical invention of something and shows how effects depend on causes..." Midway between the exact sciences and humanistic studies, the Conceptualists interrogate the linguistic elements about the functions they exercise by making use of procedures proper to philosophy and structuralism. Convinced that empirical reality is the only one that man can investigate, Kosuth, Sol LeWitt, and Venet question themselves about the nature of art, its essence or substance. They analyse the constructive character on which representation is based, questioning whether art signifies anything; they make deductions from propositions assumed as fundamental axioms; they study the syntactical dimension through which the signs composing the subject interconnect according to the rules of formation and transformation relative to the form of the sub-

Joseph Kosuth, Neon...,
Pink Eight, 1965

150

ject itself. In this analysis of artistic language, propositions that are uncontrollable yet true converge on the basis of the very terms that comprise them or tautologies that affirm nothing about reality: thus the accusations of sterility or excessive verbalism. Other objections were advanced as Conceptual Art progressed. One was obscurity; it was criticised for not being clear. Apropos of the term clarity, it is worth reflecting about what the poet Paul Valéry had to say at a time of innocence with respect to the term "clarity": "Clarity is only the habitual frequentation of previously unknown notions." Conceptualism still appeared terroristic, and it did not matter whether it was logical or pedagogical terrorism, it was still terrorism. The mild fury of those who, as they investigated mental processes, returned to the theories of Giorgio Cantor and the variables of Wittgenstein or Whitehead, was considered a phenomenon of didactic pedantry bordering on the demential, as in the case of Bernar Venet and his frigid abstraction, or Kosuth and his assertions which proved to be extremely irritating at first sight.

Marcel Broodthaers, Museum (enfants non admis)[children not admitted], 1968–69

Bernar Venet, A Discussion on the Ursa Minor, 1967–68

151

Venet, for example, advanced the theory of a language of art that only made use of exact data and mathematical coordinates, maintaining that such materials became art only because the author chose to make them so.

It is undeniable, in any case, that Conceptual Art was an investigation of the language of art that took into consideration the instruments themselves of that investigation: the consciousness that the intellect has of itself. It has not been verified whether the suppositions of Conceptual Art are as scientific as their premises intended them to be. But

Dorothea Rockburne,
Drawing which Makes
Itself, 1972

it can be maintained that while the assertions of the Conceptualists may have been falsely scientific and the algebraic references, for example, only idle talk in the struggle against the barriers of a denaturalised language, the contribution of Conceptual Art, its questioning the artist's role in society once again, cannot be discarded so easily. When Jan Wilson stated in the early Seventies his own desire for verbal communication, debating the entity of thought itself, it meant that many artists were seeking a way to free art from the market system.

Conceptual Art

Joseph Kosuth

In an age when traditional philosophy is unreal because of its assumptions, art's ability to exist will depend not only on its *not* performing a service – as entertainment, visual (or other) experience, or decoration – which is something easily replaced by kitsch culture and technology, but rather, it will remain viable by *not* assuming a philosophical stance; for in art's unique character is the capacity to remain aloof from philosophical judgements. It is in this context that art shares similarities with logic, mathematics and, as well, science. But whereas the other endeavours are useful, art is not. Art indeed exists for its own sake.

In this period of man, after philosophy and religion, art may possibly be one endeavour that fulfils what another age might have called "man's spiritual needs". Or, another way of putting it might be that art deals analogously with the state of things "beyond physics" where philosophy had to make assertions. And art's strength is that even the preceding sentence is an assertion, and cannot be verified by art. Art's only claim is for art. Art is the definition of art.

("Art after Philosophy", in *Studio International*, October-December 1969).

Joseph Kosuth

The art that I define as conceptual is such, in its strictest sense, because it is based on research into the nature of art; consequently, it is not exactly the activity of constructing artistic propositions, but an elaborating, a gutting of all the implications from all the aspects of the concept "art". In the past, because of the implicit dualism between perception and ideation, a mediation was considered necessary in art, that of the critic. This art instead also takes on the role of the critic, making mediation superfluous. The artist-critic-public system had its reason to be since the visual elements of the construction of "how" gave art an aspect of entertainment, wherefore the presence of the public. Instead, the Conceptual Art public is formed by artists above all: that is to say, the public is not separate from the participants. In a certain sense, therefore, art becomes "serious" like science or philosophy, which certainly do not have a public. To the degree in which one participates or

155

not, Conceptual Art becomes more or less interesting. In the past, the artist's privileged status limited him strictly to carrying out the role of a high priest or a medicine man of industry or entertainment. Conceptual Art, therefore, is research conducted by artists who understand that the artistic activity is not limited exclusively to the construction of artistic propositions, but includes an investigation of the function, meaning and use of each and every (artistic) proposition, and their place within the concept of the general term of "art", and that an artist's dependence on an art critic in cultivating the conceptual implications of his artistic propositions and inferring their meaning is a demonstration either of intellectual irresponsibility or the most insipid mysticism. *Fundamental to this idea of art is a comprehension of the linguistic nature of all artistic propositions, be these past or present, regardless of the elements used in their elaboration.* […]
(Translated from Italian, "Introductory Note by the American Editor", in *Art-Language*, no. 2, 1970).

Sol LeWitt
Sol LeWitt
1. Conceptual artists are mystics rather than nationalists. They reach conclusions that logic cannot reach.
2. Rational judgements repeat rational judgements.
3. Irrational judgements lead to new experiences.
4. Formal art is essentially rational.
5. Irrational thoughts should be followed in an absolute and logical way.
[…]

7. The artist's will is secondary with respect to the process that he himself starts, from the idea to its completion. His obstinacy is nothing but *ego*.
8. Words like painting and sculpture imply an entire tradition, and consequently its acceptance, placing limits on the artists who would hesitate to make art beyond those same limits.
9. Concept and idea are different. The first implies a general direction while the second constitutes its component. Ideas enrich the concept.
10. Ideas can be works of art; they are arranged in an evolutionary chain that can also find a formal outlet. Not all ideas need to be physically concrete.
11. Ideas do not necessarily proceed according to a logical order. They can take unexpected directions, but one idea must necessarily be complete in the mind before the formation of a second one.
12. For every work of art that assumes a physical form, there are many variations that do not.
13. A work of art may be interpreted as a conductor from the mind of the artist to that of the observer, but it may never reach the observer, or never leave the artist's mind.
14. The words spoken by an artist to someone else may set off a chain of ideas, but only when both share the same concept.
15. Since there is no form that is itself superior to another, the artist may use any form in the same way, from a verbal expression (written or pronounced) to physical reality.
16. If the words that are used derive from ideas about art, then they are art

and not literature; and the numbers are not mathematics.

17. All ideas are art if they have to do with art and fall within artistic conventions.

18. The art of the past is generally understood by applying the conventions of the present, thus misunderstanding the art of the past.

19. Artistic conventions are modified by works of art.

20. Successful works of art, by altering our perceptions, change our comprehension of conventions.

21. The perception of ideas leads to new ideas.

22. The artist can neither imagine nor perceive his art until it is finished.

23. The artist may have a false perception (understand it in a different way from the author) of a work of art, but nonetheless be stimulated from a conceptual point of view, by that incomprehension.

24. The artist may not understand his own art. His perception is neither better nor worse than that of others.

25. An artist may understand the work of others better than his own.

26. The concept of a work of art may concern its material or the process of its execution.

27. Once the idea for a work has been defined in the artist's mind, and its final form decided, the process is achieved blindly. There are many collateral effects that the artist cannot imagine and that can be used as ideas for subsequent works.

28. The process is mechanical, it should not be altered but left to follow its course.

29. A work of art involves many elements; the most important are the most obvious.

30. If an artist uses the same form for a group of works and changes the material, it should be inferred that the concept regards the material.

31. Banal ideas cannot be redeemed by a beautiful execution.

32. It is difficult to ruin a good idea.

33. If an artist learns his craft too well, he produces affected art.

34. These paragraphs are a comment about art, but they are not art.

(Translated from Italian, "Sentences about Conceptual Art", in *0-9*, New York 1969 and *Art-Language*, vol. 1, no. 1, England, May 1969).

Lucy Lippard and John Chandler

During the Sixties, the anti-intellectual, emotional/intuitive processes of art-making characteristic of the last two decades have begun to give way to an ultra-conceptual art that emphasises the thinking process almost exclusively. As more and more work is designed in the studio but executed elsewhere by professional craftsmen, as the object becomes merely the end product, a number of artists are losing interest in the physical evolution of the work of art. The studio is again becoming a study. Such a trend appears to be provoking a profound dematerialization of art, especially of art as object, and if it continues to prevail, it may result in the object's becoming wholly obsolete.

The visual arts at the moment seem to hover at a crossroad which may well turn out to be two roads to one place, though they appear to have come from

two sources: art as idea and art as action. In the first case, matter is denied, as sensation has been converted into concept; in the second case, matter has been transformed into energy and time-motion. If the completely conceptual work of art in which the object is simply an epilogue to the fully evolved concept seems to exclude the *objet d'art*, so does the primitivising strain of sensuous identification and envelopment in a work so expanded that it is inseparable from its non-art surroundings. Thus the extremely cool and rejective projects of Judd, LeWitt and others have a good deal in common with the less evolved but perhaps eventually more fertile synesthetic ambitions of Robert Whitman, Robert Rauschenberg and Michael Kirby, or the dance of Yvonne Rainer and Alex Hay, among others. This fact is most clearly illustrated by the work of Robert Morris, who has dealt with idea as idea, idea as object, and idea as performance.

[…] However, "no idea" was one of Reinhardt's Rules and his ideal did not include the ultra-conceptual. When the works of art, like words, are signs that convey ideas, they are not things in themselves but symbols or representatives of things. Such a work is a medium rather than an end in itself or "art-as-art". The medium need not be the message, and some ultra-conceptual art seems to declare that the conventional art media are no longer adequate as media to be messages in themselves. […]

("The Dematerialization of Art", in *Art International*, February 1968).

Filiberto Menna

[...] Conceptual art discards all forms of referentiality, and takes sides for a symbolic logic, whose model it follows in making "linguistics significances" depend "on a system of the analytical correlation of one expression with other expressions" and in freeing it from the "presence of things". For these reasons, Conceptual Art places artwork on the plane of a logical proposition and makes frequent use of tautologies and analytical terms.

[...] Conceptual Art assumes scientific language definitively as its own model in order to expunge the traditional emotive, expressive and representative components, and fixes its own investigations on an essentially analytical-descriptive plane, significantly reducing the theory and practice of art from the conventional critical viewpoint which is at the basis of modern scientific thought. Thus Conceptual investigations insistently place an accent on the syntactic dimension of language in an attempt to exploit to the utmost the premises for a possible formalisation of art that has been laid down and partially developed by the analytical line of modern art.

[...] The verbal definitions that Kosuth obtains from the dictionary tend to orient the meaning toward the pole of monosemy, moving the process from the level of direct discourse to the meta-linguistic one of definitions.

But it was B. Venet in particular who raised the question of a rigorously monosemic reconstitution of the language of art. He started from the observation that the pictorial code was unable to transmit univocal information about an artwork because of its innate semantic ambiguity, maintaining that the ver-

bal signs cannot escape from this condition of indeterminacy.

[...] Because of its constant reference to the models of the exact sciences, and in particular to logic, Conceptual Art has shown itself to have a well-established philosophical background behind it, specifically that of logical positivism which had already indicated in an analysis of the logical foundations of language the problem itself of making philosophy. The Conceptualists' insistence on the conventional character of the artistic propositions and the individuation of a value in their internal coherence and non-contradiction also refer to a principle of logical positivism that points out that the criterion of the truth of the propositions is not to be found in empirical verification but rather in the internal coherence of their linguistic context. [...]

("L'analisi logica dell'arte", in *La linea analitica dell'arte moderna*, Einaudi, Turin 1975).

Ermanno Migliorini

[...] What the Conceptualists seem to be desperately searching for, albeit with some oscillation, is the supreme, absolute value of artistry, a value that is above all others and underlying all of them. They are at times also paying a heavy price for this. The relative practical sterility of many of these theoretical assumptions relegates the Conceptualists – especially the "purest" among them – to more and more repetitions of their analyses and the relative refinements and extensions of these. Therefore to a kind of deeply frustrating "artistic" inactivity, also because many

of those analyses have been conducted with a rigour that has nothing at all to do with that of analytical philosophy, a faint echo of which, confused and inexact, can be detected in the Conceptualist texts. The continual, almost desperate affirmation that art is just this and consists of just this (i.e. conducting analyses of the value of and defining art) hardly seems to be a sufficient remedy.

It has been said that the Conceptualists seem to be seeking a supreme, absolute value. Conceptual art could also be observed in this sense in its most harshly theoretical expressions as the manifestation of a need to retrieve a deluded certainty, and in particular to avoid the uncertainty of an evaluation. An evaluation that it employs daily, case by case, in the constitution of a human world of values in order to seek, on the plane of the meta-discourse, unquestionable values that are fixed once and for all in culture. And it matters not whether the value that one is trying to grasp with a basically artistic intuition will elude or disappoint. What is important is that it appear sure and indestructible at least for the moment, and not subject to any crisis or oscillations. On the other hand, this is where the knotty problem of Conceptual Art can be recognised: in the will, in principle, to put art in the place of philosophy.

("Il concettualismo", conference of 29 April 1973, in *Situazioni dell'arte contemporanea*, Librarte, Rome 1976).

Catherine Millet

Today, there only remains to acknowledge the success achieved by Conceptual Art, its triumphant advance through

the galleries, the number of international shows dedicated to it and its importance, bearing in mind all the assimilations and conversions it gave rise to on the part of artists as well as art critics. Leafing through catalogues as thick as phone directories (*If I had a mind*, *P.C.A.*, edited by Dumont, etc.), one is appalled at the muddled collection of puns, riddles, graphic devices and Polaroid photographs. At present, all that appears to be fairly hermetic, intellectual or poetical is "Conceptual". According to the Italian trend, to be "Conceptual" one is required to choose a text from the Scriptures, keeping it preferably in Latin, then transcribing it in bronze or steel letters over neat pictures or surrealistic-looking objects. In Germany, the taste goes rather to post-Dadaist gesture and exhibitionism. But everywhere, it is enough to display one's work as simple photographic reports with the photographs blurred, fuzzy or of bad quality, to avoid the risk of being considered an aesthete, or of long-winded descriptions looking like railway timetables. In short, confusion reigns and the Plasticians so long deprived of literature merrily make up for lost time. This takes place to such an extent that those who have been using the term "Conceptual Art", since 1966–67 to define the outline of abstract art and theoretical undertaking (among others, Joseph Kosuth and the Art-Language group) should hasten, against the "literary" influx, to adopt a new differentiating term. As it gained followers, the term became empty.

[…] The problem is that because the apparently major innovation of Conceptual Art is the sometimes exclusive use of language, it is understood as an attempt to dematerialise art.

Pop Art standardised the art-work, Conceptual Art dematerialises it. This is the beautiful find of the "avant-garde" relays. One suggests the work without troubling to carry it out and, as Douglas Huebler proclaimed, the imagination of the user does the rest.

The second unfortunate point is that in our cultural context, the notion of dematerialisation merges into that of idealisation. The noting of the object seems to solve many problems.

More than ever, art becomes the refuge of a semblance of freedom which one forgets is closely supervised.

Art, with its specificity diluted by the forsaking of traditional materials, can only be identified as such through the artist's preoccupation: his definition therefore has never been so idealistic. […]

("Notes on Art-Language", in *Flash Art*, no. 27, October-November 1971).

Ad Reinhardt

The one thing to say about art is that it is one thing. Art is art-as-art and everything else is everything else. Art-as-art is nothing but art. Art is not what is not art.

The sole objective of fifty years of abstract art has been that of demonstrating art-as-art and nothing else, of making it the only thing that it simply is, keeping it isolated and always defining it more precisely, rendering it purer and barer, more absolute and exclusive, non-objective, non-representative, non-figurative, non-imaginary, non-expressionistic, non-

subjective. The only exclusive way to define abstract art or art-as-art is not to define it.

The only meaning of one hundred years of modern art has been art's new awareness of itself, an art that questions itself about its ends and its means, with its own identity and specificity, an art attentive to its own discourse, of a unique character, an art conscious of its own evolution, its own history and its own dignity, its own essence, its own legitimacy, its own morals and its own conscience, now art no longer needs to justify itself by involving "realism", "naturalism", "regionalism", "nationalism", "individualism", "socialism", "mysticism", or any other ideology.
[…]
The only purpose of art as "beautiful", "sublime", "noble", "liberal" and "ideal" in the seventeenth century was to distinguish the fine arts or intellectual art from the manual technical arts. The only purpose of the word "aesthetics" in the seventeenth century was to distinguish the aesthetic experience from all others. The proclamation of so many artistic movements in the nineteenth century was a proclamation of the "independence" of art. The only problem, the only principle, the only crisis of art in the twentieth century revolves around the unconditioned "pureness" of art and the certainty that art emanates solely from art and from nothing else. […]
(Translated from Italian, "Art as Art", in *Art International*, no. 10, Lugano 1962).

Angelo Trimarco

[…] Conceptual Art is not addressed to an outside public, nor does it require the participation of those who are not involved with art. The public is now on the inside. It is the family itself of the artists. The public and the artists are coinciding. With this move, Kosuth has placed Conceptual Art on the opposite side with respect to those experiments that were trying to resolve the art/public relationship in the Sixties (or shortly before) by asking for and soliciting the active, constant, and vital intervention of the public. Ever since the crisis of the object and the collapse of its languages, the problem has really been one of involving the spectators and making them participate, disturbing their indolence, pushing them into active roles, and turning them into actors whenever possible in the event or rite, which is not simply that of a quick glance or touch but one that leaves long-lasting marks and signs. In these surroundings, art is placed before the spectator as an instrument of the imaginary, a clear irritation of the spirit, to use the words of Max Ernst. The spectator helps the artists in the exercise of ecstasy, I would say, to come out of himself, and the artist, in turn, widens the artistic dimension by referring to the world and nature with his gesture and re-appropriation of corporeity, and so urges the spectator/actor to participate in the birth of an *other reality* and the regeneration of *sensitivity*. Art shortens (or deludes itself) the distance from life; it wishes to become life, but cannot because it is art, that is, language. In this way, it suffers frustration to the very end, it annuls any mediation and exacts immediate, direct contact. It makes the role of the critic explode.
Kosuth, on the other hand, is working in

161

the opposite direction. He knows very well that the immediate art/public relationship is a legend, and a solution (although generous) lacking in judgement. Therefore, in order to avoid the trap of immediacy, he reabsorbs the criticism and the public into the artistic operation, or better yet, into the art concept. But while the solution advanced by art, which intervenes directly and immediately on the world, is open to a mystical experience, Conceptual Art on the other hand, according to Kosuth, is not exempt from risks and inconveniences.

[...] If, in the last analysis, art is the lack of form and the final context is unknown, the artist once again becomes the high priest of the event. In this case, the priest evokes the *Logos* which is an obscure, nebulous principle instead of being a language. And he participates for himself and the public (made up of artists) in this mystery. The problem then is not so much one of forming a public made up only of artists or those who really participate in art, as it is of avoiding ascesis and mysticism.

Otherwise the same critical function, although redeemed in its banal role of intermediary, returns to being an inventory or catalogue of *visions*, the register on which the artist-priest notes his silent contact with the *Logos*. [...]

("L'arte dopo la filosofia – e altre considerazioni)", in *La parabola del teorico*, Kappa, Rome 1982).

Bernar Venet

[...] Since 1966 my activity has consisted in the presentation of monosemic pieces. A recourse to linguistic signs proved to be insufficient inasmuch as their meaning is differential and depends on the relationships they maintain in the linguistic chain. According to its context, the term presents a stratification of senses and it is from this multiplicity that the poetic image arises. The mathematical vocabulary and its symbols, on the contrary, tend to avoid any polysemy by presenting just one rigorously defined meaning by the univocity of the terms employed.

In works of art of a figurative or non-figurative character, this polysemy, that is the plurality of possible meanings departing from one or more analogous meanings, leads one to doubt the existence itself of a meaning and to deduct that certain works are a-semic or meaningless, when they are not clarified by an historical or geographical context or by a text that can be read or heard which conducts the "vague" sense back to one comprehensible meaning.

The pictures belong to the field of visual messages and the signs that they exploit can belong to one of the three following groups (elaborated by Jacques Bertin's work in France):

1. Polysemic – for figurative imagery susceptible to interpretation and which necessitates a context for its own meaning to be known.

2. Pansemic – for non-figurative imagery open to all interpretations.

3. Monosemic – where we find the graphic image (diagram) and the mathematical symbol which have the property of presenting only one semantic level.

The evolution of the history of painting has developed until today within the limits of the first two groups; while for the second it had to wait until this cen-

Venet

162

tury and Mondrian and Kandinsky; the third category is yet to be exploited, leaving the field of expressive imagery in order to explore that of rational imagery.
(Catherine Millet, *Bernar Venet*, Prearo, Milan 1974).

Bibliography
J. Kosuth, "Art after Philosophy", in *Studio International*, October-November-December 1969.
L. Weiner, "Statements", in *Art-Language*, no. 1, May 1969.

D. Del Pesco, A. Picone (edited by), "Note sull'arte concettuale", in *op. cit.*, no. 25, Il Centro, Naples 1972.
Documenta V, exhibition catalogue, Kassel 1972.
E. Migliorini, *Conceptual Art*, Il Fiorino, Florence 1972.
C. Millet, *Textes sur l'art conceptuel*, D. Templon, Paris 1972.
F. Menna, *La linea analitica dell'arte moderna*, Einaudi, Turin 1975.
A. Trimarco, *La parabola del teorico. Sull'arte e sulla critica*, Rome 1982.
S. LeWitt, *Testi critici*, edited by A. Zevi, AEIOU, Rome 1994.

Arte Povera

Art and life, materials without quality

In 1968, the critic Germano Celant baptised as Arte Povera that category of research identified with the works of Michelangelo Pistoletto, Pino Pascali, Jannis Kounellis, Mario Ceroli, Pietro Gilardi, Mario Merz, Marisa Merz, Giulio Paolini, Luciano Fabro, Giovanni Anselmo, Alighiero Boetti, Gilberto Zorio, Emilio Prini, Pier Paolo Calzolari, and Gianni Piacentino.

What was meant by the term *poverty* of art? The use of non-privileged materials like wood, paper, rags, and stones as well as of elements like water, fire, earth, etc. At the same time, it was a return to naturalness as the existential matrix, a binding of artworks to everyday events, a journey back to origins of a Heraclitean mark in order to experience a world of innocence and truth. It meant to give an authentic sense of seeing and feeling back to our faculties which had been distorted by the manipulation of a consumer society, and to propose an art that was made of the quotidian and that was at the most life itself. Through its works and actions, Arte Povera pointed out the essential nature of the materials it adopted by means of a certain cut or location stressing their morphology. It was an example of the relationship between naturalness – how much is produced by what is unpredictable in nature – and artefice – how much of the accidental is provoked by hu-

man will. By isolating and emphasising elements of common use, the public would be put in the condition of *seeing* and not just looking at things which usually do not attract any attention at all. In their attempt to find new means of communication and new circuits of diffusion, the artists were endeavouring to make an art that tended to be many things together, a collective experience so that art would be available to everyone and not just for a privileged few. In its provocation of the social reality in which we live, it forced the spectator to reconsider his own everyday life, which was now being shown to him in a new light in order to help him read a hidden dimension in gestures and things.

And so, painters and sculptors have become directors, set designers, geo-morphologists, anthropologists, proxemicists, alchemists, farmers... here they are rejecting the confines between one kind and another, dissolving them in their wish for an aesthetic totality, resorting to the inter-multimedia... here they are, nature lovers and nature worshippers working with nature and making it coincide with the only field of action possible, in the hope of extending the borders of art and destroying the money- and power-based structures.

Claudio Parmiggiani, Leather World, 1968

Pino Pascali, Bristle Silkworms, 1968

166

This apparently wild, culture-less (but substantially very refined) art proposes to get rid of its specific aesthetic quality by transposing the work of art outside of the conventional locations: no longer the picture, the sculpture, the museum, the gallery, but the artwork that is being made in the streets and in the squares, together whenever possible with the contribution of the public. "For me art and life are both a question of duration", declared Pistoletto in 1967. "I do not desire to make art die just as I do not desire to make life die. The greatest art would be that of making life live forever." The author and the viewer stand before a continuum in his mirrored surfaces in which the subject and object are together, for their roles are reciprocal.

Gilardi's "nature-carpets" describe a synthetic, de-sublimated world, and point out a subversion of the experience of the natural in which man no longer relates to his fellow creatures, but rather to inanimate things. Anselmo is interested in the intrinsic order and laws proper to the energy and essence of the object while it exists in coincidence with our life.

Mario Merz works on the combinations-confrontations-collations of bodies in space. After a series of large, neon-

Jannis Kounellis,
Untitled, 1967

Luciano Fabro,
Tamburlaine, 1968

167

Michelangelo Pistoletto,
Person from the Back,
1962

crossed, three-dimensional paintings, he has gone on to trans-fixing bottles, cones, Plexiglas, iron, and wood with fluorescent lights. By taking the force of inertia into consideration, any dynamic situation can be transformed into a static one and vice versa. Merz wants his objects to lose their solidity, and so he seeks "to remedy the static accumulation with light or other means". He is evidently testing a situation in which reality surpasses "its culture", in which a different order of things traumatizes the one in force.

Like the expert of that ancient profession that was called maieutic, Boetti takes small pieces of wood, pebbles, rope, cardboard, aluminium, and cuts, superimposes, and accumulates them. By subtracting the materials from the limbo of the insignificant, he "makes them sacred" by emphasising the *self* of the material. His constructions and connections of heterogeneous things are offered as the discovery of something that was already existing in nature. His utopian ideas arise in fact

Giulio Paolini,
The Invention of Ingres,
1968

Eliseo Mattiacci,
Seated Sculpture, 1968

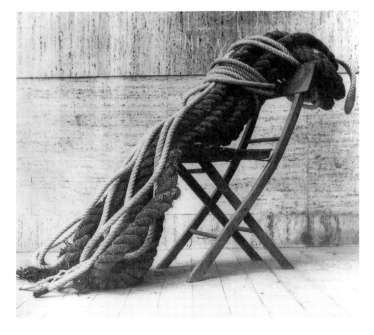

169

from an inner reality (our own) that is seeking to cancel nature. Zorio is also interested in the symbiosis of art and life, hence his return to the zero degree of visual art, "his leaving things be what they are" and the "magic of the natural". He writes: "I feel myself attracted to the vital energy of material. A total adherence to that is, for me, an adherence to the most authentic reality. When powdered sulphur is put in direct confrontation with melted sulphur, these real elements are decanted into a magical objective dimension."

Paolini and Piacentino remained on the sidelines of the Arte Povera movement initially. Paolini, who is still today one of its most renowned members, started out in 1965 with works that underscored the fact that whatever was outside of the canvas deserved more thought than what the picture itself immediately suggested. His work is characterised by the use of artifice, the assiduous presence of signs as a double truth, the ambiguity of meanings, a process that might be called "successive discoveries", an insistence on the logical-linguistic structures of the painting, and on what lies outside the bor-

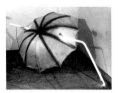

Mario Merz, Umbrella,
1967

Marisa Merz, Untitled,
1966

Giuseppe Penone,
It will continue to grow
except at that point,
steel hand and tree,
1968

ders of the picture. Paolini overthrows the norm: the author comes alongside the viewer and makes him an active participant, one who can look at what is now the object but what had previously been the subject, and vice versa. Each image is a logical paradox and a "complication". In testing a structure that corresponds to a real experience, one is forced to overcome the aporia (the rational doubt) of distance in time and space. The treatment of time is always equivocal since chronological time alternates with the absence of time of the mythic form, and with the repetition of the *arché* (the ladder, the portrait of Sappho, the portrait of the young man who looks at the portrait of the young man by Lotto). A circularity of structures that are self-destructive and self-generating. From one that contains the double there is a return to one.

Cold, calculated, concrete, and elementary (with more than one feature in common with that sculpture that goes under the name of Primary Structures), the tables, fixtures, stairs, windows, and furniture of Piacentino propose a kind of contemplative inaction. "I am for emotional neutrality... I

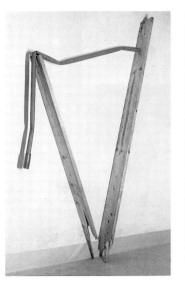

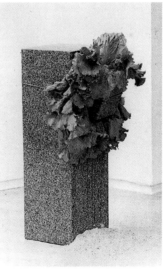

*Gilberto Zorio,
Untitled, wood
and fluorescent light,
1967*

*Giovanni Anselmo,
Untitled, granite,
lettuce, copper wire,
1968*

171

build only those objects that have always existed concretely in the perception of reality and the environment", says Piacentino. He makes his objects out of wood, plasticizes them by applying polyesters and plastic stuccos, and paints them with nitro-acrylic enamel in opaque or metallic colours. In Pascali's hands, a *metteur en scène* more than anyone else, everyday things lose their obvious significance in order to assume extraordinary, titanic characteristics ranging from cannon to giraffe trunks, to bristle silkworms and hammocks. Irony does not determine the drawn out fabled atmosphere, and even less the much-discussed "Pop" component. As a sorcerer of nature, Pascali does not liquidate values, he consecrates elements that are disappearing; he is the Promethean officiant of a dying culture and a lost dimension.

The Arte Povera artists (the *poveristi*) share a widespread need for an almost obsessive physicality and the greatest possible sensory contact with all gestures and events. In their anxious need to feel the surrounding world, they are not so concerned about emotional reactions and cognitive

Pier Paolo Calzolari, Without any other odours but mine, without any other noises but mine, mattress, neon, freezing device, 1969–70

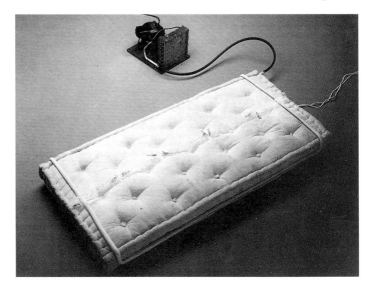

processes as they are about the ecstatic quality (at times of an exotic, ritual type) of an erudite ignorance.

Art then forces the confines of the aesthetic in order to make space for the pages of cultural anthropology which often present a tension similar to that of Zen. As with Zen – in the sense of letting the same things be seen with different eyes – they would eliminate the contrast between appearance and reality and exclude the dialectic of the opposites. Other artists have been closely associated with Arte Povera: Eliseo Mattiacci, Pier Paolo Calzolari, Claudio Parmiggiani, and Paolo Icaro, for example, are among its most memorable supporters. However, supporters only in the sense of a chronological coincidence.

Starting in 1967, Joseph Beuys (a painter and sculptor since 1948) also became active on the international scene. He too used poor materials: wood, felt, iron, wool, grease, and the most disparate everyday objects. He adopted and would adopt different techniques of communication: actions, happenings, installations, environments, and shaman stage productions. His work differed from that of the orthodox *poveristi* since he privileged what he called the relationships between art, sociality and politics. He was fascinated by the utopian idea of making men free, the possibilities of direct communication between man and the supernatural, and by the "degrees of mystical ascesis" (*cogitatio, meditatio, contemplatio*). Beuys was particularly taken by esoteric, anarchic and ecological components. As the producer of languages-ceremonies in the name of what he augured to be "total art", he used his talent for invention, metamorphosis and identification – characteristics of the mystic souls – taking on himself, from time to time, the Calvary of the Nazarene, the words of Rudolf Steiner or those of Karl Marx. He continued to the last to preach and show his conviction that he had to go beyond all limits.

173

Arte Povera

Giovanni Anselmo

I myself, the world, things, and life are situations of energy, and it is important not to crystallise such situations, but to keep them open and alive, instead, in function with our lives.

Since for every way of thinking or being there is a corresponding way of acting, my works take the force of an action or the energy of a situation or an event, etc. and make it physical, and not simply an experience of that at a level of annotation, sign or still life.

(Tommaso Trini, in "Anselmo, Penone, Zorio e le nuove fonti d'energia per il deserto dell'arte", in *Data*, no. 9, autumn 1973).

Alighiero Boetti

[...] In 1948, I tore a large sheet of brown paper into small square pieces, and I piled them up and erected a rather unstable column. In 1954, I smoothed out a one-metre square piece of corrugated cardboard. In 1957 instead, uninterruptedly, I smoothed out the silvered paper of cigarette boxes.

In 1962, I began to remove the filters from the cigarettes, creating long ribbons with them; I was amazed to find an extremely interesting granular stratification in the Muratti cigarettes. In 1958, under the guidance of Mr. Sergio Vercellino, a farmer and resident of Vagliumina (Biella), I cut about three square meters of grass.

In 1950, about twenty small ice cream cups that I had collected with difficulty, were fitted into one another so as to make an arch.

In the same year, I filled a small plastic box with some twelve matchboxes and with great difficulty I bought a packet of Marlborough cigarettes that I immediately separated, flattened, and opened up.

In 1949, I had rolled up a yellow tailor's measuring tape and inserted my little finger in it, creating a kind of tower of Babel. In 1953, I would take a red or blue rubber tape and hold it with four fingers of my right hand so as to form a square. [...]

(*Eine Kunstgeschichte in Turin 1965/ 1983*, Kölnischer Kunstverein, Cologne, October 1983).

Alighiero Boetti

[...] The sphinx, pictures, and works of art are all continual sources of words

175

and thoughts. But the circle does not close. There is always this rotundity because things are infinite, they continue and vary. [...] If I have to say what the great emotions of my life have been, I confess they have never been from nature. A flower petal, a butterfly, and a sunset may be beautiful things, but great emotions, according to me, are felt when listening to Mozart, or reading a poem, because the thought there is made up of a thousand coincidences, synchronisms, and memories that I would say are almost biological, from ancient times perhaps when we were other things, perhaps when we were not even on earth. In short, perhaps when we were closer to the gods.

[...] There are millions, billions of walls on which all kinds of things are attached, from parchment to the postcard to the marvellous picture. A good picture should have several layers, a density I would say that was molecular. That is, it must contain beauty, so that it gives pleasure to whoever looks at it, which is, in my opinion, the first fundamental layer. Even if, in other times, for historical reasons, things were made to bother or to shock, they were contingent things, ideological necessities. On the second layer, there is already an elaboration of this imagery, a feeling of disquiet or pleasure. And then there is also a third dimension, the most hidden, the most secret, the most difficult to explain. It is as if I were writing a word in black on a white sheet of paper. You usually look at the black writing; however, in the third dimension you are able to look at the white form that the black writing has created around itself, which is the mean-

ing of something that is normally not grasped. These, more or less, are the three layers of a work of art. In a word, there is everyday reality. There are these things that are hung on a wall and which should provide pleasure, which is only for those who look at them, a source to be used as one wishes... [...] There is an empty space on prayer carpets, a window, a real mental space. One sits on this space, which is of one colour, facing Mecca, and one can really enter into it mentally through prayer. It is really a window through which one reaches other levels. I think that a beautiful picture should have a similar function. As well as that, for example, of arousing enthusiasm, of exciting. When I have an exhibition and I see the people moving around and the temperature rising, there's enthusiasm. It seems to me that people are more content then, and I think that when they go home, they'll do something special, something they don't normally do. That's it, a good exhibition can be as stimulating as music or poetry. It can provide energy. [...]

(*Che cosa sia la bellezza non so*, Leonardo, Milan 1991).

Giuliano Briganti

Between 1967 and 1968, the ideological myth of a new autonomy of art was created around the notion of Arte Povera. It was an art that frees itself, through willpower and total awareness, not only from all pre-established norms but also from the structures of power and the market; it was the myth of an art that tends to cancel itself by identifying with the same life process.

At the time in which some artists were

identifying themselves with the propositions of Arte Povera, their aesthetic showed remarkable affinities and relationships with the utopias of 1968. The vitality, fantasy, subtlety, and liberty that had ignited the flame of the cultural provocation of the Sixties was transmitted to many of the protagonists of Arte Povera, I mean to say, to those artists who had become known particularly through Arte Povera, like Alighiero Boetti, Mario and Marisa Merz, and Zorio. Certainly, that intellectual and poetic tension soon slackened, and the excitement of ideas and feelings that had animated the entire decade was assuaged. But the matrix of Arte Povera, or better, the impulse that had led to Arte Povera, produced new linguistic variants during the Sixties, new cultural extensions, and paradoxical provocations. The fact remains that Italian art during the Sixties, when it was stimulated to the maximum, demonstrated how art and poetry (which means the private and the individual) remain the inalienable expressions of the human soul, notwithstanding a radical break with the past. ("L'Arte Povera", 1989, in *Il viaggiatore disincantato*, Einaudi, Turin 1991).

Germano Celant

[...] There is a "void" existing between art and life, between man's capacity to project freely and his creative link to the evolutionary cycle of life (we are at the osmosis of two moments) for an affirmation of the present and the contingent. There, a complex art that keeps the *correptio* [shrinking] of the world alive in an attempt to preserve "a man well-armed before nature". Here, a poor art, engaged in a mental, behaviouristic event, in a contingent, ahistorical, anthropological conception, ready to throw away any univocal, coherent "subject" ("apparent" coherence is a dogma to be broken), any history or past, in order to possess the "real" domain of our being.

A "rich", complex art at present, because it is based on scientific imagination, on highly technical structures, and on polysemous moments, in which individual judgement contrasts, by imitating and mediating reality, to reality itself with a prevarication of the literary aspect about what is really desired.

At the convergence of rich art and life, "poor" art is intent on conscious identification – real=real, action=action, thought=thought, event=event. It is an art that prefers essential information, a creativity that strips imagery of its ambiguity and the convention that has made imagery the negation of a concept. [...] It is an art that finds the greatest degree of freedom for creation in linguistic and visual anarchy and in a continual behaviouristic nomadism. It is a stimulus that continually verifies its own degree of existence (mental and physical), and urgently requires the elimination of the "fantastic" mimetic screen in front of the eyes of a community of spectators, so as to lead them before the mental and physical specificity of all human action, as an entity to complete and judge.

[...] It was almost a discovery of aesthetic tautology, the sea is water, a room is a perimeter of air, cotton is cotton, the world is an imperceptible unit of nations, an angle is the convergence of three co-ordinates, the floor is a portion

177

of tiles, life is a series of actions. [...] ("Arte Povera", November 1967 – February 1968, in *Il Verri*, no. 25, 1968).

Germano Celant

Animal, vegetable and mineral have risen up in the world of art. The artist feels attracted to their physical, chemical and biological possibilities, and once again feels himself turning to the things of the world not only as an animated being, but also as the producer of magical and marvellous deeds. The artist-alchemist organises vegetables and living things into magical deeds, working to discover their inner essence so as to find them again and exalt them. However, his work does not mean to use the simplest materials and natural elements (copper, zinc, earth, water, rivers, lead, snow, fire, grass, air, stone, electricity, uranium, sky, weight, gravity, heat, growth, etc.) merely as a description or representation of nature. He is much more interested instead in the discovery, presentation, and insurrection of the astonishing magical value of the natural elements. Like a simple structured organism, the artist blends into the environment, camouflaging himself with it, and widening his threshold of perception; he starts a new relationship with the world of things. What the artist relates to is not, however, re-elaborated. He does not express any judgement, seek a moral or social value, or manipulate it: he leaves it uncovered and visible, he draws on the substance of the natural event like the growth of a plant, the chemical reaction of a mineral, the movement of a river, snow, grass and earth, or a falling weight, identifying with these in order to

experience the wonderful organisation of living things. [...]
(*Arte Povera*, Mazzotta, Milan 1969).

Gillo Dorfles

[...] Are we therefore to accept the term "Arte Povera" that Germano Celant has so accurately proposed? However, there is the danger of a facile pun [in Italian]: *Arte Povera=povera arte*! It goes without saying that when translated into a language with a different syntactical structure than Italian – German, say – one in which there is an ironclad placement of the adjective and not the mobile one of Italian, then the only possibility would be *arme Kunst*, "poor art" (and not *Kunst arme*, "art poor"), which would be most detrimental to this kind of art!

Do we then wish to talk, as some have suggested, about "micro-emotive art"? As for emotivity, almost all objective and structural art comes under this heading whether they deal with macro or micro-structures. For the time being, I shall use the term of "situational art" to indicate that these works are aimed more at creating "moods", states of tension, situations of unease, weight, and contrast than at a definitive, objectivised structuring of the elements themselves. [...] I believe that an inclination for a precarious, or better, a transitory situation that is crystallised only to permit for the verification of a peculiar situation is really the most interesting moment in the majority of these works. [...]

Just exactly what is it all about? There has been a twofold attempt, in part against the excessive use of technological materials – exponents of which have

been the so-called "Primary Structures" which have become the object of consumer speculation following their invasion of the art market – and in part searching for new ideas, this time based on the "poverty" of the medium instead of its industrialisation. To use rags and felt instead of aluminium and stainless steel, to adopt wicker, straw, or debris, to revalue notoriously "poor" materials, inasmuch as they lack commercial value, has been one of the ambitions – initially genuine – of these artists. But accompanying this was a further concern: that of emphasising some new (or so they were considered) aesthetic-perceptive constants, no longer based on colour, form and composition, but rather on the "weight" of the chemical composition or the transformation of a form owing to atmospheric or chemical agents, as in the case of Merz's wax block that melts due to the effect of a lit neon light, or Calzolari's bar of ice, or Zorio's chemical elements that change colour… […] ("Arte Concettuale o Arte Povera?", in *Art International*, XIII, no. 3, 1969).

Maurizio Fagiolo dell'Arco
[…] It is my impression that the issue does not have to do with *arte povera* as much as it does with "handmade" art. […]
That is, I believe that more than their adoption of poor materials for making art, Pistoletto and Co. are characterised by the fact that technique has taken centre stage. The technique is not of industrial production, if anything, it is the spontaneous proposal of the artisan. It may even be badly made, if an idea need be blocked. Not to appear at the win-

dow of the world, but to be there. "Ideas have hands and feet", a philosopher once said.
The world of inflated imagery, the assault of advertising, the failure of the consumer (of art), the LSD of fantasy: in short, ICONOSPHERE. How can the world of art be controlled? With the collapse of the absolutist concept of "beauty", we can only resort to the relative judgement of *technique*. Indeed, the latest turning point in art is linked to the problem of technique, just as other times the turning point involved new conceptions of space, space-time, significance, or language. The artist-world-viewer relationship is joined at the technical level. We are not talking about technological art as a mimesis of the world of technique, but we are interested in talking about those artists that freely appropriate (and in first person) all possible techniques. Like skilled workers.
The overwhelming burden of the "system" can only be overcome by the method of each artist. Therefore: 1) technical experimentation; 2) technique of experimentation; 3) technique of the imagination. The rest is silence.
("1968: l'arte del cattivo selvaggio", in *La povertà dell'arte*, Quaderni De Foscherari, Bologna 1968).

Piero Gilardi
[…] It was Pistoletto, the most intellectual of the group, who again announced the new situation in Turin; you could say that the Last Famous Words of '67 were the manifesto of this new situation. […]
As I said before, it involved new artists who had developed and become known

179

internationally thanks to the efforts of the gallery of Gian Enzo Sperone. [...]

On the other hand, the need to find individual potential again was also reflected in the social unrest that was affecting all of Western culture at that time (1967–68: the student movement, the new American left, the use of psychedelic drugs and the hippies).

A real debate was going on within the avant-garde at this point. The situation was open and therefore contradictory: there was, for example, a contradiction of language, that is, language was considered an obstacle in this re-appropriation of reality.

The theatrical activity, cinema, Happenings, and the artists and all the areas in which they were operating were of particular significance during this period. Turin became the reference point for all the artists associated with Arte Povera, Conceptual Art and Process Art.

There were two paths open to artists at that moment: the first, the traditional one, was to formalise the new problems in a language that was not necessarily orthodox, as in the case of the Happening; the second alternative was to translate it directly into reality.

In fact, most of the artists in the Turin group opted for the first path, as did those in other centres of art (Rome, Düsseldorf, New York and Los Angeles). Although they had perceived a need to enter reality actively and dialectically, all these artists renounced this commitment, choosing instead to return to the path of a "neutral" reflection of reality through language...

("Intervista con Mirella Bandini", October 1973, in *Nac*, no. 3, 1973).

Jannis Kounellis

[...] The reason of the world moves between extremely small, insignificant things and others that are extremely big. It was an exercise to stay out of the rhetorical and the monumental in order to keep the logic of life in mind. It was a way of keeping distant from dogmatism and avoiding a moralistic and didactic sense. My truth which has an intentional fragility of its own is also formed by this exercise. Its presence gives dynamics, uncertainty, madness and loss. If I had all of them in front of me, I would already be finished. On the other hand, I am the one who goes in search of them from time to time so as to reach them and join them.

[...] It may sound ironic, but I am interested in a work when I can eat it. I take an image and I put it in my mouth. Like the coal in 1990, which transformed my face into a funeral mask, a walled-in mouth is equal to the door. Instead of walling in the architectural hollow, I wall in an organic hollow. [...]

("L'epos contemporaneo", essay-interview with Germano Celant, February-March 1992, in *Kounellis*, catalogue, Fabbri, Milan 1992).

Filiberto Menna

We cut out a situation under the sign of nature. The artist undermines the confines of the artificial universe of the city, widening his own horizon of operation. The term of reference is no longer constituted by objectivity whose constitutive data derive from and return to the natural world and, at the same time, to an object retrieved at the level of memory and the unconscious. Even if the

artist does not reject the relationship between the internal and the external, which is based prevalently on a visual perception which has been at the basis of all the artistic tendencies that have appeared and developed in society, he now tends to establish analogies between the two more complex terms, opening new dimensions of the external (nature) and the internal (deep-seated psychic structures).

Artists like Pascali and Ceroli, Pistoletto and Mondino, Kounellis and Marotta, and the young Calzolari (favoured in this by those artists who are slightly older, and in particular by Schifano), have understood and accepted the straightforward opening to reality suggested by Rauschenberg, Johns, Lichtenstein and Oldenburg. They do not intend to repeat what has already been done, preferring new directions and experiments: without rejecting the city, technique and the artificial, they are turning elsewhere, to nature, manual skill and the organic. [...] The artists' recovery of nature is verified as an everyday experience, an acceptance of and faith in the present. The procedures they have adopted are extremely simple and routine for they are based on manual, do-it-yourself operations, although the materials employed belong for the most part to the realm of the artificial. The nature that they restore to us is no longer presented as a representation and illusive image, but rather as something that they themselves can manipulate and construct, and which therefore assumes the autonomous concreteness of an object, or better yet of a real environment in which it is possible to move. [...]

("Una mise en scène per la natura", in *Cartabianca*, March 1968).

Mario Merz

[...] My work with neon began with light, a beam of light or a flow of light passing through objects and destroying them as the idea of an object. I passed neon through a bottle in order to destroy the bottle, in order to make something else of the bottle; however, they remain a bottle and light. Before the bottle, I made canvases which had to be projected from the wall in order to be seen. The neon passed through them, piercing them and creating a division between the canvas and the light, that is, a real destruction of the canvas as the space of canvas and painting. [...]

In this work with neon, serial images are created, that is, I made a double picture from one structure near another structure, joining it by a single neon light. The neon pierced the canvas and came out the other side, re-entered the canvas, returned outside, crossed the empty space between the two paintings, returned inside the second one, and my idea was that it could continue.

It is an idea that I developed with sheets of glass leaning against the wall, in which in some exhibitions there were from fifteen to twenty of them, but they increased in number. The neon was placed behind the glass and in this case there was no longer any destruction because glass is a transparent structure, it does not exist and it is also cancelled by repetition. The only thing left was an uninterrupted light, created by the neon. That gave rise to the number, that is, to Fibonacci's series. Fibonacci's idea

was that of a numerical sequence that had a proliferating significance and not a purely mathematical one; the number that follows is always the sum of the previous two numbers. [...]

("Intervista a Mario Merz", 10 March 1971, in *Mario Merz*, catalogue edited by G. Celant, Mazzotta, Milan 1983).

Giulio Paolini

My references to the history of painting are not deliberate. I believe that the look we direct to a painting is filled with information and culture. I am not about to analyse the past or give explanations. I myself am the prisoner of an inventory of figures. Images come to mind much as a recollection which sometimes emerges from our memory. I do not make a systematic use of past iconography. I usually find myself faced with images of artists that are customarily called "classical". Artists who had a particular attitude towards images: they considered them from a certain distance, rather than proposing them. I tried to bring ancient images back in new works, which would put into play the two polarities of the viewer and the author. It has nothing to do with a return to archaeology; on the contrary, mine is an undifferentiated reception, a memory that desires to draw on the making of the work itself. I do not have a preference for any one style, I am attracted by the myth of *why* one makes art.

When I compare two identical copies of the same ancient sculpture I do not mean to be the author or re-discoverer of those sculptures, but rather an observer who grasps the distance that divides them, and therefore someone who can grasp all the possible relationships or lack of relationships that are established between them, and between that image and us. What interests me is to enact the distance that separates them, not to touch the thing with my hand, but to make it visible to my eyes as well as to those of the viewer.

("Dichiarazioni", in *Giulio Paolini*, catalogue edited by Francesco Poli, Lindau, Turin 1990).

Pino Pascali

Realism and abstraction are equally frightening to me because they do not change… Art is the finding of a system in order to change: like when man first invented the bowl. This was the way civilisation was born, from a desire for change. After the first time, making a bowl became academic.

To make a rope bridge, to make a wooden god, to overcome a fatality, a conditioning, a fear.

What I do is the opposite of technique as research, the opposite of logic and science.

("Dichiarazioni a Marisa Volpi", in *Marcatre*, 37/40, May 1968, Lerici, Milan).

Giuseppe Penone

I haven't done anything except to take advantage of a reality that I was using daily, and was therefore not an invention.

[...] In this way, the tree, once every emotional, formal, and cultural significance has been lost or consumed, appears to me for what it really is: a vital element in expansion, in continual proliferation and growth.

I have used it as a "natural force", which I contrasted with another "force" (my own), against which it reacted (*Iron Hand*, *Weights Plus Wire Plus Lightning Rod*, *Three Interlaced Trees*) or which it absorbed (as in the attempt to make it keep a souvenir of things extraneous to it: *Wedges*). [...]

("Intervista con Mirella Bandini", in *Data*, no. 7/8, summer 1973).

Michelangelo Pistoletto

The goal and result of my mirror paintings was to take art to the edge of life in order to verify the entire system in which they both move. After this, there was nothing else to do but make a choice: either return to the system of division and conflicts with a monstrous regression or leave the system with a revolution; or bring life back to art as Pollock did, or bring art to life, but no longer as a metaphor.

[…] In my new work, every product springs from an immediate stimulus of the intellect, but it is not characterised by definition, justification or reply. It does not represent me.

The work or the subsequent action are the product of an intellectual or perceptive stimulus, contingent and isolated in the following moment. After every action I take a step to the side, and do not proceed in the direction depicted by my object because I do not accept it as an answer.

A pre-established direction is contrary to man's freedom; to pre-establish means to commit tomorrow, it means that I am not free tomorrow; and to stick to a pre-established idea means to reflect oneself in the past and deprive oneself of free will. The univocity of language demands that it be pre-established and adhered to. To believe in one's own language means to recite one's own role. [...]

My way of proceeding now is sideways. Every product of mine is a liberation of mine and not a construction that intends to represent me; I do not reflect about them, nor can others reflect about me by means of my works.

Everyone of my products is destined to follow its own path by itself, without dragging me along with it, because I am already active in another place. The problem of actuality no longer has any sense in forms; it is no longer a question of changing the forms and leaving the system intact, but of bringing the forms out of the system intact. In order to do this, it is necessary to be absolutely free; to consider the actuality of the forms means not to be free to consider the forms of the past and, not possessing the forms of the future, freedom in the system consists in being able to do one single thing.

For me, forms are not more or less actual, all forms are available, all materials, all ideas and all means. Walking sideways leads out of a system that is going straight ahead; there is no finishing line in front of us, so it does not matter if one arrives first or last; the unrestrained race at this abstract point is concretised in a battle system between individuals and the masses.

By proceeding sideways, the race between individuals becomes parallel, because each individual proceeds individually without projecting himself outside of himself in abstract points or on oth-

183

ers. This race is not made up of good ones and less good ones, because everyone is what he is and does what he does; no one needs to pretend to show that he is better, and it becomes very easy to communicate with the structures of language because it is easy to understand who everyone is and what everyone is like.

("Le ultime parole famose", Turin 1967, republished in *B't*, no. 6, December 1967).

Caroline Tisdall

[…] Above all, Arte Povera is to be remembered as a series of fragments: the fragments of the plaster models of Michelangelo Pistoletto, Paolini and Kounellis, fragments of significance and fragments of words combined with fragments of material.

What then kept all these pieces together? In retrospect, it was the Italian answer to the widespread spirit of the times, a genuine Zeitgeist that led many artists to explore territories outside of traditional artistic interests and materials. It contained elements of art like existence and everyday art, and together they questioned what art was or could be: all this was an element of the theatricality that it shared with the Fluxus movement in the United States and Germany.

However, not even the earliest achievements of Arte Povera had the participatory, pluri-disciplinary tension towards a "work of total art" that distinguished Fluxus. […]

("Materia: il contesto dell'Arte Povera", in *Arte italiana del XX secolo*, exhibition catalogue, Leonardo, Milan 1989).

Tommaso Trini

[…] In the same way that it rejects the mundane, this art also fears technological wealth. It need not declare that it is anti-technological, for everything is at its disposition, everything depends on its instrumental necessities. These researches depart from a decidedly anthropological orientation, and vest the material, and therefore the object, with the characteristics of a behaviouristic, mental do-it-yourself quality.

"Natural-artificial" is a technological subject. Anthropology prefers to say "nature-culture". After Lévi-Strauss, these two notions are no longer necessarily opposites: indeed, they present identical structures, the cultural products are not essentially different from natural ones, and language obeys the same laws that regulate the cells. For an art like this, which makes nature and culture converge visibly and plastically in a fundamental unity, identification is the current process. Many works in fact arise from a psycho-physical rhythm (Marisa Merz), an extension of manual skill and practicality (Anselmo, Mario Merz, Prini, Calzolari), or a chemical-physical reaction (Zorio). Moreover, this nature-culture identity translates that other equally important aspect of the spirit of these works: that is, the assumption of real, univocal data outside of the realm of ambiguity.

The material evaporates and becomes an operation, a relationship, two ideas expressed by two successive things. There are no new materials here as the new imagery had been for Pop Art; there are only makeshift instruments for whoever wishes to affirm the authenticity of his

own original needs. And there is such a sense of nature that the artists' attitude towards nature and material, imprinted with non-violence, is against the idea of domination that Western thought has always exercised over these as an idea of scientific conquest.

(In *Live in Your Head. When Attitudes Become Form*, exhibition catalogue, Kunsthalle, Bern 1969).

Gilberto Zorio

The connecting thread is energy understood in the physical and mental sense. My works themselves profess to be energy because they are always living works, or works in action or possible future works.

In my early works this energy was concretised in a very physical way, at the level of a chemical reaction, so that the work was not finished but continued to live on its own, while I figured as a viewer both of its reactions and those of the other viewers. This is what I mean by the idea of a process in my works.

The critical attitude towards technology is implicit; however, it has not been my intention to criticise the technological apparatus. I have used those materials simply because I needed them to contrast with their real functions. While there was a certain truculence before in the use of materials, many of which had a tactile danger or an unpleasant odour, etc., it now seems to me that my work has become more purified with respect to the materials. The real problem for me is the energy that involves me in first person, because I also want to involve the viewer in its continual vitality. In my works, energy is not simply an abstract

notion or one that is purely physical; it refers to an entirely human dimension, an anthropological dimension, to situations that are part of history, but not to ideal facts. On the other hand, I use the word "hate" which is loaded with psychic stratifications semantically. I resort to the closed fist, an image which, from an iconographic point of view, abounds in meanings. [...]

("Intervista con Jole de Sanna", in *Data*, no. 3, April 1972).

Bibliography

B. Palazzoli, *Con temp l'azione*, exhibition catalogue, Gallerie Punto-Sperone-Stein, Turin 1967.

La povertà dell'arte, Galleria De' Foscherari, Bologna 1968.

Teatro delle mostre, exhibition catalogue, Lerici, Rome 1968.

Arte Povera più Azioni Povere, Rumma, Salerno 1969.

G. Celant, *Arte Povera*, Mazzotta, Milan 1969.

Live in Your Head. When Attitudes Become Form, exhibition catalogue, Kunsthalle, Bern 1969.

G. Celant (edited by), *Conceptual Art, Arte Povera, Land Art*, Galleria d'Arte Moderna, Turin 1970.

J. Grotowsky, *Per un teatro povero*, Bulzoni, Rome 1970.

G. Dorfles, *Il divenire della critica*, Einaudi, Turin 1976.

Data, no. 32, Milan 1978.

E. Barba, *La canoa di carta. Trattato di antropologia teatrale*, Il Mulino, Bologna 1993.

Hyper-Realism

A reactionary regurgitation or a photography of the probable

The movement known as Hyper-Realism was officially recognised and publicized at the huge international exhibition *Documenta V*, held at Kassel, Germany, in 1972. This one hundred percent American phenomenon, and a direct descendant of Pop Art, seems to have first made its appearance at the 1964 exhibition *The Painter and the Photograph* at the University of New Mexico in Albuquerque.

The Hyper-Realists privilege a photographic image of reality instead of reality itself, proposing works that are *truer than true*, ones that are exaggeratedly precise registrations: Hyper-Realism in fact. As in Pop Art, the subjects refer to situations that are typical of American life and the urban scene. Malcom Morley specialises in publicity pictures of shipping lines; Chuck Close paints portraits that look like identity cards; Richard McLean uses horse races as his subject; Richard Estes, architectural structures; while Robert Cottingham, John Salt and Ralph Goings choose images of wrecks, junk, demolitions, drive-ins, or motorway petrol stations. The situations are therefore probable, indeed very likely, for the scenes that are copied from life are of American reality.

Characterised by the painstaking realism of an entomologist, Hyper-Realism is aseptic and emotionless, a kind

of algid registration, one that is maniacally precise. It has been described as having adopted the aseptic view of the photograph (but what photograph has ever been aseptic?). Hyper-Realism probably represented a desire for repression and regression that was synonymous with the return to line-up politics advocated by Nixonian ideology. It ended up in fact by neutralising the changes made by movements like Pop, Land and Minimal Art during those years. But the drive and subversive will that were levelled out and lost in the paintings of the above-mentioned artists, spring forth and dominate in the sculptures of two artists like Duane Hanson and John De Andrea.

Fortunately the hyperbole is reached in Hanson's works – the policeman hitting the black man, Bowery bums dying amidst the garbage – and De Andrea's embarrassing nudes in polyester resins. In contrast with the laconism (it

Chuck Close, John, 1971–72

is still to be decided whether it is dismal or analytical) of the painters, the two sculptors recreate, as in the theatre, scenes in which playfulness and dismay, histrionics and un-ease, perturbation and magic irritate the spectator. The al-coholic, the manager, the stereotyped tourist, the elderly woman alone at the fast food counter, these are the every-day spectres of the American scene. The public is reluctant yet bewitched by this artisan workmanship of a reality that looks like a nightmare, a lucid, agonising descent into hell.

Parallel situations

In the early Sixties in Germany, Gerhard Richter was al-ready *painting photos* using an abundance of grey paint and optical distortions, while the Italian Domenico Gnoli constituted a disquieting, metaphysical, hallucinated case. Neither of the two was a passive recorder.

John De Andrea,
Arden Anderson,
& Nora Murphy, 1972

Duane Hanson, Artist
Seated, 1972

Ralph Goings,
Airstream, 1970

Richard Estes, Key
Food, 1971

Die Sphinx von Gise (Sphinx des Königs Chephren).
Im Hintergrunde die Pyramide des Königs Cheops. 4. Dyn. (um 2600 v. Chr.)

Painters who were operating in a different yet related fashion, either because of their use of figuration or because of a certain Surrealist derivation, were grouped under the label of Hyper-Realism in the big international exhibitions. Among these: Gilles Aillaud, Jacques Monory, Gérard Gasiorowski, and Gérard Titus-Carmel in France; Francisco López and Antonio López-García in Spain; Eve Gramatzki, Dieter Arms, Peter Nagel and Konrad Klapheck in Germany; Peter Stämpfli in Switzerland; and Giacomo Spadari in Italy.

Gerhard Richter,
Great Sphinx of Giza,
oil on canvas, 1964

191

Hyper-Realism

Daniel Abadie

[...] The first evidence of American Hyper-Realist painting seems to be at the sociological level: given their iconography they could form the album of an American family. These paintings are a record of the American way of life, a commentary that is neither an apology nor a criticism. A catalogue of the subject matter includes shiny, new cars in dealer showrooms or wrecks heaped up in automobile cemeteries; the undeniable presence of a technological universe made up of engines and chrome; New York City street scenes, shops, and drugstores; stereotyped images – as they are remembered or reproduced on postcards – the American Marine at Valley Forge, or the owner of the winning racing stable with his horse and jockey... All these subjects, characteristic of the consumer society environment in which they were created, have led some critics to reach the conclusion that Hyper-Realist painting is an ideological representation of the American silent majority.

[...] Each appropriation of reality, which can only be partial since it would coincide with reality otherwise, is also a questioning of that reality. The European artists are trying to move as close as possible to it, by playing not on the illusionism of the image but rather by emphasising the procedure. By revealing the appearance, they can demonstrate that the only reality is that of the act of its apprehension. Four principal ways can be indicated: fragmentary research, abstract realism, affective awareness, and mental realism.

[...] While American Hyper-Realism deals with a questioning of the image and its powers, the European artists, for their part, have taken up this discussion of reality in order to use it as an opportunity to discuss the only possible reality which is that of language.

("False evidenze e realtà dell'immagine", in *Iperrealisti americani realisti europei*, exhibition catalogue, Rotonda della Besana, Milan 1974).

Giulio Carlo Argan

[...] The last move made to put the European artistic and cultural tradition into a position of checkmate as a culture of quality and values, is predictably also the most recent clamorous invention of

193

the American market: Hyper-Realism. Although it descends from Pop Art, it reintegrates the traditional technique of art in order to demonstrate that the latter is by now absolutely incapable of producing values. For the most part it deals with the painstakingly precise reproduction of images that are industrial products, namely, photographs and slides.

[...] A brief analysis of the phenomenon demonstrates the following: 1) Hyper-Realism reflects a desire for restoration which is easily recognisable in the framework of an illiberal, imperialistic policy, and can therefore be regarded as a typically political phenomenon of the intellectual far right; 2) it counters a maximum of conventional artistry (traditional techniques, restoration of the picture) with a minimum, indeed nothing, of the aesthetic, for the work does not elaborate but simply manipulates what is given; 3) the artistic technique itself, while it is employed as an extremely accurate exercise, is devalued inasmuch as it does not produce any value, and so proves to be superfluous; 4) this same technique is de-historicised, that is, it is reduced to a mechanised manufacture that owes nothing to the history of art, which is in fact depreciated; 5) the process is intentionally anti-historicist because it is limited to fixing data taken from the normal circuits of information, and eschews any interpretation of them. [...]

In a consumer society, even the consumer is merchandise. As for the diligent craft of imitation, more than a rebirth of the artistic *métier* it represents its final annihilation. In a society that privileges consumer techniques to productive techniques, those techniques that are unproductive are widely tolerated because they are not competitive: artistic techniques are admitted because they imply the acceptance of norms, but they are in fact relegated to being techniques of a game in which ability consists in being able to manoeuvre around rules that are fixed and considered unchangeable.

[...] Hyper-Realism crams into the act of perception, which had already been substituted from the very beginning by the photographic image, not only acquired notions but also conventions and prejudices. Therefore, a direct contact with reality does not modify anything, on the contrary, it is intercepted and deviated. The precision of the image, elaborated in a purely technical fashion and based on conventional technique, paralyses any possible impulse of the imagination at its origin and, since ideology does not exist without imagination, any possible ideological interest.

Another criticism concerns the project. The restored pictorial technique of Hyper-Realism anticipates a standard order of operations, but no project, since what must be achieved is the fixity and immutability of the image. That is, a present which is not a passage between the future and the past, but only a flat timelessness, cannot be a project, for the project is a criticism of the past and a prospect for the future. [...]

("L'artistico e l'estetico", conference of 2 December 1973, in *Situazioni dell'arte contemporanea*, Librarte, Rome 1976).

John De Andrea

[…] Why not do a real person; I had never seen any, nor heard about them, and I thought that it was a good idea. Then I made a lot of plaster casts and I also hurt several models, but when I returned to Denver I had managed to make three good characters.

[…] I think my work is an extension [of that of Segal]. We both use a real person instead of imagining a character. Segal seeks the gesture of a character, this very subtle thing, the feeling there is in a human presence. Segal has this advantage of the gesture that not even a sculptor like Rodin had. Segal's silhouettes require space. Well, I have his same advantage, the sense of the human, but I make it move one step ahead so that you almost believe in the presence of a human being. I seek a colour that is as indefinite as possible. There are many things that happen under the skin, and if you try to control them, you won't obtain enough variations. With a first layer I deal with the extremities, principally the legs, like something that contains blood. I spread this blood red a bit like in an abstract painting, then I wash, mix and thicken it until the legs are purplish. When I paint the skin, I start to work from the bottom, using a lot of red and violet. I can do it so that the pen is as efficient as a spray gun and this whole layer of red forces me to invent little by little. I have studied the skin colours and the differences in its shades and I try to paint these differences. I think that I invent thanks to the painting which is a permanent challenge. I do not keep the same palette but I invent a new one every time that I do a new character. In two or three years, I'll add other colours. I analyze them meticulously – so meticulously that at the end of the day I obtain a certain tone of red. Then I go away and come back the following day and I can't even find it again. That shows how much I analyse the colours. (Translated from Italian, "Interview with Duncan Pollock", in *Art in America*, November-December 1972).

Duane Hanson

In my sculpture I try to free myself from the subject. My first works were rather expressionistic, they took a position against war, crime, car accidents and violence in general; now my most successful pieces no longer move from a theme or an idea, they are naturalistic and illusionistic, which consequently produces shock, surprise and a psychological impact on the viewer. […] The subjects that I prefer have to do with the everyday life of the more disadvantaged Americans or the middle classes. The true reality of their lives is grasped in this resignation, this emptiness, this solitude. Therefore, although it is realistic, the human form doesn't interest me… but rather a face or a body that has suffered much like a landscape that reveals the erosion of time. By representing this aspect of life, I try to achieve a hardness in the realism that speaks of the fascinating idiosyncrasy of our time.

I do not use photographs in my work because they are two-dimensional and I do not want to have to keep to a set, rigid visual concept. I have a mould made directly from the subject's body, I cast it in fiberglass and resin, and then I rework it and put it together. If my

195

hands could learn to work in a completely detached way, I would rather model the figures in clay. […]
(Translated from Italian, "Declaration about My Sculpture", 12 November 1973, in *Iperrealisti americani realisti europei,* exhibition catalogue, Rotonda della Besana, Milan 1974).

Corrado Maltese
[…] What pitfalls are hidden by the use of this label? The term common to all "realisms" obviously is the word *realism*. In spite of appearances, however, this is not used in an elastic sense since it presumes a particular philosophical conception or better yet a particular uncontrollable *topos* of popular philosophy: that is the identification of reality with the object. In other words, according to common usage, the dynamic ineradicable relationship between subject and object is not reality – which relationship is, however, the true *reality* – but only the object by itself. Following the thread of the logic of that identification between the *real* and the *objective*, politically-structured "realism" usually intends to beautify or uglify the "real" and therefore it is a pseudo-realism; Magic Realism can invent reality, and therefore it too is a pseudo-realism. Hyper-Realism proposes the mechanicalness of photography or of plaster casts, therefore the depersonalisation of the image and along with it the elimination of any operation that might beautify, uglify, schematise or conceptualise the object. Therefore (following the thread of that logic) the realism of Hyper-Realism tends to be the only true realism inasmuch as it is the pure object, fully displayed. Naturally, things are real-

ly not quite like that, because in the immense world of the objective we can never embrace the totality, and *we are always forced to choose*. Even when we decide *to copy*. Therefore, true reality is in any case and always the relationship that the subject institutes with objectivity. Thus the structural characteristic of the entire movement begins to emerge, judging from the logic of the denomination.
[…] In Hyper-Realist painting, technical ability, although clearly legible, is ostentatiously subordinated to the photographic effect; once again the elegant, artistic technical solution in the sense of individual invention is deliberately subordinated to the depersonalisation of the general result.
[…] We cannot help but reveal a contradiction between the extreme depersonalisation of the image and the re-evaluation of the character of the pictorial execution, in its adoption of traditional supports like the canvas and frame or the square or rectangular panels displayed on the wall as a *non-mechanical artefact, presented as the emulation of the most perfect mechanicalness.* The same is valid for the so-called sculptures. That is, the artistic value is indicated as the aesthetic value, and attention is not focused so much on a face, setting or personage as it is on the technical exemplarity of whoever has simulated it. […]
("L'iperrealismo", conference of 10 June 1974, in *Situazioni dell'arte contemporanea*, Librarte, Rome 1976).

Pierre Restany
This sharp focus, this vision of things that America renders with photographic

precision, was first discovered by many Europeans last summer at Documenta V in Kassel. Their precipitation was equal to their surprise: after hundreds of metres of Conceptual wainscoting, how pleasurable to be able to contemplate a painting that was immediately visible, obvious, and without problems!

A totally objective view of the surrounding area is nonetheless one of the most constant reflections of American sensitivity. The remarkable continuity of this realist style from the Colonial days to our own times attests to the profoundly regional and isolationist essence of American painting.

The brilliant explosion of Action Painting after 1945 and New York's conquest of the hegemony of the art world had briefly created the illusion, but, notwithstanding the momentary elimination of the realist tendency from the scene, this continuity had always existed. The Precisionists and the Magic Realists at the beginning of the century and during the period between the wars, Sheeler, O'Keeffe, Benton and Hopper are the direct ancestors of the cool artists, the photographic radicals, the Hyper-Realists of today. […]

[…] The sharp focus of the Hyper-Realists objectively presents the incommensurable solitude of men and things in a postcard universe. And then, all of a sudden, a work by Kienholz changes direction before our eyes, and the statuary of John De Andrea or Duane Hanson, the automobiles of Paul Staiger, the façades of Richard Estes or the huge female thighs of Kacere appear more exotically American to us than the real thing! The enchanted circle has closed

again on a sensation of rupture: the European Hyper-Realists who employ the same procedures of objectification in their painting – derivative of mec-art – as their American colleagues, express a different, specific reality. While the new figuration of Monory, Rancillac or Télémaque has never seemed to be anything else but a faded surrogate of Pop Art in the style of Rosenquist or Wesselmann, the Hyper-Realism of Claudio Bravo, Franz Gertsch or Jean-Olivier Hucleux is a totally different thing from that of Don Eddy, Mahaffey or Chuck Close.

It is at this point that the notion of *sharp focus* intervenes, a label we owe to Sidney Janis who used it for the first time as the title of an exhibition of Hyper-Realism in his New York gallery in January 1972. […]

("Sharp focus. La continuità realista d'una visione americana", June 1973, in *Domus*, no. 525, August 1973).

Bibliography

U. Kultermann, *New Realism*, Miller Dunbar, London 1972.

Documenta V, exhibition catalogue, Kassel 1972.

"Dal Realismo all'Iperrealismo", in *Qui arte contemporanea*, no. 10, February 1973.

Opus International, no. 44–45, special issue, Paris 1973.

Iperrealisti american realisti europei, exhibition catalogue, Rotonda della Besana, Milan 1974.

I. Mussa, *L'iperrealismo*, Romana Libri Alfabeto, Rome 1974.

197

Body Art
Using the body as language

In 1974, using the body as a medium for art became a widespread form of art: it was called Body Art. All those paradoxical operations in which artists were obsessed by a need to act in function with something else or *to show themselves* in order *to be* were assembled under this label. It was a romantic strategy in order to conquer the right to put themselves back into the world again.

There was nothing moderate in the way Body Art was shown; it uncovered the monstrous organisation of the real together with all of its infirmities and sufferings. The body artists did not enact a story with characters, they themselves became the story and the characters. They sought the human-man, one who had not been castrated by the functionalism of society, the creature who eschewed the concept of profit. By freeing the forces of the unconscious, they instigated – in an insistent hysterical dramatisation – the conflicts of desire and defence, license and prohibition, the impulses of life and death, destructive and cathartic fantasies.

Anything and everything was elaborated, any event of any day: X-rays of heads or chests, voice recordings, transvestism, psychopathological ceremonials and narrations, inventories of personal accidents, acrobatics and beatings.

Gilbert & George,
Singing Sculpture, 1973

199

Many re-proposed the archetypal situations of the collective psychological condition: love/hate, aggressivity/atonement (to attack an object and at the same time save it and conserve its remains). Through the expedient of representation, Body Art rejected its own aggressivity, directing it elsewhere, onto an object of affection or the body. Even a representation of the theme of bisexuality and, therefore, of simultaneously existing and contrasting inclinations, attitudes, affections, and impulses, was an attempt to keep traumatic experiences under control. Although removed,

Katharina Sieverding,
Maton, 1/2, 1972–73

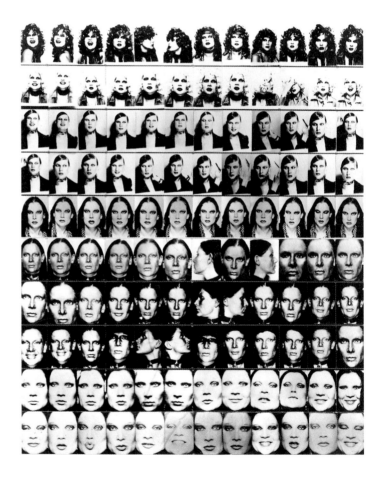

these experiences continued to make their presence felt in our lives, and so it was necessary to keep them at bay, to actually exorcise them thanks to the pleasure of reproducing, with some variations, the experience of victory over them. All this became a means for recounting ourselves to ourselves and to others who, in order to make contact with us, had to participate in the same experience.

In our society, transvestism, for example, is not a misunderstanding but a *prohibition*, and it is of prime importance to force this barrier. Once the walls of silence and cir-

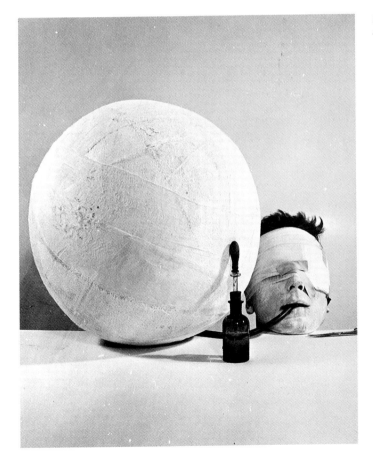

Rudolf Schwarzkogler, Action, 1966

cumspection (where it was never clear who *to be* or not *to be*) were broken and the confines between roles proven to be an obsolete convention, some artists like Katharina Sieverding, Brian Eno, Lucio Castelli, Annette Messager, and Urs Lüthi focused their attention on the confrontation and the blending of man and woman, the female and male, by inverting somatic characteristics and inventing fictitious people, so as to put the crystallisation of roles into a critical position. No one better than Urs Lüthi knew how to exploit androgynous charm, desexualising and sexualising herself and her fellow creatures in the same way with a sensitivity that almost succeeded in taking doubts and desires away from consciousness.

Gina Pane had been on the front line since 1971. She chose to give into her own emotions, broadening their range in order to involve the spectator in a *sympathetic* and *empathetic* process, entrapping him in the web of her theatrical and metaphorical psychology. An artist of a complex and dramatic temperament, violent yet tender, struck by il-

Gina Pane, Sentimental Action, 1973

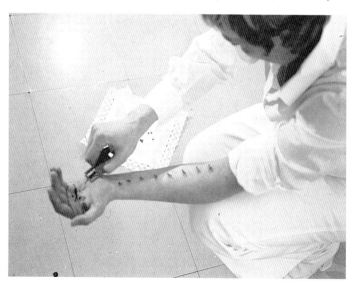

luminating imagery, and fraught with anguish and desire, Pane presented the eternal protagonists of the Great Fable, Love and Death, in her "actions". But death has always had an implication of great worldly attachment. It has often dealt with the shadows from which it would re-emerge thanks to the fascination of the game. Often the public was no longer a public, it was there, like her and with her, on the brink of the void, ready to risk. Her actions were an adventure, a journey; they were painting, sculpture, poetry, "theatre" (but not spectacle). One might say that Pane was a corporal being and only that, since her psyche made use of her organism and its organisation. And if the psyche is – as it is – the *being* of the organism of the world, and all lived experiences (that is, the capacity to know), then the body is the becoming, how much happens *to* us and *in* us. One might say, the corporal (in the same way as the personal) like the political.

Brian Eno

Ancient matrices lie behind all of this and Body Art. However, if we limit these references to our own century,

Urs Lüthi, Manon as a Self-Portrait, 1971

203

then German Expressionism, Dada, and the Surrealism of Antonin Artaud and his Theatre of Cruelty come to mind. Other precursors of this tendency were, for example, Allan Kaprow with the Happening, Yves Klein with his jump into the void, and Piero Manzoni with his tonsure.

Since 1968 more and more artists have come to be grouped under the label of Body Art through their episodic use of its techniques: Kounellis, Paul Thek, Calzolari, Mattiacci, Giuseppe Penone, Terry Fox, Dennis Oppenheim, Lucas Samaras, Ugo Nespolo, Vettor Pisani, Joseph Beuys, Richard Serra, Ketty La Rocca, Ben Vautier, Anselmo, Gino De Dominicis, Luigi Ontani, Renzo Salvadori, Enrico Bugli, and Franco Vaccori. For others, it has been their preferred, if not exclusive, form of expression: Vito Acconci, Otto Muehl, Gilbert & George, Rudolf Schwarzkogler, Yayol Kusama, Arnulf Rainer, Günter Brus, Rebecca Horn, Klaus Rinke, Michel Journiac, Hermann Nitsch, Marina Abramovic, Pacus, Giuseppe Desiato, Valie Export, Chris Burden, Joan Jonas, Ulrike Rosenbach, and Carolee Schneemann.

David Bowie

Marina Abramovic,
Rhythm 10, 1970

Body Art

Marina Abramovic

[…] My [works] were based on a certain type of danger. I often reached the extreme limit, but always in front of an audience. I showed the danger and my limits, but I didn't give answers. The result wasn't the actual danger, only the structure that I had created. And this structure gave the observer a certain kind of shock. He no longer felt safe. He was unbalanced and this created an emptiness inside him. And he had to stay in that emptiness. I didn't give him anything.

[…] It's like an operation when they cut you with a scalpel, but the operation is positive at the same time. And this is so because the scalpel is good. The scalpel is necessary for your health. First, in my work the pain was almost the same message. I cut myself, I whipped myself, and my body couldn't take any more. I was really at the end: if I hadn't stopped myself, I wouldn't even be here. Now with Ulay my work is more constructive in an optimistic sense. I don't think that causing pain to your body is a serious thing, because the body regenerates more rapidly than you think. When I reach the limits of my resistance, I feel incredibly alive. […]

("Arte vitale", in *Flash Art*, no. 80–81, February-April 1978).

Renato Barilli

[…] Today, the body and all its manifestations are being redeemed, they are going up on the scale of values because there is also a technical possibility of fixing them and making them stay. That is, a short circuit has occurred between the return to the conditions of a remote-archaic civilisation and certain means based on more advanced, sophisticated technology that seem to be custom-made for procuring their recovery. It may be that artists would have marched fearlessly on the way to a total recovery of their baser instinctual values even if they had been unaided by any recording instrument, ready to waste their explorations in a sublime, disinterested fashion, entrusting them to the winds, but we will never be able to know this or to verify the autonomy of such a march, because in the meantime valid support has been found in today's refined recording techniques. The result is there

in front of everyone – and not in a figured or illusionistic sense; and also in front of everyone, at least of those present, are the nude, direct exhibitions of the body and all its prolongations. But the naked eyes of the spectators who make up the circle are rapidly doubled by the many mechanical or electronic eyes of the cameras which with their clicks and tenacious drone provide background noise. It has been said that the only thing to be seen in those interventions are the calculations of the gallery owner or the artist himself who desires to turn the transience of the action into an object in order to obtain merchandise, something that is marketable. This is essentially true, but they are also anxious to involve those who are absent, to reach them either in screening rooms or on the video screens of their homes, thus achieving an extension of that community that McLuhan so aptly described as the "global village". Furthermore, the various mechanical-technical eyes are not only meant to be surrogates of the natural eye, especially in a conservatorial role, but also to potentiate its view: zooms and close-ups make it possible to enlarge, exasperate, and emphasise certain aspects of the body, face, and gestures which would normally escape observation, as well as the sounds and movements. [...]

("La 'performance' oggi: tentativi di definizione e classificazione", in *La performance*, catalogue, La Nuova Foglio, Bologna 1977).

Gilbert & George

[...] To be living sculptures is our vital blood, our destiny, our history, our disaster, our light and life. As the day sinks above us, we rise in our void and the cold morning light filters dusty through the window. We wear the suit of responsibility in our art. We put on our shoes for the next walk. Our limbs begin to stretch and act nimbly, like a thought without gravity they rebound for the new day. Our head floats in the highest levels of the horizon of our thought. Our hearts beat with fresh blood and emotion and once again we find that we are here all reinvigorated in body and mind. We often want to slide across the room, dragged by the void of the window. Our eyes are glued to this structure of light. Our mind indicates our decadence. The great happening outside the window confuses our vision as in an accidental film. This leaves us without impressions, giving us only silence and complete relaxation. Nothing can touch us or dissuade us from ourselves. It is a continuous sculpture. [...]

We feel briefly and profoundly because of our being artists. Our mind floats in time, visiting fragments of words heard, faces seen, feelings felt, faces loved. We take occasional sips from our water glasses.

Our conscience enters and leaves, slipping from the spaces of dreams into an old concrete awareness.

The whole room is filled with the mass and weight of our story, and sometimes we are seen chained to our chairs, and then a great deafening, intoxicating music seems to appear to us.

(Translated from Italian, "Neither Up, Nor Down", 1972, in Lea Vergine, *Il corpo come linguaggio*, Prearo, Milan 1974).

Peter Gorsen

The erotic caricature has also passed into the Happening, street theatre, the Living Theater and other forms of actions like the so-called underground cinema. At the level of an iconoclastic Dadaism or Surrealism, something like a *caricature of the beautiful* has come forth together with its antiquated forms of expression: a liquidation, an auto-da-fé of the negative concepts of the obscene, pornographic, immoral, anti-aesthetic and ugly in relation to art. In the deliberately "obscene", deliberately "pornographic", and deliberately "immoral" actions and festival-type manifestations, the mutability and historical relativity of those concepts, that is, the fact that they were not obligatory for the artistic avant-garde, appear by themselves. It is unreasonable to consider these manifestations as new art too hastily or to boycott them if they are not, independently of problematic schemes of valuation. The struggle for liberation conducted at a non-artistic level is not less valid than art.

[...] The autonomy of Viennese Actionism with respect to the original American Happening is undeniable; equally undeniable is its function as a stimulus for many late forms of Middle European mannerism, for the creation of specific body languages of action, and for the literary representation of pornographic and psychiatric situations of life. Added to this are the geographic isolation and the provinciality of the city of Vienna, as demonstrated by the Viennese painter Kiki Kogelnik's amazement when she returned there in 1956 from her adopted city of New York, and heard about the new instructions regarding the direction of the Festival of Psychophysical Naturalism of Muehl and Nitsch, at which time she remarked: "But this is Happening!" For the first time, Vienna's attention was drawn to the New York scene, but that interest would later turn back in the opposite direction.

[...] New York had known about Nitsch's *Orgien Mysterien Theater* since 1964, but it was not until 1968 that the author, invited by the movie critic Jonas Mekas, managed to present two of his most important action dramas, with a shouting chorus and a noisy orchestra, in the New York Cinémathèque, thus cementing the Viennese influence on the international Happening. Nitsch was received with reservations, if not rejected, by Maciunas's Neo-Dada front, while Kaprow, Schneemann, and Paik in particular were enthusiastic. The specifically ritual, liturgical element in the so-called "theatre of outburst" was immediately grasped in its correct dimension as a multimedia oratory with artistic pretences, while in Europe it was simply regarded as a psychological theatre of projection, a decadent Austrian faecal-mania and a religious symbolism. [...]

("Affinità di arte erotica e caricatura", in *La dimensione oscena*, Tattilo editrice, Rome 1973).

Urs Lüthi

Perhaps the most significant and creative aspect of my work is its ambivalence...

Objectivity isn't very important for me: everything is objective in the same way that everything could be subjective... Therefore, it's a matter of dealing with

209

reality, and in fact even my awareness of reality has thousands of aspects depending on my mood... I believe that for every man these aspects are actually the sum of his own awareness...

Personally, I find looking for these secret aspects interesting, and once they are discovered, I try to visualise them. I am strongly attracted by all those vibrations that live within each existence and by everything that cannot be expressed with words. However, the great events are not what I want to make visible, but rather the reason that moves them...

The result of my investigation is the portrait. A portrait that has it own existence and that lives outside of myself. As soon as the spotlights are turned off. Whoever observes it compares it to how he would like to change or divide himself... This is my contribution to one's awareness of oneself, one's own limits, one's excesses, one's own possibilities... and also to the different realities that live under the same reality...

("Autoritratto di Urs Lüthi", 1973, in Lea Vergine, *Il corpo come linguaggio*, Prearo, Milan 1974).

Gina Pane

[...] In the end what really interests me is not the amount of pain, but the language of signs. My problem in fact is to establish a language through this wound that becomes a sign. Another important element for me is to communicate the loss of energy through the wound. And in this context, physical suffering is not only a personal problem but a problem of language. The act of wounding myself represents a temporal or psycho-visual gesture that leaves traces. It is a gesture of rupture and aperture, but it is not a religious fact even though I have repeated the same gesture so many times.

At first, all action was localised in this simple gesture. After 1972–73, I began to join it to other gestures that made the gesture of the wound more hallucinatory, or distanced me from the wound. And my distance from the wound represented my conscious will to construct a more complex language.

[...] I use the metaphor, the narrative, plastic, and imaginative time. The construction of an action starts from the concept of a space form, coloured signs, wound, objects. And all these things also have a real existence and I also use them in this sense. Our physical existence and our bodies condition us in everything we do. But at the same time, all these things that I use in the actions may also evoke something else. My action *Little Journey* (1978) was an imaginary journey inside a room with closed windows. For example, I made use of a small paper boat to suggest the impression of a voyage to the spectators. Exactly as children do when they are told a story. The entire action recounts the dangers that the "voyagers" must accept as their tribute to freedom. My wound within this action and in others could be explained as the magic act performed by the doctor-healers in ancient Greece when they "repeated" the wounds that they wanted to heal on their own bodies. [...] I am interested in bringing art into the other system of perception. The body becomes the idea itself while before it was only a transmitter of ideas. There is a broad territory to be investigated. From here one can enter into other spaces, for

example, from art into life; the body is no longer representation but transformation. Our entire culture is based on the representation of the body. The performance does not cancel the painting for one assists at the birth of a new painting based on the other explanation and function of the body in art. […]

("La ferita come segno", a conversation with Gina Pane edited by Helena Kontova, in *Flash Art*, no. 92–93, October-November 1979).

Arnulf Rainer

It became a habit for me when I was drawing faces to "disfigure" them in different ways. Then, in 1968, I started to produce the *Face Farces* in an automatic photo booth at the Westbahnhof in Vienna. And today I still work this way almost every week with the help of a photographer or a movie cameraman. I accentuate the photos or the sequences chosen with signs so that the dynamics and facial mimicry are visible. Since then, any situation outside of the normal interests me, like spasms of ecstasy, psychosis, languor, humiliation, etc. etc. I do not consider these psycho-physical reproductions to be only a mimic expression, but rather an attempt to overcome them which every human being can later amplify. As an artist, I limit myself to fixing half of them and only on paper.

("Face Farces", 1968, in Lea Vergine, *Il corpo come linguaggio*, Prearo, Milan 1974).

Edoardo Sanguineti

[…] The body artists […] mix the visceral and the mass media, transgressive-ly sanctifying the big toe and the video-tape, the tibia and the recorder, invoking Artaud and Bataille when they know them, and starting, propelled by neurosis, on the tangent of "aesthetic (and hysterical) liturgy" towards a "theatre of orgies and mysteries" (Hermann Nitsch). Fluctuating between the consumer-packaged spectacle on the elitist stage of the art gallery and the privatisation of the ascesis in a rigorously clinical cell, often overwhelmed by a standardised perverted New Dada, they dream about escaping from the socio-environmental straits of a world more aseptic than any square root, by recurring to a corporal pre-code, which would therefore be the true language of Eden. They would give a name to all things, but with words freed from the chains of the Logos. The umbilical cord knows more about it than the cerebral circumvolution, the vagina is more eloquent than the Dictionary of Synonyms. The New Metaphysics is no longer on the side of the poor Psyche; everything is situated on the slope of the Soma (and of Eros, which is so visibly somatic). And those unfortunates do not know that the (schizophrenically suffering) Mystical Body that they cultivate is, phylogenetically and ontogenetically, the product of social work and human history, perhaps slightly outdated and inadequate for the services imposed on it today, but certainly not liable to embody (the correct word) some myth that completely re-appropriates the Ego. So the only other choice left then is to hunt for the Id.

In this way, the (involuntary) dialectic of Body Art in the end returns to squeeze itself into the last incantation of Private

Property, which becomes flesh and descends amongst us, as it passes nude and poor through the exhibition rooms, and if necessary, bleeding and mutilated, and transvestite and masked, in the figure of My Body and My Blood and the last incantation of the Work of Art, as the aesthetic practice of the Physiological that escapes, in its refusal to be subjected to working use, towards the suggestion of a Nature made organ and member, and at the same time, exempt from history and culture. The New Adam discovers his nakedness and ceases to be ashamed: he suspects that it was an enormous error to allow himself to be expelled from the flowering fields of Paradise for a long voyage into the dark night of history. And now that God is dead, he begins to be ashamed that he is dressed: the only thing required to go back into the forbidden garden is a gesture of goodwill. […]

("L'arte del corpo", 1974, in *Giornalino 1973–1975*, Einaudi, Turin 1976).

Rudolf Schwarzkogler

In the place of the hand-executed paintings, the premises now exist for the artistic nude to be included in actions (actions that have the real world of objects manipulated by actors as a background).

The artistic nude emerges from traditional restrictions and like a piece of wreckage finally frees himself from the reproduction machine used for information. By now, the artistic nude and spectacle are one single thing. The objects and elements of this PANORAMA move and transform in the new space assigned to them (analysis of confrontation, edit-ing, automatic contacts, etc. etc.). All this in order to make it possible for the artistic nude to be extended to the total nude who will be situated above the senses like an image that is both temporal and spatial due to the different possibilities of its repetitious gestures and its repetitious presence.

("Manifesto panorama 1 / Il nudo totale", 1965, in Lea Vergine, *Il corpo come linguaggio*, Prearo, Milan 1974).

Bibliography

E. T. Hall, *The Silent Language*, Doubleday, Garden City, N.Y., 1959.

R. D. Laing, *The Divided Self*, Pantheon Books, New York 1969.

R. D. Laing, *Self and Others*, Tavistock Publications, London 1969.

J. Beck, J. Malina, *Paradise Now. Collective Creation of the Living Theater*, Random House, New York 1971.

Avalanche, no. 1–2, 1972.

Documenta V, exhibition catalogue, Kassel 1972.

P. Restany, "I limiti del comportamento contemporaneo", in *Domus*, no. 514, 1972.

Artitudes, no. 3, 1973.

Body Language, exhibition catalogue, Pool, Graz 1973.

L'Art Vivant, no. 40–41, 1973.

L. Carmi, *I travestiti*, SD, Rome 1973.

Data, no. 12, 1974.

P. Eudeline, "Le phénomène du travesti dans la Rock Music", in *Transformer*, exhibition catalogue, Kunstmuseum, Lucerne 1974.

Transformer, essays by Jean-Christophe Ammann and Peter Gorsen, exhibition catalogue, Kunstmuseum, Lucerne 1974.

L. Vergine, *Il corpo come linguaggio*, Prearo, Milan 1974.

D. Weiss, in *La ricerca dell'identità*, exhibition catalogue, Electa, Milan 1974.

U. Apollonio, "I cinici cerimoniali della body art", in *Arte e Società*, no. 3–4, 1975.

M. Kozloff, "Pygmalion Reversed", in *Art Forum*, November 1975.

F. Pluchant, *L'art corporel*, Rodolphe Stadler, Paris 1975.

R. Loda (edited by), *Magma*, exhibition catalogue, Castelvecchio, Verona 1977.

F. Quadri, *L'avanguardia teatrale in Italia (1960–1976)*, Einaudi, Turin 1977.

J. Baudrillard, *De la séduction*, Editions Galilée, Paris 1979 (English ed. *Seduction*, St. Martin's Press, New York 1990).

U. Galimberti, *Il corpo*, Feltrinelli, Milan 1983.

F. Pluchart, *L'art corporel*, Limage 2, Paris 1983.

Sulla strada dei Magazzini Criminali, Ubulibri, Milan 1983.

G. Battcock, R. Nickas, *The Art of Performance. A Critical Anthology*, E. P. Dutton & Co., New York 1984.

P. Weiermair (edited by), *Arte austriaca 1960–1984*, exhibition catalogue, Galleria d'Arte Moderna, Bologna 1984.

S. Lombardi, M. D'Amburgo, F. Tiezzi, J. Baudrillard, *L'altro visto da sé*, Costa & Nolan, Genoa 1987.

P. Bausch, L. Childs, M. Graham, *Discorsi sulla danza*, edited by M. Guatterini, Ubulibri, Milan 1994.

L. Meneghelli (edited by), *Shape Your Body*, exhibition catalogue, Galleria La Giarina, Verona 1994.

L. Vergine, "Il corpo delle immagini del mondo", in *Fabio Mauri*, exhibition catalogue, Galleria Nazionale d'Arte Moderna, Rome, Giorgio Mondadori, Milan 1994.

213

Graffiti Art

The painting of desire or wild communication

The graffiti under discussion here include graphic-isms, graphemes, scratches, clashes, grazes, twistings and lacerations of the world or the surface on which they are applied: they are the grapho-spasms of love.

In 1972, in New York, several bands of young Cubans, Greeks, African-Americans, and Puerto Ricans traced letters and scratched writings on the sides of the city subway trains and buses, and on the walls of banks, schools, and buildings using spray paint in cans. The invasion was extremely rapid and massive; the graphic styles resembled comic strips and advertising but they contained messages in code.

Jenny Holzer & Lady Pink, If You Are Considered Useless…, 1983

At the end of that same year, Hugo Martínez, a Puerto Rican sociology student, set up the UGA (United Graffiti Artists). Twyla Tharp, the famous choreographer, asked the UGA to design the sets for one of her ballets. At that moment – it was the summer of '73 – Graffiti Art moved from the streets into the sophisticated world of the Soho galleries, and the writer-commentator Norman Mailer praised its philosophy and traced its story in a book published in 1974. Sol LeWitt, the American star of Minimal and Conceptual Art, institutionalised it aesthetically with a book about the graffiti on the Lower East Side walls which was published in 1979.

In Europe, three of its most acclaimed exponents, Keith Haring, Jean-Michel Basquiat and George Lee Quinones, received official recognition at the Documenta VII exhibition at Kassel in 1982. This marked the entry of Graffiti Art on the scene of the mainstream movements.

What was the intention of its authors, anonymous and sibylline at their debut, and already legendary in the following decade? These mysterious heroes of wild communication, these spontaneous artists whose signs were volatile and abrupt, tough and angry, vehement and vital, created a great fresco. They spread it across New York: a fresco that was irreverent and complicit, committed and contrary, implicated and distant, sentimental and caustic. In short, a kind of painting of desire that was unruly, inaccessible, and marked by a precarious vocation in which the only accessi-

Keith Haring,
Untitled, 1983

Keith Haring,
Untitled, 1983

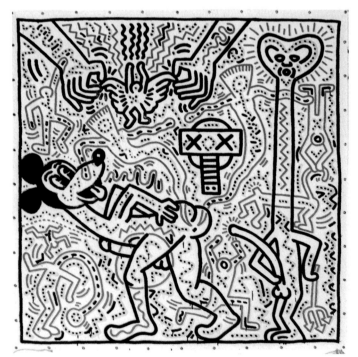

ble existence was a transitory one. The work of Keith Haring, the only white painter in the group, a student of Joseph Kosuth and Keith Sonnier, and a fan of the writings of William Burroughs, differed from that of the real Graffitists, yet it was under that rubric that Haring became as famous as Warhol. His works teem with a variety of linguistic inventions; radioactive children (so characteristic of him that they have become a logo); cartoon and comic strip characters; hominoids in agitated, atomised, unhappy, and excited states; gigantic male genitals, sad, happy, and anthropomorphised; fellatios, both coarse and joyous. And there is more: Cruella and Mickey Mouse; rock and zap culture; radiant children squirted victoriously out of a penis; penis daggers piercing bleeding hearts; the genitals of skeletons squirting sperm on flowers making them radioactive; clusters of figures expelled from the hole of a foot; the glans with the little face of a woman with a platinum blonde wig; and the Primitives and exotic references (so much so that he was referred to as "the New Wave Aztec").

Jean-Michel Basquiat, Early Moses, 1983

George Lee Quinones, Jealous Eyes, 1983

217

Haring did it all with chalk, felt tip pen, ink, and acrylic paint, first on the expired posters of subway or Broadway billboards; later on the covers of magazines, records, catalogues; on the walls of hospitals, schools, museums; on pavements and at fun-fairs. But also on amphorae, copies of Donatello's *David*, and hot-air balloons; on the walls of the Fiorucci shops in Milan and New York, on the walls of Barcelona and Pisa, on the Berlin Wall in 1986; and on the models photographed by Mapplethorpe. Haring managed to represent the despair of life without which there is no love of life, febrile anxiety as well as amazement and gaiety: in short, the hint of a smile through a flood of tears. After ten years of hectic activity, the Bruegel of Pennsylvania or, better yet, the young philosopher of com-passion, was no longer on the scene, annihilated by AIDS, against which he had done everything in his power to combat.

Basquiat, originally from the Caribbean, first signed

Kenny Scharf,
Aaaacech, 1983

himself as SAMO (Same Old Shit!) which was already a de-
claration. But by the time "SAMO is dead" was written on
the walls, he was no longer the cryptic New Yorker with a
message from the poor. He was busy inaugurating his first
one-man show at the gallery of Annina Nosei in 1982,
where he used his real name, Basquiat, and he was also
consolidating his friendship with Warhol. His graffiti now
covered canvases, not walls, with childish doodles, skulls
and telephone numbers, Arabic and Roman numerals,
people's names and addresses, arrows and crowns, black
athletes and mythical racists. Dubuffet, Pollock, de Koon-
ing, and Twombly, and American and European painting
of the Fifties and Sixties were all mixed together and of-
fered up as a kind of existential puzzle, that was slightly
slipshod but quite bewitching, by the kid from Brooklyn
who never finished high school and was dead by the time
he was twenty-seven.

The Puerto Rican Quinones (a friend of Frederick

Ronnie Cutrone,
The Handwriting
on the Wall, 1982

219

Brathwaite, an African-American whose tag was Fab 5 Fred) was a spray can ace together with another African-American from Manhattan, Futura 2000. Then there was Rammellzee, the theorist behind what was called Gothic Futurism or Iconoclast Panzerism, that is, armament training, and his followers A-One, B-One, and C-One, Tocsik, Koor, Crash, Wasp, Kano, Daze, Freedom, Lady Pink.

Parallel situations

The closest to the graffiti style were Ronnie Cutrone, the author of gigantic cartoons set against photographic backgrounds of United States symbols and myths; Kenny Scharf, the chiseller of televised images as well as household appliances and typical science-fiction locations; Richard Hambleton, whose dark figures and violent shadows lurk on deserted city corners; James Brown, whose work is reminiscent of Indian cultures and primitive art; Jenny Holzer, who began by printing her "truisms" on tee-shirts and posters; and others like Judy Rifka, Donald Baechler, and Houston Ladda.

John Ahearn, Double Dutch, 1982–83

One of the more unique artists is John Ahearn whose plaster casts of torsos and bodies (only blacks and mestizos) recall the works of Segal, Kienholz, and De Andrea. However, Ahearn attaches his to walls and, as Francesca Alinovi commented, "…set in a regular sequence, they are all dark-skinned, and reveal an explosive racial force because the masks, manipulated by the artist and yet extremely faithful to the original, have a surprised look as in a snapshot at the magical point of contact or separation between life and death. Those petrified grins like the ones found in Pompei, shout with a frozen vital energy; they are on the brink of a physical explosion. Those heads and those entangled bodies are similar to the Roman funereal masks or the photographic image itself: one senses a desire there to block that last instant of life forever and to conquer, through the reproduction of the image, the force of death".

Rammellzee, Olympia's Torch Has Fallen, 1984

Graffiti Art

Francesca Alinovi

[…] While in America as in Europe the triumph of tradition and fine painting is being celebrated, out comes the gurgling current of the underground like an impetuous, boiling hot spring.

Avant-garde art is not only not dead but has dug up its battle-axe and is beating its tam tam along the lines of the frontier of Manhattan: 1982, escape from New York! The art of the future stares with big, dark wide-open eyes at the centre from the periphery, mixed with the wreckage and rubble of the decaying city, spread out among the ghettoes of the racial minorities, fed on the warm blood of Blackness on the way up. Reagan has given America the image of his hyper-realistic plasticated face, a macabre version on a human scale of a sculpture by Duane Hanson, and the artists have thrown themselves back into reality and society. Or rather into the wreckage of reality and the rubble of society: slums, trash, decay.

[…]

Avant-garde art today is frontier rather than underground art: both because it is literally situated in the areas geographically on the edges of Manhattan (the Lower East Side, as I said, and the South Bronx) and because it is placed in an intermediate area between culture and nature, mass and elite, black and white (I mean skin colour), aggressivity and irony, garbage and exquisite refinement. These artists are simultaneously "pale face and Indian" and are the new kids of New York: tough kids with a kind, mocking air who smear the city with their symbols and graffiti but who go to the galleries in order to be seen and roam the most lurid districts of New York like gangs of warriors, taking part as the latest fashion at the most elegant parties. The kids are the new rulers of the New York art scene, bringing with them the image of an eternal childhood in which they play at cops and robbers, risking their necks, taking part in raids on the city under siege and ransacking anything and everything from among its trash.

The metropolis is an ouroborous which is eating its own tail. The metropolis has worn itself out and now, like an immense field of burnt earth, yields up the fruits of its soil: TV screens, wrecked au-

tomobiles, smashed glass, bits of used furniture, electric cables, valves, parts of motors. Nature and culture in the new prairie of New York are perfectly integrated. They are one and the same thing. [...]

It all began at the end of 1979 and the beginning of 1980. Stefan Eins, an artist of Austrian origin, after running a gallery in Soho near Canal Street, decides in the autumn of 1979 to take the big, decisive step and move to the poorest and most notorious district of New York: the South Bronx.

Soho, once an assault ground for avant-garde galleries, has been transformed meanwhile into a wealthy and very expensive residential area. The galleries, all of them very successful, compete in terms of solidity and respectability with the ones in 57th Street and the situation lacks vitality.

Everything is too regular and predictable. The job of running a gallery is purely routine. Stefan looks instead for a place which offers adventure and at the same time the chance for art to meet a public different from the usual gallery-goers. The context of art is as important as the artistic activity. It is the context which gives semantic meaning to the work. Or rather, it is the relation between the work and its context which creates new circuits of semantic energy. The new space in the South Bronx, a former shop with a window on the street, decorated by the exceptional Graffitist Crash, is renovated by Stefan himself and two other co-directors of the gallery, Joe Lewis, a Jamaican artist, poet and musician, and William Scott of Puerto Rican origin. It immediately be-

comes exclusive – unique in the way it is furnished (several internal partitions are soon covered in "tags", the signatures of the authors of graffiti in the Bronx) and unique in terms of the composition of its public. Only very few New Yorkers from Manhattan go there (many are afraid to venture that far, even though the position of the gallery is actually in a very quiet area); but large numbers of people of Hispanic and South American origin who live in the area do. Stefan immediately becomes very popular; in his gallery, which on principle spurns the ritual of the inauguration, and where anything can happen on any day at any time, artists of white origin and the local population hold long conversations exchanging their experiences.

Meanwhile, in Manhattan some very radical artists' collectives are formed. Nobody talks about collectives, either in art or in politics, in America since the days of the marches against the Vietnam war, and the controversies about art-as-a-commodity seem just as distant and faded. Yet, at the beginning of 1980, the CoLab (Collaborative Projects, Inc.) is formed, a very experienced group of artists who decide to organise a big public show open to anyone who wants to exhibit, artists and non-artists, old people and children, blacks and whites, amateurs and professionals, in antagonism, as any self-respecting avant-garde would be, with the museum, galleries and even the so-called non-profit spaces, the alternative spaces created in the Seventies, now transformed into monstrous bureaucratic machines. To be provocative, the show is set up in the area which is the symbol of lower class culture and

illicit dealing in New York, Times Square, and immediately has considerable repercussions in the art world. Some critics, like Lucy Lippard, write enthusiastically about the event while many galleries quickly move in to get hold of the most outstanding talents. The New Museum, for its part, decides straightaway to dedicate a big exhibition (the catalogue of which can still be seen) to the three main organisations involved in the venture: CoLab of course, Fashion Moda and Taller Boricua, another collective of Puerto Rican artists now disbanded.

CoLab, too, has now broken up.

But some of its members, including the critic-artist-film maker Mike (Walter) Robinson, have regrouped around ABC No Rio and continue to exhibit as a group in shows such as the one held last October at the Artists' Space (with the participation of Ellen Cooper, Jane Dickson, Bobby G, Rebecca Howland, Cara Perlman, Kiki Smith). Moreover, Collectives Internationale has recently been created, coordinated by an artist, Judy Rifka, and a critic, Barbara Moynehan.

I must say that the initial aggressivity of the groups, associated with a punk-New Wave background, has in the meantime softened. This is partly because even the energy of the kids has been to a large extent absorbed by the museums and galleries and partly because within the various collectives individual creativity prevails above all, extremely uninhibited with regard to the market itself. [...] ("Frontier art", 1982, in *Arte di frontiera*, exhibition catalogue, Mazzotta, Milan 1984).

Francesca Alinovi

[...] The blacks, sanctified by the success of graffiti, have literally invaded the New York art scene, sparking off unpredictable chemical chain reactions in the painting milieu. For the first time in history, after taking over the field of music and dance, the blacks have moved in to conquer the art world.

If you really want to feel alive when you spend a few months in New York, you have to venture along the unfamiliar maps traced by black journeys – the subway trains and crumbling walls of the South Bronx are a must. But take a look at the huge roller rinks transformed into megagalactic arenas for rap concerts (concerts-exhibitions organised even in such temples of culture as the Squat Theatre), and go along to the bars, discos, clubs and markets at the heart of the Lower East Side or the South Bronx. On Friday evenings, at the crowded Roxy – the huge Roller Skating Track where weekly rap concerts are held – you can meet the stars of official art who show up relaxed and smiling for the occasion, and former New Wave idols like John Lurie or Eric Mitchell.

But the real attraction is the extraordinary, uniform mass of teenagers of all extractions dancing to the rhythm of the orgiastic, spoken music, interspersed by lightning exhibitions of breakers, smurfers and electric boogie dancers – those supple, spectacular black street dancers who would shame any pupil of the Merce Cunningham Dance Company. The energy of these blacks is incredible and infectious, but is only partially connected to what has been called the "wild" style.

225

"Wild" is not the right key for interpreting black strength. Rap music, for instance, is spoken music, a narrative of events, a transmission of mental stories and cries from the body. Smurfin' and electric boogie dancing is an electric discharge through the nerves in which the body disconnects in schizophrenic gestures remote-controlled by the convolutions of the brain. Black culture is not just body culture, or biological culture, or non-thought culture. The black culture, like that of their white friends, is a culture of the acculturated body, of contrived biology, of thought that follows a different logic, but is still based on the culture that has accumulated in the Western world.

The black culture, of course, also has a background of submerged culture which is impenetrable to us because it has been neglected so long by the inquiring eyes of white information channels. But it is the grafting of white on black that produces the really fantastic encounters, those linguistic prodigies who are the potential future masters of the magical interrelationships between the new human species. […]

("21st-century slang", 1983, in *Arte di frontiera*, exhibition catalogue, Mazzotta, Milan 1984).

A-One

[…] The one on the wall, that's not a language: they are letters. Letters are behind language, earlier than the word but at the same time they are the foundation of knowledge. If there were no letters, there would be no knowledge, and if there were no knowledge, there would be no architecture of houses, there would be no one who shouted, and if there were no one who shouted, where would Rammellzee be? He shouts and I shoot with spray paint. Rammellzee is the one that elevated the style, he is the elevator of the style. He is at the head of a new movement, Rammellzee's army, and this army is an army of style, the army of a real war. Inside this real war and this real army there are some members of Gangsterism, Panzerism, and of the nasty squat, direct do-nothings of decadence. All those who are associated with this movement have to do with different styles and techniques: Iconoclast Panzerism, Gothic Futurism, the Grand Jurism style, Nymphism, Map Technique, Project Technique.

[…] A real war. The war of the letters. The assassination of letters on behalf of the armed letters. My job is to make war. This is my role. This is the role of A-One. […] It isn't a war between gangs; it isn't a war between people on the streets. Even if it is true that people really did fight in the streets because of letters in the past. And maybe in the future people will still fight in the streets because of letters. […]

(Translated from Italian, "Interview with Francesca Alinovi", in *Flash Art*, no. 114, June 1983).

Jean-Michel Basquiat

[…] When you think of Italian painting, you think of…
Leonardo.
The modern Italians you like?
Cucchi and Clemente.
The Americans?
Franz Kline, Norman Rockwell, Henry Ford, Wendell Willkie.

The books you read?

The Bible. I read it sometimes.

The Old Testament or both?

Both.

Music?

Miles Davis.

Architecture?

I don't know much about it.

You look at it?

I do, I just look.

You are seldom alone, very often with people.

I am trying to be more alone now, ya.

You make music?

I produce records, I did one rap record. Now I am working on an African drum album. [...]

("Interview with Lisa Licitra Ponti", in *Domus*, no. 646, January 1984).

David Bianco

[...] Even the "official" art critic has been unable to investigate the deep-rooted, complicated implications lying behind the explosive newness expressed by the Graffitists, a reflection therefore of that "transparent" American society that once again has legitimised its leadership with respect to the black community. Admittedly, this phenomenon has been rapidly dismissed as a passing fashion, one that many felt was bound to eclipse as fast as these aggressive messages criticising society and convention had been anaesthetised when they moved from the walls of the subways to those of the galleries and banks, as can be seen in the recent case of the City-bank of New York's use of gigantic graffiti to announce its new working hours to its clients.

[...] Graffiti and writings, surmounted by a crown complete with a copyright logo, are rapidly appearing before the eyes of unconditioned spectators. They do not proclaim any relationship with a territory, ethnic, or musical group, as so happens in the majority of cases, but are now apparently cryptic writings, at times subtle nonsense, that reveal their own allusive meaning only at the end, so as to prolong the viewer's attention, referring to other appointments and phrases: a kind of puzzle that the viewer must solve by himself. [...]

("Graffiti in galleria", in *Il Manifesto*, 27 August 1993).

Ronnie Cutrone

[...] When I was at the Factory with Andy Warhol, I learned to make art a job, not to first be inspired, then paint, but to paint and then be inspired; many days I'm not inspired but I still paint... For me, art is a job.

[...] I love Pop Art, it is what I grew up with, but the best way to express my feelings toward what we are doing now and Pop Art would be... Pop Art, Andy Warhol once said, is about liking things... you like a certain aspect of the culture, you blow it up, you make it noticeable, you give it back to the public. The art that I am doing very often is about not liking things, about being critical, about being stupid, about being funny... That is what I think the biggest difference is between Pop Art and my work, or Keith's or somebody else's, it is about pointing out things that are not good, while Pop Art made everything good, Coca-Cola became God... as an icon, the same way religion does... Almost all my work comes from the Bible,

227

whereas I know of no Pop Art that has ever come from the Bible… I grew up on television cartoons, on Saturday morning I watch cartoons. They are violent, they are silly, nobody dies in a cartoon and it all comes together, all the ancient symbols and the modern symbols are cartoons. I use ancient, modern, postmodern, premodern, anything that works together, as I see it, I use my symbols, I use what already exists most of the time. I use it to make a story, I use an ancient manuscript from the monks… The beasts, Christ, the symbols are cartoons of Christ, they are the lamb and they are funny men with the halo and the robes… The lines, the linear quality is of a cartoon, that is what comes out, that is what strikes you. The blending, and the shading, that's painting. I don't think about painting, or painterly things, I think about the idea; it is more conceptual.

[…] The Soviet Union as a bear, it's a cartoon; America has an eagle, it's a cartoon; the Democratic Party, the Republican party, an elephant and a donkey, it's a cartoon. Society takes these symbols very seriously and yet it is only cartoons.

("Interview with Corinna Ferrari", in *Domus*, no. 646, January 1984).

Antonio D'Avossa

[…] The birth dates of graffiti are as follows: 1967, the year in which the New York Subway Authority established a twenty-five-dollar fine or ten days in prison for whoever was found singing, dancing, playing an instrument, or writing graffiti in the subways; 1968, when Julio 204 started writing his name regularly for two years outside of his own neighbourhood (north of Washington Heights) as a challenge against the city, and thus started off a genre that had not belonged to anyone else before him; however, it was not until 1970–71 that these writings began to be spread, albeit in limited fashion, by Thor 191, a black writer who had started back in 1969, and Friendly Freddy, the first Brooklyn writer who was also black, who had made his debut in 1969 around Flatbush Avenue; and lastly, an article in the July 1971 *New York Times* that recognised graffiti for the first time as a valid art form. The article mentioned a Greek boy, Taki 183, as the founder of this new fad, and went on to say that the city administration had spent some three hundred thousand dollars in 1971 in order to combat this vandalism and remove the writing from public spaces.

Taki 183, unlike the other writers, decided to write as much as possible and everywhere. In no time at all he was famous throughout New York. That was when everyone joined the bandwagon. If you wanted to become known, the easiest way was by writing graffiti. Thousands of kids, for the most part from the lower classes, and therefore influenced by "other" cultures (African-Americans, Puerto Ricans, South Americans, Cubans, Greeks, Italians, etc.), ranging in age from twelve to eighteen, gathered together to follow Taki's example, covering the walls of the city's schools, neighbourhoods, subways cars and stations.

[…] Richard Goldstein was the first journalist who seriously tried to interpret this new phenomenon in an article

that appeared in March 1973, describing it as the first authentic youth culture to come from the streets since the time of rock 'n' roll in the Fifties.

Here is his description of an "expressive commando": "At first it seemed to be a fairly harmless thing. A small group of kids from Washington Heights slips into the subway sheds at night, jumping from rail to rail, dressed in overalls and polo-shirts, with their mothers' rubber gloves, and over-sized army work jackets that hide the cans of spray paint, each adjusted so as to give a stronger and thicker jet. One of them has stolen a bunch of keys from a conductor, and so they can open the doors, turn on the lights, and set off the alarms. The cars are standing there like silent whales, and the kids are ready to leave their indelible signs on that flesh, moving quickly up and down like action painters, until the whole car, inside and out, looks like the broken lines of colour on a television set. And the morning after, when the cars start working, they will whiz past the amazed eyes of a hundred thousand sleepy New Yorkers who will share the incredible experience of meeting SNAKE 1, STITCH, TUROK 161, and TRIK in the way they had decided."

[...] Claes Oldenburg described it this way: "You're in a sad, grey subway station when suddenly a graffiti train whizzes by carrying the light of a bunch of tropical flowers. You think: it's anarchy, and you wonder if the trains will continue to work. But then you get used to it."

[...] One thing is for sure and that is that the New York art scene has changed radically these years. The irrepressible explosion of a new generation of artists who have given or taken from or to the streets is a concrete fact, as is the increasingly keen attention being paid to the most exemplary artistic experiences in post-war America, first and foremost of which is Pop Art.

("La questione dei graffiti", in *op. cit.*, no. 57, May 1983).

Jole de Sanna

[...] It so happens that the Americans, or so it seems, have decided, or so they are trying, to make use of inert energies, wastes. All of the building fronts in the gallery neighbourhood of Soho have been painted: anyone can walk by insignificant drawings on the stairs of a building which, however, may become politically significant if the city decides to accept the enormous mass of these frescoes. The frescoes are there, they have a real weight. Inside the private Soho galleries, it is the subway and the graffiti that hold court.

All of underground New York is covered with graffiti, those intertwining, spontaneous, anonymous writings (but they are no longer anonymous in the galleries). The subway cars have literally disappeared under the doodles, and the authorities deliberately leave them there, the same authorities who pay a few cents for every Coca-Cola bottle that is picked up from Fifth Avenue. If the City of New York really wanted to keep the subway clean, it would keep it clean; if the City of New York tolerates the devastation inflicted on the subway car walls, and you, traveller, have no other choice but to be there, then it means that it does not matter to the City of New York that you are conditioned

by that sight. There is no emptiness in the network of graffiti, you have no other choice but to see.

The number of galleries entirely dedicated to Graffiti Art confirms the fact that an attempt is underway to profit from inert material, from things that are occurring outside of the academies, new or old museums, and official grants, in order to create a cultural project out of the unconventional social behaviour of one group of American citizens. [...]
("New York titola le scorie", in *Panorama Lombardia*, June 1984).

Keith Haring

[...] I consider myself a perfect product of the space age not only because I was born in the same year that the first man was launched into space, but because I grew up watching TV, reading the newspapers and magazines, and being bombarded by news about atomic energy and the menace of a nuclear disaster. I also grew up with Walt Disney comics.
I am therefore a perfect son, an exemplary model of the contemporary period, because I am only twenty-four years old and I grew up in America. And my images, just because they have to do with very simple and common human words and ideas, are very universal, they mean to be very universal, and to be communicative in a universal way. My designs are only very graphic designs, there are no other kinds of stratifications or complications. My designs stretch out on the surfaces and show themselves for what they are, there is nothing hidden or illusionistic. Even the materials are very simple. But what interests me above all is that my designs

could be extended onto any surface. My designs could be traced on any support or material, like Egyptian hieroglyphs, or Mayan and Indian pictograms. My designs mean to activate a surface and spread energy. And transform a neutral, anonymous surface, giving it a personality.
[...] I work with concepts, ideas, universal images but not with archetypes or stereotypes. I work on things that belong to the common experience, to everyone's knowledge: animals or combinations of men and animals. Facts that date back to the origins of time, and that are also found in classical art: you see angels that are human beings with wings.
My images do not come from the unconscious but only from visual information, and they are more instinctive than interior. But above all they are from the common experience. [...]
(Translated from Italian, "Interview with Keith Haring", edited by Francesca Alinovi, in *Flash Art*, no. 114, June 1983).

Robert Hughes

[...] Actually, it now seems that the pseudo-heroics... however repressive and hegemonic when applied to whites, are positively desirable for blacks. Such "reinforcement" criticism is now increasingly fashionable in America. It's bad to use words like "genius", *unless* you are talking about the late Jean-Michel Basquiat, the black Chatterton of the Eighties who, during a picturesque career as a sexual hustler, addict and juvenile art-star, made a superficial mark on the cultural surface by folding the conventions of street graffiti

into those of *art brut* before killing himself at the age of twenty-seven. The first stage of Basquiat's fate, in the mid-Eighties, was to be effusively welcomed by an art industry so trivialised by fashion and blinded by money that it couldn't tell a scribble from a Leonardo. Its second stage was to be dropped by the same audience, when the novelty of his work wore off. The third was an attempt at apotheosis four years after his death, with a large retrospective at the Whitney Museum designed to sanitise his short frantic life and position him as a kind of all-purpose, inflatable martyr-figure, thus restoring the dollar value of his *oeuvre* in a time of collapsing prices for American contemporary art. In the course of this solemn exercise in Heroic Victimology, all the hyperbole of the artist-as-demiurge was revived. [...]

Lurking behind this drivel is a barely concealed longing for cultural segregation. It corresponds to one of the most corrosive currents in the American polity today – corrosive, I mean, to any idea of common civic ground – which is to treat the alleged cultural and educational needs of groups (women, blacks, Latinos, Chinese-Americans, gays, you name it) as though they overrode the needs of any individual and were all, automatically, at odds with the allegedly monolithic desires of a ruling class, alternatively fiendish and condescending, composed of white male heterosexual capitalists. More and more, it is assumed that one's cultural reach is fixed and determined forever by whatever slot one is raised in. [...]

(*Culture of Complaint*, Harvill - Harper-Collins Publishers, London 1994).

Goffredo Parise

[...] American national-popular culture begins... in the classic way, like all national-popular cultures begin, where the decadence of the elite culture (and politics) begins, much like the way Christian culture smothered pagan culture or the vulgar tongues replaced Latin. The Christian culture was a popular culture, the vulgar tongue was a popular language, the graffiti of New York are a popular culture. Up to this point, there is nothing really new in the analysis of graffiti. The innovation, however, the real explosive "cultural revolution" that this new style announces is the following: [...]

1) *Graffiti do not communicate anything.* What does this mean? It means that a purely formal message is being launched by graffiti, one that belongs more to figurative art than to the language of communication. And yet it deals with writing, a new and heretofore unknown writing, one that does not belong to any culture, although it vaguely resembles Arabic, Indian and Asian writing. What is more, it is writing, the significance of which is unknown to its authors, as if an illiterate were to invent a calligraphy of his own that was based exclusively on the visual and not on content.

2) *The style of the graffiti is uniform.* Therefore, just like the writing of a language, the graffiti are already "set" into a graphic code. However, their uniformity is not provided by convention as in all written languages where a meaning corresponds to a "sign", but by something else. What? This something else is nothing but the uniformity of the American product in series.

231

3) *Graffiti are handmade*. The American universe is known to be industrial, one that is not based on handicrafts. To produce something by hand, which is neither useful nor commercial, is to go against the laws of American culture. This fact is extremely important for our analysis.

4) *Graffiti are ideology*. That is, they are not only an expression of political protest on behalf of the first American national-popular culture but, as in all popular cultures, they have, apart from their apparent mutism, a strong ideological charge. What does this ideology say? It says that the American national language, English, when used on the walls, in buses, in subway cars, on the sides of lorries, and on letter boxes, is immediate, communicative, and useful. Useful for what? To communicate to the Americans, reminding them of their duty as producers and consumers. Nothing more. The American language is used substantially in an exclusively economic context. It is printed. It is informal. It can be substituted by another language that says the exact opposite on the same walls of New York, inside the same subway cars, buses and on lorries. That is, it can be substituted by a language that is gratuitous, indecipherable and lacking in economic significance, one that is hand-written, with the ideal formal models of the Third World, both beautiful and useless.

It is neither right nor possible to make any predictions about such a recent and important event. Everything, any ideology, even revolutionary ones, are integrated into the American system and converted to its use. In my opinion, the first American national-popular culture has yet to be integrated notwithstanding all the efforts to date. As a matter of fact, it is reacting in some very interesting ways. [...]

("Graffitisti", 1976, in *Artisti*, Neri Pozza, Vicenza 1994).

Rammellzee

[...] We describe ourselves as "tag master killers" because, militarily, we write the illegible. Then I personally am known as "master killer" because I am the head of an armed band and I own the chief symbol, the letter Sigma. The members of my band are three, A-One, B-One and C-One, and I can arm them. However, they are totally autonomous in arming themselves by themselves. I let them be totally autonomous in arming themselves by themselves. Yes, for defence. They are totally autonomous and independent in self-defence.

[...] They are not murderers, they don't murder artists, they... but why am I saying "they"? I can't say they. It is not them who kill. They practice armament only. It's the letters that kill the other letters. So "they" are not them, "they" are the letters. And this is what they do. [...] There is only one style, and it is the present result of Sigma. It is Iconoclast Panzerism. No other styles exist in this evolution of the structure of the letter. Yes, I can also tell the others what they have to do. But I don't force them. I can advise them. But I don't want to be their teacher. What I am is a general! I can direct their energy in a certain direction. And then, if the energy wants to remain a "wild style", well then it does. But it isn't and it cannot be because you don't

arm anything at all if you only do what you want to do. There are also rules and regulations for the "wild styles", first of all, whoever wants to do the wild style must be wild with his own style. Iconoclast Panzerism instead and Gothic Futurism are disciplined-disciplining styles.

[…] [The armed letters] resemble the old Medieval warriors armed with missiles, [the disarmed ones] […] appear decorated with flowers. This is the ornamental style, the first is the "armamental" style.

[…] I know the Gothic texts, the manuscripts of the Medieval monks.

[…] I've studied the original texts. I went to study them at the Library at Bryant Park on the corner of 42nd Street and Fifth Avenue. I saw a lot of them… They are there… uhm, there's a long row of them on display as you enter, right as soon as you go into the building. And I also know some real professional monks. I'm a professional monk.

[…] [As for my experience as Mic-Controller inside Rap Music] I would say rather that it has to do with another form of consciousness-unconsciousness, similar to that which gave rise to my pamphlet. When I speak as Mic-Controller I don't know what I say, and that's why it works. I simply say. And it's real. The rhythm simply comes out of my face. And it comes out only because I know slang. I know the slang of the confused, the slang of the joint. I know the slang of New York, the slang of Chicago, the slang of Detroit. I know the slang of the subway, the slang of the street, the slang of robbers. You see, I know all these kinds of slang. And to combine them together is really like talking into the microphone. The sounds do not come into contact like in words. We break up the words. So when we say ROC/K into the microphone, we don't pronounce ROC/K but simply R.O.K. or R.O.C. […]

[…] [The Iconoclast Panzerism movement and Gothic Futurism] are not "my" movement. They are movements that started about three thousand years ago. And they were started by religious monks who were then done in when they lost their power over the letters, and this power was taken by kings and bishops and transformed into military power. But they lost it because they didn't have a valid symbol. Their symbol was the arrow. And their arrow was not able to transform itself into a missile. This arrow that they possessed was never able to be used in an efficient way because the direction it pointed to was the direction of hell, and they, because they were monks, couldn't use it in that direction. What we have done with graffiti more or less from 1972 to 1974, or thereabouts, has been exactly this. We have pointed the symbol of the arrow exactly towards its flight path: to hell! Having pointed the arrow in the right direction, we have therefore developed the structure of the arrow. And the more we proceeded in developing the arrow structure, the more this was regulated in its arrow structure. And at that point the style was no longer "wild". The style at that point was not style any more. And since what we were doing became more regulated, we discovered as a consequence that we had to regulate

the entire matter. Then we realised that the title "graffiti" was a title that none of us had ever used, it was a title in short that had been stuck on us and that meant more or less scribble-scratching or simply to scribble-write on walls. Then some of us wondered: "Write what?", "What are we writing?", without knowing how to answer. So we tried to find out and we realised we were writing Iconoclast Panzerism. We were writing a military armament training based on a symbol of destruction. And the result of what we were doing came out of the memory that we still had of tunnels, darkness, rats, policemen, dead-ends, and shit. And there where the letter had stopped in its evolution was Gothic. While mechanisms like those of tanks and the radio are Futurist, because Futurism is a mechanism. So Gothic Futurism signifies Medieval Mechanism. And Iconoclast Panzerism signifies the symbol of destruction for a military armament training.
(Translated from Italian, "Interview with Francesca Alinovi", in *Flash Art*, no. 114, June 1983).

Jerry Saltz
[…] The artists (usually black kids coming from inner city ghettos) were considered side show phenomena – it was all one manifestation, marginal but important, of middle class guilt. Almost all of these more recent artists had attended art schools and they wanted to be artists; by nature undisciplined and "animal", outlaws and rebels, the Graffiti movement is not so much the consequence of any material movement of the Sixties or Seventies as it is a maximum

exploitation of one's own resources, a disorderly attitude towards the rules of the game and a trap for all the serious problems of art and its mysterious legerdemain. They felt more tied to music than to anything else. The Graffitists wanted a bigger slice of the market for themselves, and they were ready to do without the usual scenes and spaces, so they invaded the streets and alleys instead. Their roots lay in Performance Art and with the groups of the Seventies, with a very *low* form of Pop Art and in their desire that art have a role in everyday life, a meaning outside of the gallery or the museum. Their attitude was frivolous but arrogant, "we are all artists"; and if you weren't *with* them, you were *against* them. Graffiti Art was the natural consequence, but under the effect of amphetamine, of a desire to make art more popular, to integrate it into life, and of the political radicalism of the Sixties, stripped of any pretence and objective. […]
(Translated from Italian, "Istantaneous – American Art 1980–1989", in *American Art of the 80s*, exhibition catalogue, Electa, Milan 1991).

Adriano Spatola
The world in which we live is a sign-covered world. Signs are what make possible the reconstruction and interpretation of its past, like its present. The hand that has traced them and continues to trace them is the instrument of one of the most ancient and radical needs of man. Whether is it a magical-religious activity or an advertising technique, an unconscious instinct or refined craft, free play or a simple means of commu-

nication, this need that was born with humanity has been ramified and differentiated, complicated and multiplied incessantly, until it has come to represent one of the most striking aspects of our civilisation. We move in a forest of surfaces that are stained, engraved, drawn, encrusted, and written on, we run into them like mirrors, and we are reflected in the oldest just as we are in the contemporary ones. Our past history is conserved in caverns, on rocks, in temples, and on tombs; today's history is being written on the walls of houses, in the streets, and on pavements. But the line that joins the first human sign to the advertising poster is an uninterrupted line as Desnos has said: "l'affiche est de la famille des graffiti". In the very moment that we make contact with this human vocation for the written or spoken word, the image or the sound, we become aware of its complex nature, atemporal yet undoubtedly historical in its perpetual metamorphosis, and we touch with our hands the sediment, the veritable traces, that this inexhaustible molecular agitation has left inside and outside of ourselves.

But the messages flow at different levels and speeds like the current of a river, the most corrosive force being that at the lowest level where the current pushes mud and stones against the dam of the officially adopted linguistic behaviour of a society. [...]

("Poesia anonima", in Franco Vaccari, *Le tracce*, Campietro Ed., Bologna 1966).

Bibliography

R. Goldstein, "This Thing Has Gotten Completely out of Hand", in *New York Magazine*, 24 March 1973.

N. Mailer, *The Faith of Graffiti*, Praeger Publishers Inc., New York 1974.

F. Bolelli, *Musica creativa*, Squilibri, Milan 1978.

A. Nelli, *Graffiti a New York*, Lerici, Cosenza 1978.

C. Bruni Sakraischik, *The Purest Form of New York Art*, exhibition catalogue, Galleria La Medusa, Rome 1979.

S. LeWitt, "On the Walls of the Lower East Side", in *Art Forum*, December 1979.

A. Ominous (L. Lippard), "Sex and Death and Shock: A Long Review of the Times Square Show", in *Art Forum*, October 1980.

A. Sargent-Wooster, "Graffi, graffiti e altro; l'estetica della ribellione", in *Modo*, no. 36, January-February 1981.

Documenta VII, exhibition catalogue, Kassel 1982.

N. A. Maufarrege, "Lightning Strikes (not once but twice): An Interview with Graffiti Artists", in *Arts Magazine*, November 1982.

F. Alinovi, in *Arte di frontiera*, exhibition catalogue, Mazzotta, Milan 1984.

XLI Biennale Internationale d'Arte di Venezia, exhibition catalogue, Venice 1984.

Anniottanta, exhibition catalogue, Mazzotta, Milan 1985.

L. Warsh, J. M. Basquiat, *The Notebooks*, New York 1993.

L. Malerba, "Berlino graffiti...", in *La Repubblica*, 12 December 1994.

L. Piccinini, "Wall Art", in *Il Manifesto*, 17 September 1994.

235

Transavantgarde and the New Savages
The return to the private and to painting

At the end of the Seventies a kind of remaking of tradition-
al art took place throughout the West which was termed
Postmodernism. For painting and sculpture, Postmod-
ernism meant a return to order, to the picture, to narrative
painting, albeit for many imbued with a sense of irony or
disenchantment. No longer was the past questioned, it was
simply remade; Postmodernism went from the revival to
the remake, from regression to the copy, from nostalgia to
self-projection. It borrowed from Italian Novecento, the
Metaphysics of Carlo Carrà and Giorgio de Chirico, the
works of Filippo de Pisis, Mario Sironi, and Scipione in
particular, but also from Orfeo Tamburi, Lorenzo Viani,
Ottone Rosai, and Corrado Cagli, the great extravagant
dreamers of the Italy of the Thirties and Forties.

Francesco Clemente,
Rudo, 1981

Among the protagonists of what was referred to as the
privatisation of art were Sandro Chia, Francesco Clemente,
Enzo Cucchi, Mimmo Paladino, Nicola De Maria, and in
the beginning also Mimmo Germanà. They had been ogan-
ised and theorised by the critic Achille Bonito Oliva and
promoted at first by the dealer Emilio Mazzoli. These
artists became remarkably successful internationally in just
a few years' time. Their first exhibitions were followed by
others which included other names and styles: Nino Lon-

gobardi, Marco Del Re, Sabina Mirri, Filippo di Sanbuy, and Gianni Dessì. The so-called Transavantgarde marks a return to the Italic tradition, to places typical of painting and its imagery, claiming the right and pleasure to make free use of quotations, tributes, borrowings, and digressions. Its language evokes an experience of the real and the fulfilment of the dream following illogical associations as they may appear. In the end, painting returns, nature returns – flowers, trees, animals – the entire story of humanity returns.

The visionary and splendidly puerile work of Clemente, the compromise between the archaic and the fabled in Paladino, the density of implications, hints, and fleeting seductive physiognomies of Cucchi, and the coloured musical textures of De Maria: apart from any labels or critical effusions, these are the qualities that have gotten these four painters all the attention they deserve.

In his pseudo-erotic sorties, Clemente paints figures of

Sandro Chia,
Narcissus, 1981

Mimmo Paladino,
The Great Cabalist,
1981–82

an enchanted fixity; he is alert to interior emotions which he recounts with melancholy and grace as he gathers the arcane signals reaching him from India or New York. Paladino, perpetually poised between erudite forms and the essential ones of the Primitives, between polyglottism and the vernacular, plucks and enhances the charms of the cultured Mediterranean. Cucchi, febrile and visionary, elaborates landscapes and figures that verge on the religious.

One wonders whether these are deliriums or monologues that question one's own life, about life, before painting and beyond the painting itself. One also wonders whether it is a claim for formal liberty against the "background noises" of ideologies and headlines. It may be that the Transavantgarde does not project itself beyond the obstacle, but chooses to abandon itself to the grim incantation of the world. Others are to be remembered along with the Italians: in France, Gérard Garousse, Gerardo Dicrola and Jean-Michel Alberola; in the Czech Republic, Milan Kunk

Rainer Fetting, Negro with Knife, 1982

Enzo Cucchi, Closer to the Gods, 1983

Helmut Middendorf,
African Still-life, 1981

and Jiri Dokoupil; in Spain, Miguel Barceló, José-María Sicilia and Julião Sarmento; and in the United States, James Brown and Julian Schnabel.

Together with the Italian proclamation of "painting that returns to be painting" was that of the German Neo-Expressionists or "New Savages" in the early Eighties.

Rainer Fetting, Helmut Middendorf, Bernd Zimmer and Salomé painted in a violent, dense, gestural manner, one that was "the bearer of expression and content". Zimmer, Fetting and Middendorf ran the Moritz Platz gallery in Berlin in 1978, where this highly coloured, howling "impetuous painting" had its start.

For the Expressionists of the Twenties, art had been an opportunity to intervene in society without censure in order to claim the right to provoke and polemicise. Their work, a sarcastic comment against militarism, capitalism, and the corrupt bourgeois, reconnected with the German artistic tradition in its dramatic and crudely grotesque imagery, where the theme of death for example was exasperated to the point of paroxysm. It is not clear whether that

Jonathan Borofsky,
Running Man, 1980

of the New Savages is an aesthetic rebellion or an ethical-social question. Having searched for an identity in ideologies and places that were not German, perhaps with a post-war feeling of guilt, the Berlin painters, in order to eliminate the aesthetic of the polite and cerebral, have returned to painting with an abundant use of "blood and tears" so as to again communicate in the Germanic manner. This also has the advantage of putting the painting back on the canvas, and the canvas in a frame, and returning the frame to its place on the wall.

Following the success of the New Savages, painters who had been working in the same fashion early in their careers also began to receive attention; among them, Anselm Kiefer, A. R. Penck, Georg Baselitz, Markus Lüpertz, and Jörg Immendorff.

Bernd Zimmer,
Remaining Tree Stump,
1984

241

Transavantgarde
and the New Savages

Giulio Carlo Argan

[...] I have to be sincere, art seems to have lost even the energy to live through its own crisis; the only phenomenon that is not merely one of survival and that contains a certain problematic charge is the one that goes under the name of the Transavantgarde.

I doubt whether it can be acclaimed as the resurrection of art three days after its death; it seems more likely that this is only the last convulsion. In any case, it must be made clear that the Transavantgarde is not the crisis, but its terminal stage: the crisis started long before, its origins are rooted in the ideological weakness of the old and new avantgarde movements, in the irresoluteness of the intellectual cadre in which those were inserted, and the repeated political setbacks they suffered. Today, the Transavantgarde is attempting to transpose the problem onto another plane by force, to take art out of a culture of rationality and finality, out of one that makes projects and evaluates.

Since this culture is finished, it could be an attempt to rescue it, although I really do not think that art can survive without its having a value or its being a project.

[...] I once spoke about the project and its destiny, we are in the sea of destiny with the Transavantgarde. But is the age of projects irrevocably closed? And was leaving it to destiny a necessity or an option? The project had two stages: analysis or criticism, hypothesis or invention. Projecting was a method of the productive imagination. The two columns of the Transavantgarde are tautology and quotation. Tautology is apodictic, art is art and that is all there is to it, it is not made for anything or anyone, it is a space of existence, and it certainly is not a guarantee of well-being. Quotation is not an historical experience, history is nothing but an archive: it is something that one carries along with one from the past, like the consequences of a disease. Tautology and quotation are repetitions, but if one cannot progress, then one can only repeat, and repetition is desperation.

[...] One assists then at the slow death of the image, the prisoner of the material (the distant echo of the materialism of the informal tendencies can be heard here). Why this sudden interest in the

physicality and therefore in the degradability of the image?

There is talk of the castrated imagination, of a repressed 1968, of an extremely revolutionary velleity curbed by the system. But what I do not see is the protest itself, the challenge to a culture that, self-programmed, can do without criticism and a working project. Is it possible that other agreements have been secretly made, and that art has really been placed outside of the system?

[...] Can the Transavantgarde aspire to the role of a cultural model? Or will it choose to go on reciting its stories of ordinary madness on the sidelines, floating on the stormy sea like a shipwrecked ship whose name can still be read? There are points of affinity between the culture of mass information and the Transavantgarde which still do not make it possible, however, to speak of a functional relationship. The ancient relationship of art and value has been broken, and it is excluded that art may perform any role in the social reality: today it is presented as a consumer object but it does not aspire to have any preferential qualifications in this field. The Transavantgarde makes use of the body as the vehicle of unconscious energies. The images themselves have a physical heaviness, they remain mixed with the material of the colour. They do not pass with the same transience of television or advertising images, they stagnate and require a certain time for observation. The nature of those images is ambiguous: on the one hand, they are made heavy by the pictorial material, while on the other, they are as inconsistent as names, as if they almost wanted to give visual proof of the Lacanian connection of the unconscious and language. The stagnation is like a repetition and with repetition the image is altered and corrupts, it becomes habitual, it is recognisable without even looking at it, and thus it ends up by assuming a vaguely mythic sense. Lastly, one notices that it has a physiological yet tenacious vitality of its own that sometimes spills outside of the picture and wanders over walls, pavements, ceilings and floors. One expects it to continue to grow, but it ends by occupying our vital space, throwing us out. It does not disguise the unseemliness or at times the vulgarity of its own behaviour: prostitution accepts the challenge of playing the provocative game as an exhibition of technical bravura, the unbiased use of slang. Just like the trivial, representative, yet vigorously fantastic, narrative art of Bukowski. A relationship is to be found with society: no longer educational or edifying, but one that is a game, a brawl, a complicity. Together with the grim gaiety for that matter, an acute odour of death emanates from this mass of unrestrained images. [...]

(*Avanguardia Transavanguardia*, Electa, Milan 1982).

Renato Barilli

[...] The Italians are entitled to have a chronological precedence over the Germans for reasons that once again are historical. De Chirico, the greatest exponent of the implosive tendency to remake the museum, was Italian, and for that matter he was not moving in a desert, for the widespread climate of "normalised" metaphysics was flourishing around him (the Novecento for

one). Nor is it surprising that the most representative of the Conceptual "Quotationism" in the early Seventies – Paolini comes to mind – were Italians. This area of quotations broadens as the implosion becomes more and more personal and free, and others like Rosai, Licini, and Scipione enter the melting pot. The works of Clemente, Chia, Cucchi and Paladino are distinguished by their free use of these quotations and the syncretism that has resulted.

[…] At first, they maintained an elegance of movement, and a refinement of imagery that originated in what was "made in Italy", and they certainly contributed considerably in helping colleagues elsewhere rediscover their respective hidden treasures. But then our artists broke that precious fabric of revivals and variations, and tried to become as "wild" as they could, producing an excessive amount of barbarity and "bad painting". Now, while being wild for the Germans implies the revival of an historical tradition and an important period of art (that of Die Brücke and Der Blaue Reiter), for our artists it means the renunciation of a precise filigree, as they attempt to simulate an uncontrolled fury and depart from all tradition. In short, with their protest, fury, and painting "badly", the young Germans are constantly measuring themselves with the past, repeating it with all due differences, and this is therefore acceptable.

What is not valid, on the other hand, is the mechanical transposition of that same cry of fury when it is carried out by painters like ours who have an entirely different history behind them. […]

("Selvaggi vecchi e nuovi", in *La giovane pittura in Germania*, exhibition catalogue, Galleria d'Arte Moderna, Bologna 1982).

Georg Baselitz

[…] An artist works without justification. His social ties are asocial, his only responsibility is his behaviour, and this in front of his work.

The work of art originates in the artist's mind and it remains in the artist's mind. There is no correspondence with any public. As it cannot pose any questions, it cannot make any assertions in the sense of communication, message, opinion, or information.

There is no help for it nor is its work profitable.

No condition of a social or private type will lead to a result or influence, change or render one necessary. Consequently, intermediaries are not necessary for the works of artists, nor are places for such mediation. This is no longer the time for social representatives interested in art. The disdain for art is universal. There is no applause for a new work of art. […]

("Four walls and Falling Light", in exhibition catalogue, Kunstverein Braunschweig, October-November 1981).

Achille Bonito Oliva

[…] The cultural area in which the art of the Eighties operates is that of the Transavantgarde, which considers language as an instrument of transition, or passage from one work to another, and from one style to another. While the avant-garde, in all its post-war variations, developed according to the evolutionary idea of *linguistic Darwinism* whose an-

245

cestors were to be found in the historical avant-garde movements, the Transavant-garde, on the other hand, operates outside of these obligatory conditions, following the nomadic attitude of the reversibility of all past languages. The dematerialization of the work and the impersonality of execution that characterised the art of the Seventies along strictly Duchampian lines have been replaced by a return to manual skill and the pleasure of execution which has brought the tradition of painting back into art. The Transavantgarde challenges the idea that art is progressing in the direction of Conceptual abstraction. It states that there may be a possibility that the linear direction of the previous art, whose attitudes considered that the languages of the past had been abandoned, may not be definitive. [...] The Transavantgarde artists work with a technical and operative originality; their attention, polycentric and dispersed, is no longer set in terms of a frontal juxtaposition but incessantly crosses through all contradictions and commonplaces.

(*Avanguardia Transavanguardia*, Electa, Milan 1982).

Flavio Caroli

[...] Neo-Expressionism had already begun in Germany on the comprehensible bases of an autochthonous culture during the Seventies with the historic names of Baselitz, Immendorf, Lüpertz, and other companions of theirs; it was sighted opportunely by some foreign artists who had business connections with German dealers (Kounellis was constantly talking about Günter Brus during 1976–77); it was taken up by some Ital-

ian painters who pushed their work more and more towards a deformation of form; and was then relaunched in an anthropologically new and standardised form by the artists of the latest generation, and among these the Germans have the closest ties with a tradition that is rooted in their culture. [...]

[...] We can sense a vitality, at times desperate, and the anger and violence of the new German cities pulsating in the paintings exhibited; an unease and rebellion against an apparently orderly and productive world that hides within it the wholesome germ of a frightening will for individual expression. Have you ever spent a Sunday in Cologne or Berlin? Everything seems organised for the melancholy rites of "free time". And yet, between the punctual trams and the clean squares, the rumble of life can be heard in the distance: the life of sex, drugs, and alcohol; the life of an inner disorder that no programming or wealth will ever be able to appease, and that only art can try to express.

[...] Apropos of the current international situation of art, when I speak about a "Magic-Primary" creative attitude, I am thinking about the emergency and inevitability of similarly profound tendencies. About a "Magic" that evokes the seductive fantasies of a lost spontaneity in the artwork. About a "Primary quality" that emerges from the deepest, most unmentionable impulses of the unconscious, as the fathers of psychoanalysis, Freud and Jung, have taught. [...]

("I mostri di una domenica tedesca", in *La giovane pittura in Germania*, exhibition catalogue, Galleria d'Arte Moderna, Bologna 1982).

Flavio Caroli

It is not a tendency, it is an orientation, an aura, a tension of the imagery, an anthropological condition. It is not a school, nor does it wish to make proselytes: the school is a constraint, an enchaining (the opposite of linking together), a lesson taught and accepted. It is not a tendency: it is a movement, in the sense that it is activistic, evolutionary, fluid, some might say root-like. It is a request from the collective unconscious, informed ahead of time by the antennae of the artists. Primary Magic is the farthermost past in the nearest future.

The archetype is what is Primary. The art of the Primary is a search for archetypes: original nuclei lost in humanity's prehistory, symbolic forms deposited in the collective unconscious. Why should there be a search for the Primary *today*? Because we live in the absence of a future and in a time that is ahistorical. The absence of a future prohibits the ideological projection of the historical avant-garde. It was optimistic and moralistic. Today it is impossible to be optimistic because the ahistorical contemplates neither the good nor the bad, it only contemplates being. One cannot be a moralist because moralism is teleological, eschatological, finalised. If there is no evolution, there is no end. Magic is fascination, beauty, some might even say seduction.

It is the pre-logical evolution of animistic bodies: the divinity of art, the protective principles of the opus. If the Primary has prehistoric archetypes, then, in this context, Magic has historical archetypes: the history of art as an accumulation of tensions, the aggregation of sublimity and beauty, the curtain between the possible and the real, between the unconscious and the revealed. ("Il Magico Primario", in *Magico Primario*, Fabbri, Milan 1982).

Sandro Chia

[…] The best discussions about art that I've had have been with collectors who today are real critics in the strictest sense of the word. A collector is someone who, when he says "I like it", follows up with an action, that is, he is ready to pay the price for his judgement. It's like playing poker, and when you say "I see you", you have to put your money down on the table.

[…] The collector's word is followed up by action. Money is very important for artists, not because an artist is particularly avaricious, but because money has an interior, alchemic meaning. When you read the letters of artists, from Michelangelo to Raphael, Titian or de Chirico, they always talk about money.

[…] But nobody really understands the work, sometimes not even I understand it. I mean to say that it is better not to understand the work too much because whatever the interpretation is, the work in itself is always mysterious. I do not have, nor do I wish to have, a key to read my own work; on the contrary, it is made up of something impregnable, something that is in constant movement. […] It is my intention to become a great artist, but the road is long and difficult, and even if I am strong and courageous, I may not be able to make it, but I do enjoy running this mortal risk. I know very well that playing this great game depends on me and me alone, and I have no intention of sparing myself.

[...] The Transavantgarde reminds me of nothing, because it means nothing, like Neo-Expressionism means nothing. Unfortunately, for the work of a very few painters, many less than those mentioned on the conventional lists, there is no corresponding work, so to speak, of theory, but that may also be fortunate because it gives them greater freedom. [...]

("Sandro Chia", interviewed by Giancarlo Politi, in *Flash Art*, no. 121, June 1984).

Enzo Cucchi

[...] An artist journeys in an absolute void; can he leave it? He must not leave it, he must not be a slave to that! An artist must simply stop establishing a relationship with the outside. Because even in testimonies that were intensely ideological, the Futurists for example, the artist continued to maintain a relationship with the outside. This has to be interrupted. A relationship with the inside has probably never occurred, but today I think that it is necessary, because if all the signs have gone crazy, the first thing that comes to my mind is that these crazy signs are floating in a jungle, and you move around there like an illegal trying to bring a sign out, without bothering to say whether it is good or bad.

[...] But what is the Transavantgarde? Ask the critic who is responsible for it, he knows how to use this term...

[...] It seems to me that today the world of art is full of "characters". It's unbearable. It should be the other way round, or at least be a sign of the contrary...

("Interview with Gabriele Perretta", in *Juliet*, no. 39, December 1988 – January 1989).

Zdenek Felix

[...] The appearance of young artists like Enzo Cucchi, Sandro Chia, Francesco Clemente and Nicola De Maria has been influencing the current climate and art scene almost like an avalanche since the late Seventies. Around 1980, in Germany, Switzerland, Austria, Holland, and other countries, the artists began to look for their expression in a language of imagery [...] that was subjective and often provocative. The most tangible sign of this changed situation was represented by an entire generation of artists' renewed interest in painting and those means of expression that heretofore had played subordinate roles in the art world.

[...] The generation included those who were born between 1944 and 1956; the situation developed in local centres between 1977 and 1982, while its parameters became evident internationally in 1980. The event that first threw light on the young Italian artists was an exhibition held in 1980–81 in Basel, Essen and Amsterdam that showed works by Sandro Chia, Francesco Clemente, Enzo Cucchi, Nicola De Maria, Luigi Ontani, Mimmo Paladino and Ernesto Tatafiore. A series of exhibitions of the young German artists also proved to be milestones and had repercussions in many independent centres. In Berlin, in the spring of 1980, the exhibition *Heftige Malerei* (Violent Painting), organised by Thomas Kempas with paintings by Rainer Fetting, Helmut Middendorf, Salomé and Bernd Zimmer, caused

an outcry. A group of artists were presented there who had already been showing their intensely coloured paintings in Berlin since 1977 at the Galerie am Moritzplatz which they themselves ran. That same year, the paintings, drawings and collages of young, still unknown, artists were presented at the exhibition *Mülheimer Freiheit & interessante Bilder aus Deutschland* at the Paul Maenz gallery in Cologne: Hans-Peter Adamski, Ina Barfuss, Peter Bömmels, Werner Büttner, Walter Dahn, Georg Jiri Dokoupil, Gerhard Kever, Albert Oehlen, Gerhard Naschberger and Thomas Wachweger. All these artists were working in Cologne, Hamburg, and Berlin, and they rejected all the conventions of painting with what, to all appearances seemed, to be a lack of style. Equally important exhibitions included the one that Jörg Immendorff installed in his Düsseldorf studio, *Finger für Deutschland* (1980); *Rundschau Deutschland I* held in an old factory in Munich; *Bildwechsel* in the Berlin Academy of Art; and *Junge Kunst aus Westdeutschland '81* in the Galerie Hetzler in Stuttgart (1981). […]

("La pittura in Germania: gli inizi degli anni '80", in *La giovane pittura in Germania*, exhibition catalogue, Galleria d'Arte Moderna, Bologna 1982).

Christos M. Joachimides

[…] During the Fifties, the most important exhibition of Pollock, de Kooning, Rothko, and Kline was held in Berlin, at which time the young German artists discovered the new dimensions of form and freedom. This new freedom of expression accompanied by a romantically exaggerated self-awareness, became the instrument of these artists who were working on a new image of themselves by examining their own past.

They found a promoter in Michael Werner who, in 1963, together with Benjamin Katz, opened his own gallery in Berlin. He was particularly interested in Baselitz, Lüpertz, and Penck. The first Baselitz exhibition immediately turned into a scandal when the public prosecutor (for decency) confiscated a certain number of pictures under the pretext of obscenity. The lack of an adequate collectors' market in West Berlin prompted Werner to move to Cologne in 1968 where his gallery became the focal point of the new expressive way of painting.

("A Gash of Fire across the World", in *German Art in the 20th Century*, exhibition catalogue, Prestel Verlag, Munich 1995).

Heinrich Klotz

The reemergence of the figure restores to painting the great potential of the narrative image. Conveying one's own experience of the world again becomes the painter's concern. Perhaps the most direct approach came from the Berlin painters Fetting, Middendorf, Salomé and Zimmer. Confessing to what moves them the most, they laid themselves open, stripped themselves bare in defiance of all programmatic or theoretical caution. When Middendorf and Fetting depicted discotheques – singers, guitarists, dancers, the crazies and eccentrics of the Berlin New Wave scene – they were showing us exactly what they had experienced. […]

249

During the years the Neo-Fauves emerged, Peter Bömmels, Walter Dahn and Jiri Georg Dokoupil, Hans Peter Adamski, Gerhard Naschberger and Gerhard Kever, all Cologne painters, formed the core of a quite different group, the Mülheimer Freiheit, which existed for a short time after 1980, until the artists went their separate ways. [...] The return to mimetic, narrative painting by way of abstraction – and not by way of a retreat to pre-abstract modes – is symptomatic of a phenomenon that has proven decisive for the post-modern ethos.

("Abstraction and Fiction", in *Refigured Painting. The German Art Image 1960–1988*, exhibition catalogue, Prestel Verlag, Munich 1989).

Mimmo Paladino

[...] Each work of mine is always and totally in equilibrium, in the sense that movement is never declared, neither one way or the other. I consider myself an artist suspended on a wire: I can fall from one moment to the other, but I don't want to fall from either side. And the painting is the product of this equilibrium.

[...] [The discontinuity] originally was not an intentional attitude, it was more of an uneasiness that our own work provokes which arises from instability, dissatisfaction, and a desire for freedom. With time, unfortunately, there has been a return to "style", to an identifiable language. The market and the galleries have been a real interference; in a way they have deadened the initial vitality that was made of a continual fabrication of mysteries and short-circuits. [...]

("Intervista con Michele Bonuomo", in *Terrae motus*, catalogue, Electa, Naples 1984).

Norman Rosenthal

[...] Once again the artist looks backwards through the abyss of the twentieth century so as to vindicate the aesthetic values that are certainly part of Germany's contribution to civilisation. It is believed that Theodor Adorno, the famous German sociologist of the Frankfurt School, said that after Auschwitz it was impossible to write poetry again. George Steiner speaks about a "moribund" German language after the last flowering of German literature during the years of Weimar, which produced masterpieces by writers as different as Rilke, Musil, Thomas Mann, Brecht and Kafka. But just as the years of exile produced the masterpieces of Beckmann and Klee, the exile that united both Mann and Brecht also saw the production of some of their best works. The greatest victory for Nazism would really have been the total destruction of German culture, and this would also include its pictorial culture.

The artists of the first half of this century, they themselves an elite, toyed with something that came close to the fire of culture. The world was seriously and horribly damaged. The post-war artists, who perhaps best represent the German spirit, are those who, having fully taken note of the horrors of this century, blend together with irony and respect a veneration for the healing powers of the artist and the renowned cultural tradition of Germany.

(Translated from Italian, "A Will to Art

in 20th-Century Germany", in *German Art in the 20th Century*, Prestel Verlag, Munich 1995).

Giovanni Testori

[...] They arrive, these painters, like lightning bolts; they hang their paintings that are exaggerated and always or almost always excessive, way beyond the customary standards of force, tension, violence and dimension; they light their fires that suddenly turn the day into dismal night and night into a realm of livid sinister flames; flames similar to those that illuminate the streets of the earth, the markets of prostitution, human shame and destitution, but also the limits of extreme, uttermost, desperate hope. With a kind of scandalous pressure, that seems unaware of pauses and modesty, they exhibit the drama of how impossible it is for them to live here now and like this; but they exhibit, they extol, and together they also tread on their unhappy, woeful loves, and that cruel, self-destructive mysticism that usually rises like a thick, heavy, senseless, yet redeeming vapour from the most atrocious challenges and the most atrocious perfidies proper to it, sexuality. Unlike the protest of their fathers, theirs is not of a social or an ideological nature; it is torrentially existential and may even be of an undetectable lethalness. Actually, an awareness of the unconscious exists in their paintings that are as endless as their dimensions are; it displays and exalts them as it is about to enclose them in a tiny cell of tangled dementia. These painters know that man's blindness can no longer depend, as it was once believed, on this or that power, but rather brutally on that basic condition which is birth, as if the umbilical cord of every person were tied to some obscure lump, some obscure tuft of gloom, ruin, and death. [...]
("Ritorna il fantasma di Edipo", in *Corriere della Sera*, 14 November 1984).

Bibliography
A. Bonito Oliva, *La Transavanguardia italiana*, Politi, Milan 1980.
XXXIX Biennale Internazionale d'Arte di Venezia, exhibition catalogue, Venice 1980.
A. D'Avossa, "Note sulla Transavanguardia", in *op. cit.*, no. 52, 1981.
F. Caroli, *Magico Primario*, Fabbri, Milan 1982.
Documenta VII, exhibition catalogue, Kassel 1982.
Z. Felix (edited by), *La giovane pittura in Germania*, exhibition catalogue, Galleria d'Arte Moderna, Bologna 1982.
C. Joachimides (edited by), *Zeitgeist*, exhibition catalogue, Martin Gropius Bau, Berlin 1982.
Anniottanta, exhibition catalogue, Mazzotta, Milan 1985.
A. D'Avossa, "La Transavanguardia", in *Arte in Italia 1960–1985*, Politi, Milan 1988.
Refigured Painting. The German Art Image 1960–1988, exhibition catalogue, Prestel Verlag, Munich 1989.
N. Rosenthal, "C. C. C. P.: ritorno al futuro", in *Arte italiana del XX secolo*, exhibition catalogue, Leonardo, Milan 1989.
German Art in the 20th Century, Prestel Verlag, Munich 1995.

Anachronism
The past (or the museum) as an illusion

In the spring of 1980, Maurizio Calvesi presented a handful of Italian painters, among whom Alberto Abate, Stefano Di Stasio, Franco Piruca, at the De' Foscherari gallery in Bologna. It was the beginning of a manner of painting that *exalted the past*; in the following years it would be referred to as Anachronism, Cultured Painting, Hyper-Mannerism, or Memory Painting.

Carlo Maria Mariani, who had been noticed many years before by Maurizio Fagiolo dell'Arco, painted in "museum" fashion, dwelling on myth. But Mariani, with his angels, nymphs, poets and prophets – the subject matter of his opulent canvases – constituted one case, an anomaly, a paradox.

With the Bologna exhibition and, later that same spring, at another one held at the La Tartaruga gallery of Plinio De Martiis, who had supported the international avant-garde of the Fifties and Sixties in Rome – perhaps because of a thirst for neo-classical chimeras or for a need to please the cultured and famous – other painters came onto the scene, like Lorenzo Bonechi, Marco Tanganelli, Bruno D'Arcevia, Lawrence Weiner, Franco Vaccari, Omar Galliani, Ubaldo Bartolini, Carlo Bertocci. In a certain sense, Salvo, Roberto Barni and Athos Ongaro were also part of this group.

While Mariani had clearly moved into the area of the *false* and *fictional*, the others seemed to exemplify a certain coercion to regress. One often assists at the *Second Hand* of the *Olympian Dream*. In reality, these artists are far from that awesomeness of the pre-Baroque that was referred to as Mannerist, and the Nietzschean sensitivity attributed to them by some critics, their only nostalgia being for a lost paradise. It has been argued that Anachronism is equivocal not so much because it copies the Classical, but because it repeats the idea of the Classical, one that tends to be closer to the models of Pietro Annigoni and Gregorio Sciltian than to those of Guido Reni. That is, the picturesque Classical, or rather, the picturesque remains of the Classical that have been aborted or suffocated in the oleographic.

Carlo Maria Mariani, The Hand Guides the Intellect, 1983

It has also been argued that this painting may contrast with our consumer civilisation, but this is difficult to believe since the works seem to have been created for commercial use. It is difficult to consider these works as a form of insubordination, for our eyes can only see the reproduction of a genre that is a sterile imitation of the sources on which it is based.

Alberto Abate, Portrait of the Artist with his Demons, 1983

Lorenzo Bonechi, Figure with an Angel, 1982

Anachronism

Maurizio Calvesi

[…] [With the "Anachronists"] research is moving in the direction of an unusual way of reinventing the art of the past, in which the historical model (from the Renaissance, Mannerism, Baroque, Neo-Classicism, or Romanticism) serves a purpose that is similar yet different from that which the original model probably had for the historical avant-garde painters.

It was, in fact, in primitive art that the avant-garde painters at the beginning of the century sought the essence of that "authenticity" that they felt had been lost in the history of Western civilisation and tradition. By overturning this premise, the "Anachronists" have recognised that the most exuberant form of mythic imagery has been manifested in the Western painting (or sculpture) of the past centuries, and in classicism, and that it represents a repertoire to revisit and revive in the encounter between memory and consciousness. The "tradition" or "academy" that they refute is the academic tradition of the avant-garde. What they reject ("anachronistically", in contrast, that is, with their own times or its practice) is then art's compromise with consumerism, pointing out a "value" in art that contrasts with the non-values of consumerism. Thus they re-propose a painting of slow, stratified processes, whereas the avant-garde had abbreviated the times of painting down to the immediacy of the gesture.

It would be erroneous to discern a form of passive restoration or a cancellation of present day anxieties in this research. Indeed, such anxieties, suffused by an almost morbid touch of introversion or suffered extroversion, are visible in the mythological fantasy of these artists. It would also be erroneous to call them a group or the exponents of a specific tendency, seeing that they are so different and independent from one another in Italy, France, and England, both in aesthetics, models, and attitudes, reaching an extreme that I would define as mental "transvestism". In some cases, there is such a total identification with the model of the past that the artist conceives and paints "as if" he were a painter of the past, although he does leave an occasionally ironical or "conceptually" detached trace of a self-analysis of his own operation.

257

("Arte allo specchio", in *XLI Esposizione Internazionale d'Arte di Venezia*, exhibition catalogue, Venice 1984).

Goffredo Parise

The effect is that of the *trompe-l'œil*, something that appears but is not. The cause of this effect? For us, it was clearly the Baroque, Baroque art, the sentiments of the Baroque, the Baroque operation: that is, emphasis, nostalgia, ecstasy, the rhetoric of something that confuses by means of the eye or the heart. What is this something? It is painting quite simply.

[…] But oh dear, […] there is no painting here. There is much, a great deal about painting, from Böcklin to Dante Gabriele Rossetti, from Symbolists like Füssli to Savinio, from Delvaux to other more or less famous Surrealists; there is, as we have said, de Chirico above all, but there is no painting.

In compensation, there is literature. And since there is a lot of it and little of painting, many words will be spent about this strange, new, yet always Conceptual operation.

[…] It is true, in any case, that style is style, but in painting it is expressed in painting: if the painting is, as in this case, allusion, *trompe-l'œil*, metaphor and above all an essay that is at the same time melodic and metaphysical about painting, the concept remains, and so does the sound, and even the chorus.

Thus, each painting – while still expressing in itself, as a figurative test, the strong and very current narcissism that characterises all the younger generations subject to "anthropological mutation", such as consumerism – this too is con-

demned: by its conceptualism and the ideology of not distinguishing itself from the others. It is true that the "workshop" of the past at times standardised apprentices and masters, but the rejection of history today has not gone quite so far. […]

("Anacronisti", 1980, in *Artisti*, Neri Pozza, Vicenza 1994).

Roberto Pasini

[…] The various exponents of a different version of citation can be numbered under this label. It is a citation less free and easy and less lively than that practised by the New-New Ones who are intent on recuperating the more archaic iconographic imagery of the sixteenth, seventeenth, and eighteenth centuries. In it, painting becomes saturated with a new mysticism of the work, a devotion for the past, a tension at its origins that radicalises the problem of deviation, ironic consciousness, and that acrobatic, quintessential lightness that governs the entire operation of Postmodernism, reaching a threshold of identification with the model, a deprivation of the "between", and therefore a "repetition" that is not "different". Herein lies the fascination and risk of a similar aesthetic, which captivates and disconcerts at the same time, liberates impulses long repressed by the avant-garde culture, re-proposes values that were for long unacknowledged and considered obsolete, and overturns the senescence of their signs, presenting them as a source that can be drawn on eternally in a new conception of consumerism, time, and making art.

[…] The antithesis between originality

and origination is at the bottom of this change of tack, and de Chirico had already conceived it when he put it in the mouth of his Hebdomeros. In this way, art is transformed into "work in regress", it frequents the immobility of the museum and becomes an exercise for "gallery-haunters"; we have fallen into that strange, doubtful, yet charming situation in which maximum alienation coincides with maximum re-appropriation. To use the words of Heidegger, "Being [of painting, we can add] is ontically 'extremely close' to itself, [and] ontologically 'very distant'." [...]

The broad spectrum of citations under examination in this brief introduction shows us that at the end of the century (and the millennium) there was and continues to be a multi-dimensionality of the phenomenon of return which is articulated by the rhythm of an impasse that perceives the presence of a "stopper at the bottom", or rather, of a futureless condition. Therefore, the citation, in its various forms, is symptomatic of the recoil, and attests to a widespread *sense of the end* which, although it is not viewed in an apocalyptic or millenary sense, finds the embryo of an epochal anxiety in the collective and the artistic conscience. Such an anxiety is not determined by a fear of the *finis mundi* so much as it is by a mechanism inherent in the historical process itself, so that in determinate circumstances that almost always coincide with the end of a century or with the end of an historical-cultural cycle, the prevalent position is that of eclecticism, or horizontal expansion. This could be described as the "catwalk effect"; that is, when all the girls appear *simultaneously* at the end of a show to parade for the public. Thus, the current art sanctions the co-presence of many returns, and the gift of ubiquity is lavished on us by the typical Eighties' citation.

Art finds itself serving itself, and the etymology of the key term on which our argument rests reveals the secret connotations of the operation over which it presides. *Citation* derives from the Latin *cito, citare,* that is, "to call", an intensive of *cieo, ciere,* whereas the adverb *cito* means "rapidly, in a hurry". Art calls the authors of the past, convokes them (the term "to cite" is also valid in legal jargon), calls the roll, but naturally "in a hurry", so that they do not reappear in flesh and blood, but rather in fragments, according to a spirit that does not replicate the connotations like a registered reprint, but catches some pretext or crumb of them here and there, the arcane sense of a correspondence.

The false traveller does not move from his armchair. As he awaits the end (be it small, medium or large), he leafs through the album of history, delighting in its infinite finitude.

("Il Falso Viaggiatore", in *Anniottanta*, exhibition catalogue, Mazzotta, Milan 1985).

Italo Tomassoni

[...] Some contemporary artists individually cultivate a sophisticated, extraneous mannerism behind a screen of execution lacking in pathos. Such mannerism confuses reality and establishes, through pretence, the supremacy of what is false. At the origin of this experience is a reflection about art and the

impossibility of representing it which was inaugurated by the investigations of the classical.

[…] By its placement in another time, this painting also puts into practice a different space. This space is the void, the separation from physicality, the loss of an atmospheric sense, the rarefaction of physics and also metaphysics. In such a suspended condition, the artist, a stranger to everything, savours the disintegrating taste of losing his identity, and can finally administer his own divided sense calmly as the serene unknown master of languages and formulas that have been transferred to him by the involuntary mechanism of memory.

A parallel art is thus formed, a doubly abusive binary of history whose stations are not even those of time lost and refound, but those of a lateral, motionless time, evasive of rules and satisfied with its indefinite, untraversable season. Together with an old schizophrenia centred on time and its lost capacity to define and date itself through style, these defective experiences throw light on the nihilism of a megalomaniac art that is experimenting with its own destiny and ontological damnation, which is that of representing imagery or producing a simulacrum, therefore unreality.

[…] The parallel artists are no longer subjugated to the myth of the alternative, but are busy primarily with liberating themselves from a compulsion to paint: they let their work be reabsorbed in the fluctuating tide of the history of art for which they represent an alteration, assuming the flow of imagery that crowds their perturbed experience as the cultivators of form and style. As the

subjects of such deplacement, these artists court disaster and for an instant try for to conceal effortlessly the identity they have fought for which had conditioned their existences and limited the heroic activation of their erudite memories. In much the same way as an actor has to come to grips with a new part, the artist leans on history not to imitate its reasons or to take art out of its context. On the contrary, he defrauds the art of history in order to disclaim the principle of eternity and permanence by making art one text, and a single, contextual visionary experience. The cancellation of time coincides with a philological practicability; the body of the history of art is lyophilised, and a wide variety of times communicate in the humours that emerge. Perhaps minor contemporary authors, those without a future, and certainly those without a past, measure themselves with other times and spaces through untimeliness.

As Goethe said, only geniuses are forced to live in their own time. Minor artists do not allow themselves to be conditioned by time, for the time they practice depends on them, and creates an effect of displacement within the temporal dogma of history. Naturally, the entire game is pervaded by an infinite irony, and these artists do not bother to remind themselves that their art is a variation of the phenomenology of fiction.

[…] Essentially these images have been played entirely on appearance and surface and without profundity. In any case, they have been more inaccessible and hermetic than the idea of profundity and they have not had any specific sig-

nificance or content while evoking every possible sense in art. This type of estrangement of art in art generates a sense of death that presides over those simulacra which, perhaps like no other form of contemporary art, remind us of the irremediable and irreversible loss of the history of art. In this context, imagery is a dead language in the sense that the death of the image is experienced by the image that generates it.
("L'azione parallela degli ipermanieristi", in *Flash Art*, no. 113, April 1983).

Bibliography
M. Calvesi, *Buon giorno, fantasmi*, exhibition catalogue, Galleria De' Foscherari, Bologna 1980.
F. Caroli, *Magico Primario*, Fabbri, Milan 1982.
I. Mussa (edited by), *Pittura colta*, exhibition catalogue, Galleria Pio Monti, Rome 1982.
M. Calvesi, *Gli anacronisti o pittori della memoria*, exhibition catalogue, Graziano Vigato, Alessandria 1983.
M. Calvesi, I. Tomassoni (edited by), *Il tempo dell'immagine*, exhibition catalogue, Foligno and Spello, 1983.
F. Caroli (edited by), *La forma e l'informe*, exhibition catalogue, Galleria d'Arte Moderna, Bologna 1983.
M. Calvesi, I. Tomassoni (edited by), *Anacronismo, ipermanierismo*, exhibition catalogue, Anagni 1984.
XLI Biennale Internazionale d'Arte di Venezia, exhibition catalogue, Venice 1984.
Anniottanta, exhibition catalogue, Mazzotta, Milan 1985.
I. Tomassoni, *Ipermanierismo*, Politi, Milan 1985.

The Eighties

Regression, will-o'-the-wisps, rediscoveries and new arrivals

Were the Eighties really a "perverse, idiotic and dangerous" decade as Thomas Bernhard wrote?

One might say that, more or less from 1968–69 to 1987–88, much of what was new in art was stigmatised by an incapacity for a future vision, or perhaps, better yet, by a vision of the future dominated by fear. Since art is not made up of a bunch of reassuring affections that can be adopted when needed, all kinds of survival strategies have been practised as a result of the lack of interest, ideology, and the hope of a project: the absence of violent emotions, a lamentable bourgeois melancholy, a disappointment in reality, a mannerist pastime, a minor desireless unhappiness.

Abundant space has therefore been given to micro-emotions, solipsistic fervour, our own circumspect treatment of ourselves, and a mephitic particularism of privacy (that later transcends into the privative). It has also inveighed against the re-use of past formal models.

We have seen, in the pages dedicated to the "movements" of these years, how there has been a mixing up of Abstract-Informel, Expressionism, museum painting, Metaphysical Painting, and that of the dentist's waiting room: *high* culture and *low* culture, for a product that has been called *Postmodern*. The illusion of a past that has re-

mained stationary reigns in this process, while the present, in many aspects, has already become posthumous.

Perhaps art has never been so *mundane,* in the sense that mundane is ordinary, instant and lacking in depth.

When one thinks of the artists of the Sixties and Seventies, the interpreters of Programmed Art rather than those of Body Art, those of Conceptualism rather than those of Land Art, for example, one can see how they, who were affected by that exquisite disease which is the desire to remake the world (freely quoting Henry James), had proposed a model of art that was critically bound to the needs of the present and yet was an alternative to what had previously been in vogue. Until the Eighties, art had repre-

Anish Kapoor, Void Field, 1989

sented a desire to come up with new ways of communicating as well as an attempt to free people so that they would be able to live better inasmuch as they could manage their own lives with a greater awareness.

Only a few artists rebelled against the timid conversion back to those models of life and thought that were re-assessing the concepts of stability and security; desire was gone and all passion spent. Grace, charm, and solemn, pompous forms concealed considerable fatuity, the trifle connected to the paradox, a certain folkloric brutality and the mediocrity of a prosperous condition that was neither sublime nor exciting, having no inclination for the brilliant idea or error.

The result? Minor works, *d'après*, repetitions, delicate perdition, *pas de deux*. This is not to say that there have been no exceptions; however, these have not altered the general panorama.

On the other hand, and perhaps because of all these reasons, the Eighties were the decade in which heretofore neglected

Joseph Beuys, Plight, 1985

265

artists became famous like Joseph Cornell, Carol Rama, Marcel Broodthaers, Louise Bourgeois, and Francesco Lo Savio; and underestimated ones recouped like Roman Opalka, Michel Badura, Agnes Martin, Claudio Parmiggiani and Eva Hesse; others were again celebrated like Mario Schifano, Cy Twombly, Mario Merz, Michelangelo Pistoletto, Jannis Kounellis, Giulio Paolini, and the extraordinary Louise Nevelson; while painters like Francis Bacon or the enormously seductive figure of Joseph Beuys continued to be honoured.

Art galleries and museums bestowed a great deal of attention on those who were sensitive to social and political problems. Once it had been Saul Steinberg and Jack Levine, now it was Carlo Tullio Altan, Topor, Folon, Tullio Pericoli, just to mention a few of the better known ones.

Pericoli, who together with Emanuele Pirella had become famous in the Italian press for his satirical vignettes, constitutes a case apart, for in addition to his professional activity he is also a painter of watercolours. But what kind of painter is he? Visionary, it has been said. Certainly, his figures, landscapes, and stories suggest the past, and more

Cindy Sherman, Untitled, 1989

Charles Ray, Mannequin Fall '91, 1991

than dreams, they are the exhalations of an erratic, suspended way of life. The author seems to raise a gossamer curtain in order to lead us back into a secret atmosphere that taps an archaic yet familiar patrimony of signs and symbols. Persevering and subtle in his parodistic rhapsodies, Pericoli transforms the absurd, the unpredictable, the playful, the clownish, and the orphic into a catalogue chockful of clues with an irony that is at times Socratic and at times romantic. His works are filled with signs that grow on themselves and give rise to a bizarre depository of stories.

This proliferation then of continual surprises that fluctuated between discoveries and rediscoveries was due to a circuit of energies that also attracted other generations: therefore Cindy Sherman as well as Tadeusz Kantor; Lothar Baumgarten and Gino De Dominicis; Gerhard Richter and Orlane; Richard Serra and Sterlac; Magdalena Abakanowicz, Julian Opie, Jeff Koons together with Salvatore Scarpitta; Mona Hatoum and Anish Kapoor, Rebecca Horn and Gabriel Orozco, Reinhard Mucha but also Laurie Anderson, Hilla and Bernd Becker as well as Niele

Thomas Ruff, Freak 102/13, 1994–95

Andres Serrano, The Morgue, 1995

267

Toroni. They no longer represented groups in the sense of movements, tendencies, or styles, but rather the emergence of many diverse individualities.

There was a return to politics in the mid-Eighties. The Gran Fury (eleven from New York) criticised the false morals of the religious cults, and relaunched the theme of AIDS. Throughout the Western world there was a return to the political commitment of artists, which, starting in 1967 with Ad Reinhardt, Joseph Kosuth, Hans Haacke, Enzo Mari, Enrico Castellani, Piero Gilardi, Fabio Mauri, Carl Andre, Nancy Spero, Daniel Buren, and the Art Workers' Coalition, had characterised the art of that decade and the following one. Thus the art of women or, better yet, the women in art made their presence felt, since feminism, once the original sexist claims had been expended (Valie

Christian Boltanski,
Purim Feast, 1990

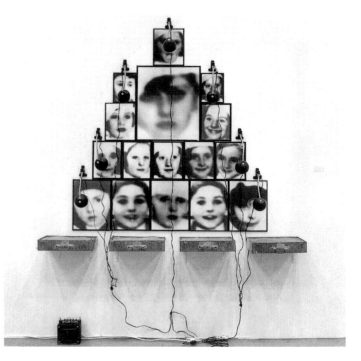

Export, Judy Chicago, Suzanne Santoro, Natalia LL., etc.) turned to the political. The feminist question was continually regarded as being more and more tied to those areas of society that were changing the fastest, and which were giving rise to phenomena like terrorism, retrogression, marginalisation, multi-racism, an interest in ecology, and the perceptive pollution exercised by the mass media, etc.

The American women artists have been particularly outspoken in blaming obscenity and violence for the decline of the United States. Once the glue of ideological and sentimental solidarity that held the great international community together had dissolved, and the false values of productivity and efficiency exposed, there was an about-face in America as the country changed from being a melting pot of different languages, cultures, and ethnic groups that

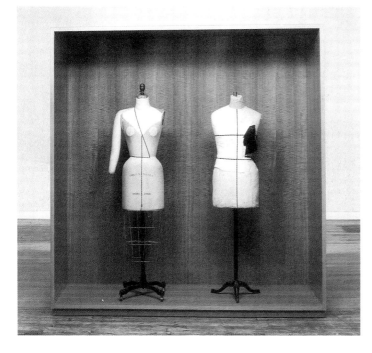

Haim Steinbach,
Untitled, 1990

were united in their Americanness into a land of separate-ness and division. The crushing of culture by politics was looked on as the most worrisome event of the decade. All this and much more was represented by Jenny Holzer, Bar-bara Krüger, Annette Lemieux, Cindy Sherman, Cady Noland, Nancy Rubins, Kiki Smith, and the very young Barbara Watson, as they all, in substance, declared: "Death is the modern question." And they talk about an obsession of the end in a world denatured by technological arrogance.

Greater fortune finally has smiled on sculpture. Contrary to painting, sculpture was not part of the passing fashion; it is much more difficult to run across soppy mannerism in sculpture; revival just does not pay in sculpture.

During the last fifteen years, sculpture has become *schismatic* although it has remained linked to its almost magical genesis. It qualifies space in an *other* way, one that is discontinuous and in opposition to the dogma that a structure is a continuous, finite space, creating a laceration in the lexicon of the work. Almost all of the artists, the fa-

Matthew Barney, Cremaster 4, 1994

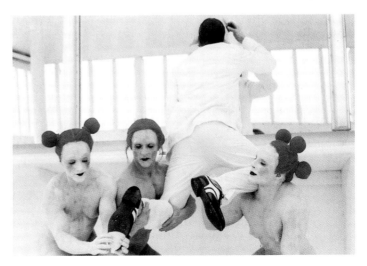

mous (Giò Pomodoro, Anthony Caro, Mauro Staccioli, Luciano Fabro, Anne and Patrick Poirier, Amalia Del Ponte, Antonio Trotta, Nagasawa, Saburo Muraoka), and the young (Anthony Gormley, Giuseppe Maraniello, Jan Fabre, Nunzio, Luigi Mainolfi, Alison Wilding, Anish Kapoor, Tony Cragg, Susana Solano, Eduard Habicher, Eric Bainbridge, Bill Woodrow, Richard Wentworth, Juan Muñoz) have maintained a classical imprint while exploiting a terrestrial, sensual matrix that is both symbolic and biomorphic.

Among the artists who form a kind of inconstant cartography showing the climate, atmosphere and temperature of our days are the Italians Paolo Icaro, Ettore Spalletti, Ernesto Tatafiore, Gianni Dessì, Piero Pizzi Cannella, Silvio Merlino, Marco Lodola, Aldo Spoldi, Maurizio Cattelan, Stefano Arienti, Liliana Moro, Eva Marisaldi; the French Jean-Marc Bustamante, Ange Leccia, Sophie Calle; the Czechs Jan Knap and Jana Sterhack; the Swiss Markus Raetz, John M. Armleder, Fischl & Weiss; the Germans Thomas Ruff, Anne Loch,

Carol Rama,
Seductions, 1984

271

Raffael Rheinsberg; the Austrians, Eva Schegel, Franz West; the Norwegian Per Barclay; the British David Bowie, Abigail Lane, Rachel Whiteread; the Americans Haim Steinbach, Charles Ray, Kiki Smith, Clegg & Guttmann, Robert Gabor, Peter Halley, Lorna Simpson, Paul McCarthy, Matt Mullican, Sherrie Levine, Laurie Simmons, Louise Lawler, Matthew Barney, Andres Serrano; the Belgians Wim Delvoye, Guillaume Bijl, Jan Fabre, and Thierry de Cordier.

They have passed through a variety of fruitful experiences that were rich in suggestions, and by comparing them have stimulated reflections about the existence of a contemporary "taste". On becoming part of their own expression, these past experiences have reformulated it into a system in which it can exist with any other reference. By attesting to a variegated depository of forms and contents, they once again render the past ambiguous, intense and interlocutory, relating its aspects and cadences with those of the present.

The Nineties are passing, we are already midway. Art is interrogating itself in order to promote itself as an object for

Paul McCarthy,
The Garden (detail),
self-moving plants
and figures in an
artificial garden,
1991–92

Katharina Fritsch,
Group at the Table,
32 figures in painted
polyester, wood
and cotton, 1988

public exhibition in a kind of ego-anthropo-centrism that often seems disturbed and delirious.

Neither the ego nor the self are included among such important themes as society, history, nature or culture; there is no longer an art project parallel to a social project. The *soap opera* has inspired the *soap life*.

The strong yet defenceless New Wave of the world exasperates and deliberately exaggerates the mixture of cruelty and comicality, ferocity and nostalgia. It satirises Romanticism, the Classical, the grotesque, the surreal, as well as news flashes, clips and spots, cyber-punk and virtual reality, the films of Federico Fellini and those of David Lynch. It even satirises the minor neo-realist, neo-*intimiste*, neo-domestic stories of a schizoid world that navigates in a sea of contradictions only to shipwreck in the film noir or television treacle. And it continues to satirise the problem of abortion and the anti-AIDS campaign, ecological problems and shady stories of sex, serial and transsexual crimes, fiction, hard rock and grunge.

Many artists, who for the most part are divided, separate, and too far from or too close to the cult of memory and sentiments, make no judgements about the violence that is described and shown in such detail. They choose to adopt the tic-filled trash of teenage culture, throwing every visual solicitation into the alchemic pot of the post-human, that inadequate crossroads of communications and diversified languages. The world of art is a risky scene; it is frightfully unstable and often cruel because the dangers that lurk are anomalous and inconstant, and the results precarious. But hasn't it always been like that?

The Eighties

Francesca Alfano Miglietti

Bodies, an infinite collection of bodies dot the rebellious universe of contemporary art, an exultant geography of mutations in which the body has ceased to be a declaration in order to become a significant surface of rewritings and reversals.

One of the most obvious signs of the cognitive revolution in recent years is the way in which human beings see themselves, and thanks to the ongoing debate about the traditional social and sexual roles, a new definition of human life has already begun to take place in their mutated bodies.

As biotechnologies, cosmetic surgery, new technologies and a dimension of post-identification converge, there is a good possibility that the body will increasingly become a reversible choice. The body is a destiny, wrote Freud, but this is no longer the case today. Bodies can be recreated, rethought, altered or grafted with new meanings; the body surface can be inscribed with signs and dreams; the body can be a moment of extension in our altered relationship with the media, a moment of junction in the mind/world relationship. [...]

In this revolutionised human condition, many artists, the theoretic constructors of mental environments, have chosen the body for their works as the most powerful metaphor of a revolutionised theoretic condition. A process that disseminates the body, a process that goes beyond physical limits through a communicative network that extends throughout the planet.

Bodies, the extrapolated bodies in movie images, the piles of dead bodies in war-stricken countries killed by intelligent arms, the bodies of the homeless dragging carts laden with all their possessions, the bodies of transsexuals, transvestites, homosexuals and prostitutes, deteriorated bodies, violated bodies, altered bodies, and also shapely bodies, smooth bodies, virtual bodies, technological bodies. Bodies of bodies... and more and more often the artists are using their own bodies.

Their own bodies for images, actions, and performances, setting us in front of conceptual dimensions that have been appropriated, changing their signs and situations which, once extracted and isolated from reality, display an absurd

existential logic. Thus, skin, eyes, hands, legs, sex, hair, and lips become territories of significance, terminals of de-territorialisation, horizons of transit, a multiple identity hallucination, a geography of nervous systems extending into the universe, new non-identifying maps.

[…] These are the bodies that are on the scene, a fragment of some of the more significant moments in a way of conceiving the new art which has chosen the body as a territorial uncertainty and the mental dimension of de-territorialisation, a body that can decide from time to time if and how it will appear, that can speak about itself by using traces, fragments, and absences, as the project of a structure or as a projection beyond itself. Works that respond neither to stylistic punishment nor to fashion stupidity, works which in their dimension of multi-identification have become the instruments of a dimension that can even redesign the world and its humans.

("Corpi, biocorpi, ultracorpi", in *Virus*, no. 4, April 1995).

Francesca Alinovi

A spectre is wandering around the Postmodern continent, a furtive, paradoxical spectre: that of an occult and perhaps ineluctable Platonism. Today, it really seems that the living are generated from the dead, and that cathode tubes hook up our minds to the super world of superior ideas, if it is true that our earthly existence increasingly resembles the impotent voyeurism of the Platonic cave dwellers, while, on the other hand, the intellect has developed so much it travels at ultrasonic speeds on the complex binaries of sidereal networks. In other words, society has been turned into a spectacle and translated into images, irreversibly flattening the profundity of reality and spreading it like a surface film on the screens of our perceptive relationships, be they film, television, or photography. Meanwhile, the simultaneous computerisation of the brain has opened our minds to the endless dimensions of an overloaded knowledge: an excess of awareness which seems to transcend us on the one hand, while on the other, as in the Platonic myth of the cave, it seems to generate within us a dangerous suicidal frenzy for oblivion, a self-destructive will for obnubiliation.

[…] Today, we are irresistibly attracted to the falsity of the illusion, while we reject the truth for what it is. Therefore, it is appearance that we wish to tap and aliment, not the immobile fixity of the absolute. So much so that while for Plato this was situated beyond the natural world, it appears to us today to be relegated to the impossible authenticity of nature: postmodernism is the anti-naturalistic phenomenon par excellence which has substituted biology with electronics, and the world of tangible, physical things with the changing universe of their impalpable relationships. The new essences have become appearances. […] ("Natura impossibile del post-moderno", in *L'arte mia*, Il Mulino, Bologna 1984).

Giulio Carlo Argan

[…] Postmodernism contests the avant-garde for its utopianism, but since it was repressed, it considers utopia a failed project. It maintains that the fact of being (or being there) exempts the artwork from any investigation into the reason

for its existence that might lead back to its project and finality, even if these are supernatural. If actuality is a characteristic of the modern, I would say that it is the quality of being present for the here-now of Postmodern. It is a matter of identifying value with price, and the reality of the artistic fact with its economic reality. If the value changes with the price, the conceptual stability no longer exists that was attributed to it at the time when it was thought that it might change due to the evolutionary or revolutionary process of history. The mutability of value versus price is based on the frequency and volume of consumption: the greater it is, naturally the higher the price, which increases consumption and prevails over value which in turn slows it down. Since the consumption of the image is more rapid and massive than the consumption of objects, the system tends to substitute the consumption of images with the consumption of things. Since art is the production of images, its economic value prevails over its aesthetic value. Carrying this to the extreme and overturning the sense of the Hegelian formula is what we mean by the death of art.

Is there any possibility of a renaissance? The consumer system has not yet been established and generalised in the Western world, and much less so elsewhere. It may be that what Alain referred to as the technical system of the arts has finished forever; but we do know that the historical area of art does not coincide exactly with the conceptual area of aesthetics. It is theoretically possible that consumerism will generate its own aesthetic, and that this generate another art, maybe even advertising. But Schiller had already described the aesthetic experience as an experience that was unbiased, autonomous, authentic, and free. If the computer society is, as the consumer society is today, a free society and the means of mass communication are not the instruments of power, there will be no regression and an aesthetic experience will be possible, which will in turn be brought about by inventive, planned, artistic processes. Unfortunately, it is quite unlikely that this will occur if the technical system of production and consumption continue to be a system of capitalist power. As long as this is the case, art will remain (if it manages to survive in some individuals) a utopia without hope, uneventful, and without any possibility of ever becoming a project. The society of well-being presents itself as an automatically fulfilled utopia, without any human impulse.

Since value is not compatible with consumption, it follows that a consumer society is a society without values. As far as I know, the concept of art is not independent from the concept of value. Seeing that the Postmodern, which the war [the Gulf War] made the essence of consumerist mentality, dismisses value, it perpetrates the death of art. But one paints and sculpts, indeed, with a garishness of effects that the Conceptualism of the past avoided. Death does not mean total nullity, for the cadaver of dead art is right in front of us. The young critics show it to us just as Cassius showed Caesar's bloody body to the Romans.

("Utopia o regressione", in *Arte: utopia o regressione?*, edited by L. Vergine, Mazzotta, Milan 1992).

277

Jan Avgikos

[…] The way in which the art of a decade codifies the spirit of an era is rarely direct and never monolithic, and yet the most burning issue at this moment in American art, one that has been developing for several years, is well defined politically and increasingly polemic. Politically and socially oriented art is not, in itself, anything new, and yet the impulse of political art, which now proliferates in the background of the doctrinaire cultural climate of the "New World Order" in America, is headed in the direction of a growing schism that seems destined, on the one hand, to reflect a national obsession that feeds on moralism and "just causes", and on the other, to reject any solidarity with those "altruistic impulses" in the interest of the autonomy of art. To put it more simply, the schism is between politically correct art and politically incorrect art.

To ask what makes art political these days is like asking how useful politically correct art can be when it seems to be colliding with the dominant orthodox culture and officially established and sanctioned interests. Collectives like Gran Fury, the Guerrilla Girls and Group Material, for example, have been outspoken about the AIDS policy in America, sexism in the world of art, and the invisible institutional prejudices that have perpetuated the social status quo. Their strategies have been quite successful thanks to their structures which have a constant turnover of collaborators or, in the case of the Guerrilla Girls, are completely anonymous, as well as to the fact that these agit-prop groups see to it that explicit information is available

without the complication of having to sell an artistic product at the same time. By operating on the fringe of the market, or by staying completely out of it at times, they can plumb the limits of existence of true art.

[…] Political art developed out of the political discussions of the Eighties, which were primarily a criticism of social representations, while today it is debating the pros and cons of ideological polarity. Let us take into consideration for example the general theme of the body, sexuality, gender and subjectivity which includes the expression of the gays, the female presence in a patriarchal society, the use of pornography and references to AIDS. While the unit of measure determining political correctness or incorrectness must necessarily fluctuate from one user to another, there are precise institutional morals that indicate how far art can go before it goes too far. For example, the representation of social differences is politically correct as long as it adheres to the political left's version of the rights of homosexuals, feminism, and activism against AIDS. The underlying rule is that such subjects are delicate and must be treated accordingly: the class structure of society in general may be discriminatory and exploitive, but art must maintain more elevated virtues. […]

("1900-America", in *Anni novanta*, catalogue, Mondadori, Milan 1991).

Franco Bolelli

[…] I believe that the Postmodernism functions today as a system that justifies what exists, which is the exact opposite of what an artistic function should be. I

believe, that is, that a great deal of what goes under the label of Postmodernism today runs the risk of guaranteeing that frightful operation of dissuasion that is implicit in the very concept of existing.

[…] We have a reality in which everything coexists with everything else, a stratified reality, a reality that is apparently magmatic but very orderly in the apparent disorder of its multiple tendencies. Because I believe that while it was right, on the one hand, to avoid the classic shoals of ideology, on the other, we have landed in something that is equally inauspicious, and perhaps even more dangerous, which coincides, that is, with the ideology of anti-ideology. […]

This logic that much of the post-modern has promoted during these years is expressed by the concept of indifference, a concept, in my opinion, that ought to be challenged today on the theoretic and cultural planes of the ways of life.

The concept of indifference, detachment, and cynicism is one of the worst tendencies to be seen currently.

The point has been reached, artistically speaking, in which any material or any artistic experience is acceptable, there no longer being a scale of values. However, transforming this affirmation, which in itself is valid, into a concept in which the absence of value becomes the only value is to completely renounce that principle of passion that, I believe, is at the very heart of the artistic phenomenon. If art is not created out of a great inner need, then I do not know why it is created. […]

("Le meraviglie del possibile", in *Incontro con il postmoderno*, Mazzotta, Milan 1984).

Michele Bonuomo
Eduardo Cicelyn

[…] The ethical and enigmatic dimension of beauty has become an urgent requirement of contemporary art and has returned to manifest itself today in a Europe of rapidly changing borders and identities. Although we have let Dürer's message – "I do not know what beauty is"– resound since the dawn of modernity, the scene has changed and so have the artists, but the questions have remained the same. They are questions that require no answers and do not even ask for explanations. In order that the play of meanings remain open, peremptory demonstrations are unnecessary: the enigma is necessary more than any truth. […]

In the Eighties, which were marked by a declining lack of confidence in the progress of the old and new avant-garde, faith in the self-regulating mechanisms of a wildly expanding market imposed ephemeral associations which, from time to time, satisfied the growing consumer demand for art and became popular and a standard of behaviour. However, the duration of life and the world today has become a concrete problem for the common sense, and art is also thinking and reflecting about this general state of basic insecurity.

[…] A new theory of art is not what may really matter today: on the contrary, art should be conceived of as a praxis that makes time by working this time, because our time is a utopia of the present that is to be saved. In this sense, aesthetics returns to being an ethic like a new practical reason with one categorical imperative: our time, which is the time of

each one of us, the time in which each one of us is someone, is the time to be saved.

Art, however – and this is the meaning of the contemporary adventure – does not conform to the present and against history by a re-appropriation of the state of becoming. [...] Paradoxically, the place of contemporary art, the art that is considered difficult and incomprehensible, is the "simplest" place, the "involved" work that imitates nothing and has no memory of anything.

Art as the pure state of becoming is the philosophical problem. If truth is no longer the ultimate aim of theoretic research, and beauty the goal of the aesthetic experience, what makes the artists' and philosophers' work generally comprehensible and desirable? It only takes a little ingenuity – Adorno hinted – just enough to be able to see and understand. But what is left to see and understand that has not already been seen and considered at length and historicised? How can there be an experience of something that changes in its changing? The artists in their exemplary singularity, in their being basically and only what their works are, even when their discussions become allusive and metaphorical and go so far as to theorise silence and programmed solitude, have shown the way towards an idea of finiteness, of being in the world, of a subject that does not yield to becoming. "In the end", to conclude with Roland Barthes, "a little of the subject always remains. What subject? The one that observes in the absence of the one that does. Certainly, you can make a machine, but whoever contemplates it is not a ma-

chine: it is someone who desires, fears, enjoys, and gets bored." [...]
(*Che cosa sia la bellezza non so*, Leonardo, Milan 1992).

Dan Cameron

[...] After eight years of intense polarisation and stylistic sophisms, our decade has settled into a phase of almost total eclecticism. Not that all artists now are necessarily intent on preparing intercultural soups, but they do seem profoundly aware everywhere of the means that are necessary to completely transform art from the way that civilisation reproduces a context within which it encloses its own representations of itself. The overlapping meanings that are being created between art and ideology, art and social representation, art and commerce, and art and entertainment, create a void of intentions that language hastens to occupy. This is the international codification of art as a symbol of high intentions and permanent values, but it is also engaged in acquiring a sense within a less stratified environment. Inexplicably, art at the end of the Eighties is more public than it has ever been in the recent past, and yet it has not sacrificed one thread of its innate pomposity nor of its obstinate refusal to cede its own secrets to the uninitiated. [...]
(Translated from Italian, *When is a door not a door?... When it is open*, in *XLIII Biennale Internazionale d'Arte di Venezia*, exhibition catalogue, Fabbri, Milan 1988).

Giorgio Celli

[...] Postmodernism as a rethinking and recovery, a historical-cosmological col-

lage, is, in my opinion, despite all its declared ecumenisms and autonomies, one of the aspects of a more general phenomenon called the "death of the social" or the "rediscovery of the private" which philosophers and sociologists have been dealing with for some time now. The Postmodernism, to better circumstantiate things, is in the first place a post-Conceptual and, a minor corollary, a confutation of the epic. There is indeed no doubt that the Conceptual, in its passage from the imagery/larva to great intellectual conflagrations and epiphanies, had elaborated a kind of "collective thought" of the "social mind", although it privileged and celebrated the "inner space", and has thus remained in the last analysis and in the majority of its results, a profoundly extroversive and communicative modality for managing aesthetics.

Entirely different ways and desires have been revealed by the New-New Ones who are populating galleries and promoting the celebration of a second past, abundant in experiences and ·satisfactions. Briefly, this deals with the *recherche* for a lost art that is developing between the two opposite yet complementary poles of compassion and irony. [...]
(Studio Cavalieri catalogue, Bologna 1981)

Roberto Daolio
[...] In addition to reproducing and serialising a project taken from its destiny as an original prospect and, in a certain sense, a salvific one, there has been a widespread use of quotation in the recently concluded decade. In the anachronistic terms of re-proposal and recovery as an exaltation of a single "exclusive" way of working, as much as in the more eclectic, lighter solutions of a series of signals, placed between quotation marks, but oriented towards superimposition and change.

The crossing has been carried out by keeping the availability of variation in mind and by positioning a level of discontinuity with the recent and distant past. A rediscovered manual skill is proceeding, however, at the same rate as detachment and indifference which, out of necessity, are found to influence the terrain of simulation.

The strong contrast has brought back to the here and now an uncontrolled revival of ideas and concepts that had been reinvigorated in the magma of so much slimy, dripping painting. The idea of "beauty" or "ingeniousness" again founders in a system of positions and values that no longer adheres to the authentic historical and culture function of art. There is an urgent need for "contemporaneity" to provoke a confrontation that is not isolated in order to rethink the production of objects and the relation between their real use and their symbolic valence taken as a whole, so as to transfer the order of the problems from the factual plane to the aesthetic one. The actual refusal on the part of many artists to legitimise an option of non-adaptation to the archaic system of a pure instinctual, impulsive, sensitivity can be explained by the self-referential disclosure of concepts alternating on the "real" scene of the world. And which result in being created in the diverse forms, both simple and complex, of already "produced" objects, and in any

case (often) presented in the inventory and complete catalogue of post-industrial society. Including the imagery. Given the increasingly incessant proliferation in the capillary network of icons and figures in a spasmodic as much as captivating migration from one context to the other. […]

("Al volo", in *Anni novanta*, catalogue, Mondadori, Milan 1991).

Jeffrey Deitch

[…] The passage to the post-human world of cybernetic space and genetic engineering is gradually drawing to a conclusion. Many of the new attitudes towards the body and the new codes of social behaviour do not seem to be particularly significant when analysed singly, while when considered together they reveal a decided tendency towards a radically new model of the ego such as that of social behaviour. […]

The generation that has watched and perhaps tried to imitate the physical transformation of Jane Fonda by now possesses a profound awareness of the freedom that each one of us has to control and change our own bodies. The more widely accessible the use of advanced technologies become, the more logical it is to conjecture that the generations that come after Jane Fonda will want to create genetically perfect children endowed at birth with physical characteristics that have been improved by years of exercise, liposuction and cosmetic surgery. […] This is the type of attitude that will probably lead to its integration with the post-human being.

[…] Analogously to the avant-garde of our society, many of the more interesting artists of the younger generations are confronting one another with new conceptions of the body and new definitions of the ego. They are attempting, that is, to respond with their own particular language to the same interrogatives concerning the traditional notions of sex, sexuality and identity that so many individuals in the world are trying to give an answer to today. Much of the new figurative art has reacted by describing the "real" world, however, it really cannot be defined as realistic in the traditional sense of the term. This because such a large part of the "real" world that the artists are reacting to, has in fact itself become fictitious. The concept of a reality in a stage of disintegration, determined by the acceptance of a multiplicity of real, and thus artificial, models, will not make the Realism that we were accustomed to knowing possible for much longer. This new figurative art may actually mark the end of Realism instead of its revival. […]

(Translated from Italian, in *Post Human*, exhibition catalogue, Castello di Rivoli, Museo d'Arte Contemporanea, 1992–93).

Mario Diacono

[…] If the painter today does not seem to have political designs, it is not because he has abandoned politics, but because politics has abandoned culture: just as politics decided to expunge individual consciousness from history, it deprived itself of its connection to art. What does the birth of the new images coincide with historically for that matter? With the end of the racist myth of the cultural revolution and with the be-

282

ginning of the mythicizing of the new social subjects: women, the marginalised, the drug-addicts. There was more authoritarianism in the pretext or the messianic expectation of collective functions that would abolish "private subjective practices" than in all the possible epiphanies of a machismo of the image. It is obvious that the constellation of women, drug-addicts, and marginalised has had no astral impact on the appearance of the new images. Both phenomena are part of the situation that was created at the end of the Seventies with the collapse of the great utopias of class regeneration and the political healing of man from alienation that had been promised by the movements of that decade. The only ideology promised to the artist today, as for any artist who has desired to be a person of his own time, is that of being a form of contemporaneity. The contemporaneity of the Eighties has to deal with the impossibility of the project and at the same time with the possibility of a multiple penetration of history. The capitalist/fascist/communist man no longer exists, and it is difficult to know what kind of men we want to be: an era of universal social democracy will probably be announced in which the three above-mentioned modalities will be fused and inseparable from one another. With the mediocrity of the state as its future, art is attempting the last adventures of mature disorder. For the moment it is a matter of an individual, and not collective, disorder, but let us give time to time. [...]

(In *Mario Merz*, edited by D. Eccher, exhibition catalogue, Hopeful Monster, Turin 1995).

Emilio Garroni

[...] Our senses and passions often exist under the sign of stupidity, and what is even worse under a sign of ferocious stupidity. I agree about the "small pleasures", at least as far as that curious like-dislike of art is concerned. The fact is that what we call "art", like anything unitary, has had a short and perhaps irretrievable season. It arose in the eighteenth century out of a group of different activities, at times similar and at times unequalled, a complex of local identities (as in the case of poetry), resemblances (as in the case of the figurative arts) and also differences that were at times radical (as in the case of music and the other arts). Now, with the transformation and multiplication of "artistic" activities, it seems to have again returned to being a complex of resemblances and differences, under the increasingly labile mark of the seventeenth-century label of "art". No longer is it the exemplary bearer of meaning, or even of non-meaning, as in certain of the more significant aspects of art and literature of our century, for it has generally tended to become an art of consumption or entertainment, even at apparently medium-high levels.

[...] One must be careful not to endow so-called "artistic inspiration" – (just what exactly is "artistic inspiration"? Art, no matter what it deals with, is certainly a question of talent, at times fulminant and fulminating, but also of slow, tiring, long thought-out work) – with excessively divinatory or mystic virtues. We certainly do not touch, nor did we touch, truth with art, but something much more important: the very

meaning of our thinking, speaking and doing from which it may spring, and the truth and non-truth, and whatever gives sense to what we think, say and do. To life, in short. And in this sense, to things themselves. […]

("Intervista di Doriano Fasoli", in *Flash Art*, no. 187, October 1994).

Jannis Kounellis

[…] The problem of quotation is a misunderstanding put forward by critics to underrate the subversive level of art. It refers to a kind of descriptive literary view of art, where no idea of the… visual clash exists. It's put forward by a special class of people whose aiming point is stabilisation. There's much ambiguity in it, a lack of clarity, a greater lack of courage, implying a kind of eclectic bourgeois outlook. The final tension is lacking that creates renewal, that creates history. The visionary will is lacking that has accompanied art during its history. There's a certain type of criticism, born from Croce's idealism that has never understood what the tensions and vision of modern art really were, and so this incredible misunderstanding has arisen. These people have never seen art as a clash, because they haven't really lived any art season. Any. […]

("Conversation with Lisa Licitra Ponti", Milan, 3 March 1984, in *Domus*, no. 650, May 1984).

Joseph Kosuth

There is no moment that is right or not right to be an artist. The artist's material is more than anything else, the historical moment in which he lives, and the culture that has formed him and the moment. There are no "good" or "bad" forms in art just as there are none in language. The "significance" lies in the systems of relationship, not in the forms. (What artists do is produce meaning, even when – or above all when – they try to annul the given meaning.) They create knowledge, a knowledge from which political responsibility derives. We are speaking naturally of an idea of the artist and of art that is historical, ethical, philosophical, bound to a revolutionary tradition even if (or maybe *because*) it changes form with the change in the practice. That is knowledge, and knowledge makes the world. There is naturally another idea of art – which has been around a lot these past years – the idea of artists "subcontracted" by interior decorators. Artists who continue to move forward playing with pencils, and the dealer is their mother and father. Weak artists, I think, favour the growth of a weak culture, one wanting in judgement. And the more this occurs, the more our cultural lives, indeed our political lives are in danger. An integral part of the *modern* was the notion (always more problematic) of making art "for the history of art". Problematic, but it was the least bad among the reasons for making art. And it explained a specific, tacit passion for an activity that had no other aim than to know itself, and its own terms, in order to be of some use to the world. But it seems that during these years an alternative to the "history of art" has made a way for itself: "the history of the art market". You see more and more work around that has a sense for *this* history, *not* for the history of ideas. Regrettable, this fact. The two

histories are parallel, often they overlap; they seem to be the same thing for many but they are clearly not. One is the history of a corpus of ideas that has been forming through the social values of a tradition, and this has enabled it to materialize in terms of human evaluation, apart from the simple economic terms of power relationships. The other history is the documentary trace of "exchange relationships" of *desire*, but it also means (and this is more ominous) that a cultural history has made its appearance in which art has in fact irrevocably been removed from the hands of the artists. [...]
(Translated from Italian, "Kosuth's Modus Operandi", in *Domus*, no. 665, October 1985).

Lou Reed

There is no time
This is no time for celebration
This is no time for shaking hands
This is no time for backslapping
This is no time for marching bands
This is no time for optimism
This is no time for endless thought
This is no time for my country right or wrong
Remember what that brought
This is no time for congratulations
This is no time to turn your back
This is no time for circumlocution
This is no time for learned speech
This is no time to count your blessings
This is no time for private gain
This is a time to put up or shut up
It won't come back this way again
This is no time to swallow anger
This is no time to ignore hate
This is no time to act frivolous

Because the time is getting late
This is no time for private vendettas
This is no time to not know who you are
Self-knowledge is a dangerous thing
The freedom of who you are
This is no time to ignore warnings
This is no time to clear the plate
Let's not be sorry after the fact
and let the past become our fate
This is no time to turn away and drink
or smoke some vials of crack
This is a time to gather force
and take dead aim and attack
This is no time for celebration
This is no time for saluting flags
This is no time for inner searchings
The future is at hand
This is no time for phone rhetoric
This is no time for political speech
This is a time for action
because the future's within reach
This is the time
This is the time
This is the time
Because this is no time
This is no time
This is no time
This is no time

Jerry Saltz

[...] When America turned its back on Europe in the Seventies, Europe was left to defend itself on its own after having been subject to the continuous invasion of American art at least from the late Forties. It was unable to maintain the enormous number of artists, young and not so young, who had something to say but who were totally frustrated in their attempt to say it either to or with the Americans, and who therefore drew on the long, deep-rooted tradition of figu-

285

rative painting and the way of treating materials. During the Seventies, European artists, particularly in Germany and France, reinvented painting through their own image, which was known only to a small minority of their colleagues in the United States. The Seventies in Europe were the Eighties in America, but without its hyperactivity and economic wherewithal.

[…] While the conquest of painting might be compared to that of the North Pole, we could say that Europe was the first to reach it and occupy it for a goodly period before the Americans arrived to reclaim their property.

It was really incredible to discover during the recent travelling exhibition of the German artist Sigmar Polke that his works had been totally unknown to the majority of Americans until the early Eighties! And this was not only true for Polke, but also for Anselm Kiefer, Gerhard Richter, Georg Baselitz, Jannis Kounellis, and many Italians who were part of the Arte Povera movement. America had been caught in her sleep, and it remains to be seen if she will be able to catch up on the lost time. But we have not yet taken into consideration Europe's major post-war artist. Joseph Beuys comes on stage. Assisted by Polke, Richter, and dozens of German painters, he has inflicted a resounding defeat on the United States in a frontal attack while the Italian artists have come through the back door one after the other. America was not even aware of this, and this was probably what has saved her. Had she realised how desperate the situation was, I doubt that she would have been able to organise any kind of

action by following the old American habit of letting things reach a crisis, and then rapidly inventing "a healthy dose of good old Yankee ingenuity". American art, so contorted and self-preoccupied, surrendered; that is, at least the best and most intelligent noticed the arrival of this new wave in time to save their own artistic lives, even if they were only able to do it by the skin of their teeth. It is interesting to note how all the artists who emerged in the Eighties belonged to the same generation of the thirty-year-olds. In other words, it was not too late for them to make this newly discovered vitality their own and not just limit themselves to copying it. For the majority of the older artists it was already too late. […] In the Eighties, art became a business, and the word *market* replaced all other words. In fact, artists began to dress like businessmen (certainly not like those of the Fifties who in order to earn respect wore jackets and ties). […] The majority of the artists of the Eighties will only appear as a "return signal" on the radar of history. Background noise and nothing else, material for doctorate dissertations.

Many of the East Village galleries ended up as flops, others moved to Soho. Only a handful have survived today. Many of the artists abandoned their East Village galleries for the more comfortable neighbourhood of Soho, while the country was also undergoing a similar transformation. The core had overheated, and the ongoing fusion was causing mortal doses of anger and rancour. The armaments race had weakened our financial resources and the public debt become an uncontrollable colossus. The

environment had been exploited to the maximum, and Wall Street became variable, as did the savings and loan banks. On Tuesday, 22 October 1987, the New York Stock market dropped more than 500 points, losing more than 22% of its total value in a hysterical fit of frantic exchanges. The United States wondered if it might not be on the brink of a second depression. And the art world sat and waited to see what would happen to its "thousand-coloured cloak". Nothing happened, at least not immediately afterwards: prices continued to increase in the two big auctions held that autumn, although not as much as in the old days. Some works were not sold, and the auction houses (whose directors will end up in hell along with "independent curators" and "art advisors") undertook a programme of "damage limitation" underscoring the need for a "re-arrangement". It was the era of the "control of the fall". And they tried to look on everything positively, even if something really had changed. Some – the most cynical – went so far as to say that the Eighties had ended that day. [...]

(In *American Art of the '80s*, exhibition catalogue, Electa, Milan 1991).

Angelo Trimarco

[...] The indifference and the equivalence of languages were a result of the disappearance of the theorist, and certainly characterised Postmodernism. The indifference and the equivalence of languages are basically the collapse of values and their organisation into hierarchies. The avant-garde and the Modern Movement have been of inestimable value for more than half a century. In sub-

stance, it was the tendency that defined good and bad art, the architecture of research and architecture of false consciousness. The avant-garde and the Modern Movement have become a guaranty for experimentation and also for a growing sensitivity. Of course, in Postmodern art, be it the Transavantgarde or the New-New Ones, there is not the anger and violence that is spreading through the geography of architecture, where the attack on the star system and the *functionalist statute* of the Modern Movement has created moments of undeniable incandescence. This more placated, serene behaviour with regard to the avant-garde can be explained by the fact that the reckoning with the new tradition has neither been avoided nor postponed for more than twenty years. Moreover, recent history confirms this. It does not come as a surprise that one of the surest confines in the history of contemporary art, the one between the avant-garde and the Novecento, has recently given way. On the other hand, Conceptual Art has shown the uselessness and the non-necessity of referring to the avant-garde in its elaboration of a definitive proposal for the dematerialisation of the art object. Now, the history of art, the entire history of art appears, as the Eighties are being examined, like an endless sky filled with signs and figures, resolutions and deviations, and the persistence of languages, all of which are absolutely indifferent and equivalent. In this way, the hierarchies collapse and the values are set at zero, privileges and impediments are cancelled, as are remorse and repentance. These materials and memories have sim-

ply turned into the pieces of a game, moments or uncertain transits. Like the pieces, and no less provisory, are the reports and memories of the lower cultures and their technical systems. And there is more. Together with the repertory of forms from the history of art and material culture we find, scandalously, fragments of autobiographies and splinters of private life, that slow flow of subjectivity, the obstacles of remembrance and the veil of the fable. The return of the subjective, therefore, as the equalisation of interior language and public language, silence and noise, infancy and history. […]

("Lo sfiorire del teorico", 1981, in *La parabola del teorico. Sull'arte e la critica*, Kappa, Rome 1982).

Lea Vergine

[…] The creation of a project and especially an ability to survive in the future today appear to be obsolete, losing strategies. On contemplating an a-problematic and analgesic existence, one is delivered into the coils of that sticky stuff that is our society which seems to guarantee survival without too much suffering or excessive exertions. However, we turn out to be seriously restricted. This placid prison becomes a sort of protective container in which artists and critics stop to ruminate past experience and behaviour as they again skim through the outdated pages of their becoming, taking refuge in a celebration of the past, of time gone by, of a life dotted with satisfaction, without irony or pathos.

One does it in order to stay afloat. One surrounds oneself with anything that lacks contradiction. That is to say, one moves back to the past, or to the recent past, in order to avoid the trauma or simply the difficulty of having to face and accept the historical present.

Why do such wretched parodies exist in art and in life? So as not to take up the onus of changing a world – let us put it this way – that is considered an obsolete dream in a society that is half-criminal and half "moderately qualified" (Hans Magnus Enzensberger), one stimulates a temporal regression towards infantile and adolescent behaviour to the point that one believes it. In the arts – given the obvious differences – the same formal and Conceptual regression exists. The methods of communication and expression consistent with how much assaults us daily with violence, cynicism and cruelty have been frustrated, censured, or substituted by those in vogue during the last century or fifty years ago. Everything that has occurred in the last thirty years, for example, has been eliminated or ignored as if it had never happened. The present is being lived as a surrogate of past events, in the prospect of a threatening or terrifying future, a future envisioned with anxiety. The past, unrepeatable, is lived as if it were not out-of-date and, since it is not out-of-date, it continues to determine the daily present.

[…] If we accept the fear for what has happened in the past, we would not need to pretend that the past can be the present. But we eliminate, we repress, we live by proxy, we deceive ourselves in the excesses of the ego.

The elimination of the past means that a part of our lives is lost. An uninhibited vision of the future, a vision of the future

as a loss, leads only to what the psychiatrist-philosopher Ludwig Binswanger referred to as "melancholic prospecting". Will we all end up by denying the world we are part of in a delirium of past imagery and representations, in a prolonged agony without death?
("Utopia o regressione", in *Arte: utopia o regressione?*, edited by L. Vergine, Mazzotta, Milan 1992).

Bibliography
A. Huxley, *Vulgarity in Literature*, Chatto and Windus, London 1930.
The New Art, exhibition catalogue, Hayward Gallery, London 1972.
The Condition of Sculpture, Hayward Gallery, London 1976.
G. Bartolucci, "Di una sensibilità postmoderna?", in *Incontro con il Postmoderno*, Mazzotta, Milan 1982.
A. Trimarco, *La parabola del teorico. Sull'arte e la critica*, Kappa, Rome 1982.
J.-F. Lyotard, *The Postmodern Condition*, University of Minnesota Press, Minneapolis 1984.
L. Bentivoglio, *Il teatro di Pina Bausch*, Ubulibri, Milan 1985.
P. Virilio, *L'orizzonte negativo*, Costa & Nolan, Genoa 1986.
B. Corà, in the catalogue *Europa oggi*, Electa, Milan 1988.
J. Beuys, M. Lende, *Kunst und Politik: ein Gespräch*, Wangen 1989.
Les magiciens de la Terre, edited by Jean Hubert Martin, Centre Pompidou, Paris 1989.
G. Vattimo, *La società trasparente*, Garzanti, Milan 1989.
P. Virilio, *La macchina che vede*, Sugar-Co, Milan 1989.
G. Di Pietrantonio, *Vita e malavita di Enzo Cucchi*, Politi, Milan 1990.
E. R. Comi, "Conversazione con Leo Castelli", in *Spazio Umano*, December 1991.
Arte: utopia o regressione?, edited by Lea Vergine, Mazzotta, Milan 1992 (Proceedings of the Conference of San Marino, June 1991).
H. M. Enzensberger, *Mediocrity and Delusion*, Verso, London and New York 1992.
A. Trimarco, *Il presente dell'arte*, Temaceleste, Syracuse 1992.
P. Virilio, *Estetica della sparizione*, Liguori, Naples 1992.
U. Volli, *Esercizi di pluralità dei linguaggi*, Feltrinelli, Milan 1992.
P. Bausch, in *Atti del convegno internazionale* (Turin, June 1992), Costa & Nolan, Genoa 1993.
B. Yoshimoto, *Kitchen*, Washington Square Press, New York 1993.
Catalogues of the Whitney Museum Biennials, New York 1993–95.
G. Verzotti, "Il volto d'altri", in *Soggetto Soggetto*, exhibition catalogue, Charta, Milan 1994.

General Bibliography

In the Spirit of Fluxus, exhibition catalogue, Walker Art Center, Minneapolis 1993.

Italian Art in the 20th Century: Painting and Sculpture 1900-1988, exhibition catalogue, Royal Academy of Arts, London 1989.

Refigured Painting. The German Art Image 1960-1988, exhibition catalogue, Solomon R. Guggenheim Museum, New York 1988.

F. Alinovi, *L'arte mia*, Bologna 1984.

L. Alloway, *Systemic Painting*, exhibition catalogue, Solomon R. Guggenheim Museum, New York 1966.

M. Amaja, *Pop Art... and After*, New York 1965.

M. Amaja, *Pop as Art: A Survey of the New Super-Realism*, London 1965.

M. Archer, *Art Since 1960*, London 1997.

G. C. Argan, *L'arte moderna. 1770/1970*, Florence 1970.

R. Barilli, *Informale, Oggetto, Comportamento*, Milan 1979.

C. Barrett, *Op Art*, London 1970.

G. Battcock, *Super-Realism*, New York 1975.

G. Battcock (edited by), *Idea Art: A Critical Anthology*, New York 1973.

G. Battcock (edited by), *Minimal Art: A Critical Anthology*, New York 1968.

G. Battcock (edited by), *The New Art: A Critical Anthology*, New York 1966.

G. Battcock, R. Nickas, *The Art of Performance. A Critical Anthology*, New York 1984.

J. Beardsley, *Earthworks and Beyond: Contemporary Art in the Landscape*, New York 1984.

A. Bonito Oliva, *Europe-America: The Different Avant-Gardes*, Milan 1976.

A. Bonito Oliva, *La Transavanguardia internazionale*, Milan 1982.

G. Brett, *Kinetic Art*, London 1968.

J. Cage, *Silence*, Middletown, Conn., 1961.

L. Caramel, *Arte in Italia, 1945-1960*, Milan 1994.

G. Celant, *Arte Povera. Conceptual, Actual or Impossible Art?*, Milan and London 1969.

G. Celant, *Conceptual Art, Arte Povera, Land Art*, exhibition catalogue, Galleria d'Arte Moderna, Turin 1970.

G. Celant (edited by), *Identité italienne. L'art en Italie depuis 1959*, Florence 1981.

M. Compton, *Optical and Kinetic Art*, London 1967.

291

M. Compton, *Pop Art,* London 1970.

Th. Crow, *The Rise of the Sixties*, London 1997.

C. Finch, *Pop Art – Object and Image*, London and New York 1986.

H. Foster, *Post-Modern Culture*, London 1985.

T. Godfrey, *Conceptual Art*, London 1998.

E. H. Gombrich, *Art and Illusion*, London 1960.

C. Greenberg, *Art & Culture*, Boston 1965.

R. Hughes, *Culture of Complaint*, New York and London 1993.

C. Jencks, *What is Post-Modernism?*, London and New York 1986.

C. Joachimedes (edited by), *A New Spirit in Painting*, exhibition catalogue, Royal Academy of Arts, London 1981.

T. Kellein, J. Hendricks, *Fluxus*, London 1995.

M. Kirby, *Happening*, New York 1965.

La Monte Young (edited by), *An Anthology*, New York 1962.

J. Leymaire et al., *Abstract Art since 1945*, London 1971.

L. Lippard, *Pop Art*, New York and London 1966.

L. Lippard (edited by), *Six Years: The Dematerialization of the Art Object from 1966 to 1972*, New York and London 1973.

E. Lucie-Smith, *American Realism*, London and New York 1994.

E. Lucie-Smith, *Movements in Art since 1945*, London 1995.

K. McShine, *Primary Structures*, exhibition catalogue, The Jewish Museum, New York 1966.

R. C. Morgen, *Commentaries on the New Media Arts: Fluxus & Conceptual, Artist's Books, Mail Art, Correspondence Art, Audio & Video Art*, Pasadena 1992.

B. Rose, *American Art since 1900: A Critical History*, London 1967.

H. Rosenberg, *The Anxious Object*, New York and London 1964.

H. Rosenberg, *The Tradition of the New*, New York 1959.

J. Russell, S. Gablik, *Pop Art Redefined*, London and New York 1969.

A. Sonfist (edited by), *Art on the Land: A Critical Anthology of Environmental Art*, New York 1983.

N. Stangos, *Concepts of Modern Art*, London 1994.

I. Tomassoni, *Arte dopo il '45. Italia*, Bologna 1971.

C. Tomkins, *Post to Neo: The Art World of the 80s*, New York 1988.

M. Tuchman, *The New York School – Abstract Expressionism in the 40s and 50s*, London 1970.

L. Vergine, *L'arte in gioco*, Milan 1988.

Index

*The author and the publisher wish to
thank the following publishing houses:
Adelphi, Allemandi, Carucci, Charta,
Chêne, Cooptip, Costa & Nolan, De
Luca, Edizioni d'Arte / Zarathustra,
Edizioni Mediterranee, Einaudi, Electa,
Fabbri, Feltrinelli (© Giangiacomo
Feltrinelli, Milan 1961), Hopeful
Monster, Il Mulino, Il Saggiatore, Kappa,
La Nuova Foglio, Leonardo, Lerici,
Lindau, Longanesi, Marsilio, Mazzotta,
Mondadori, Neri Pozza, Prearo, SE,
Tattilo, Vita e Pensiero.
And also: The British Council; The
Cunningham Dance Foundation; Jeffrey
Deitch; Galerie 1900-2000; Galerie de
Poche; Galerie du Génie, Paris; Galerie
Zwirner, Cologne; Galleria La Polena,
Genoa; Galleria Primo Piano, Rome;
Kancélar presidenta republiky CSFR;
Kunsthaus Zürich, Zurich; Ministerio
de Cultura de Venezuela, Subdirección
General de Artes Plásticas; Museo d'Arte
Contemporanea di Rivoli; Museo d'Arte
Contemporanea Luigi Pecci, Prato;
Padiglione d'Arte Contemporanea,
Milan; Paris-Musée / Société des Amis
du Musée d'Art Moderne de la Ville
de Paris; Parkett-Verlag AG, Zurich;
Rowan Gallery, London; Walker Art
Center, Minneapolis; and all other
contributors to this volume.*

302